A Monumental Vision
The Sculpture of Henry Moore

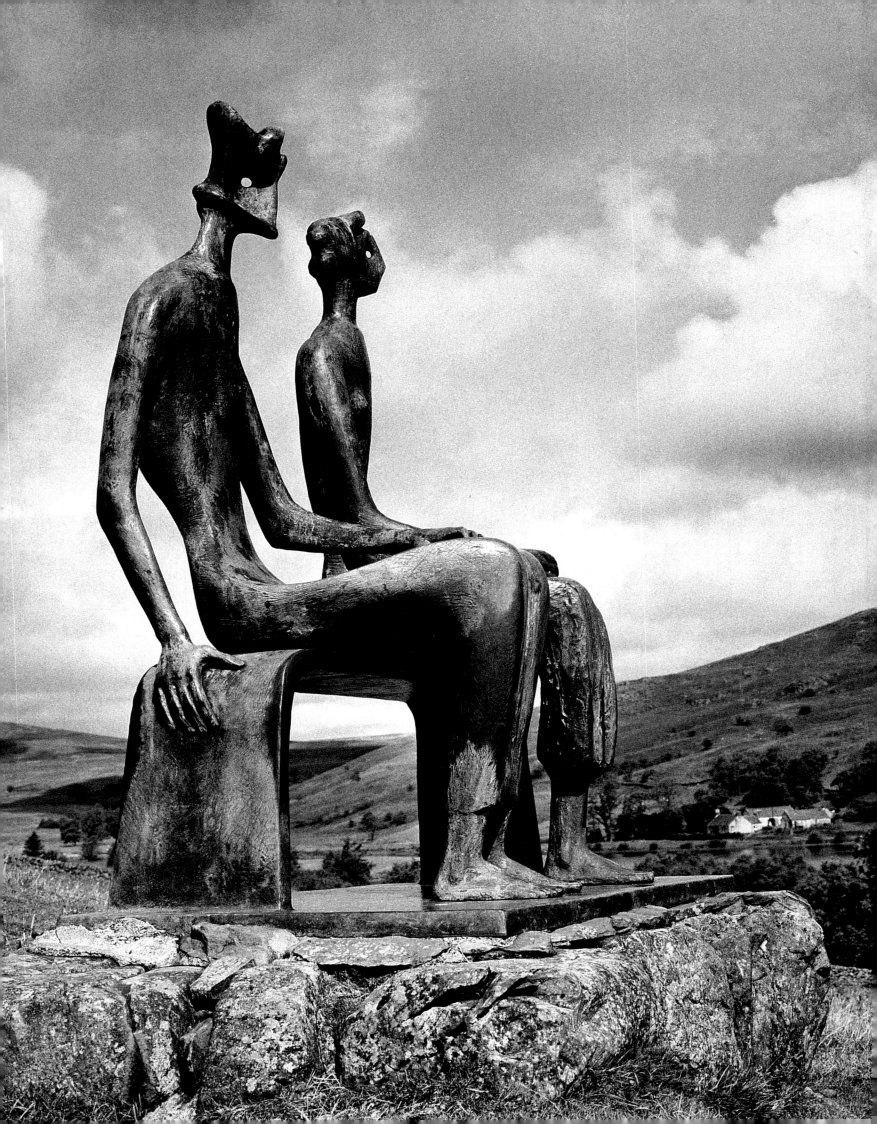

A Monumental Vision

The Sculpture of Henry Moore
John Hedgecoe

Stewart, Tabori & Chang
New York

Dedicated to my great friend and inspiration, Henry Moore

With the exception of Henry's reference picture of work in progress on the Northampton Madonna, all of the pictures in Parts 1 and 2, and most of the pictures in Part 3, were taken by me. I wish, however, to thank the Henry Moore Foundation, and particularly its curator, David Mitchinson, for helping by augmenting the collection of pictures in Part 3, making it an invaluable compendium of Henry's work. My thanks are due to the Foundation, not just for the use of their pictures, but also for their encouragement in making this book what I hope will be a fitting tribute to Henry in the centenary year.

Others at the Foundation, who have been very helpful, are Anita Feldman Bennet, John Farnham, Emma Stower and Jackie Curran. I am grateful to Jocelyn Stevens for writing a foreword, and to the directors and staff at Collins and Brown, especially Cameron Brown, Cindy Richards, Kate Haxell and Muna Reyal. My thanks also go to Roger Sears for the editorial direction and to David Pocknell and Bob Slater for the design.

Published in 1998 and distributed in the U.S. by Stewart, Tabori & Chang, a division of U.S. Media Holdings, Inc., 115 West 18th Street, New York, NY 10011

First published in Great Britain in 1998 by Collins & Brown Limited, London House, Great Eastern Wharf, Parkgate Road, London SW11 4NQ

Distributed in Canada by General Publishing Company Ltd., 30 Lesmill Road, Don Mills, Ontario, M3B 2T6, Canada

Distributed in all other territories by Grantham Book Services Ltd., Isaac Newton Way, Alma Park Industrial Estate, Grantham, Lincolnshire, NG31 9SD, England

Library of Congress Cataloging-in-Publication Data

Hedgecoe, John.
 A monumental vision : the sculpture of Henry Moore / by John Hedgecoe.
 p. cm.
 ISBN 1-55670-683-9 (hardcover)
 1. Moore, Henry, 1898- —Catalogs. 2. Moore, Henry, 1898-
—Appreciation. I. Moore, Henry, 1898- . II. Title.
NB497.M6H42 1998
730'.92—dc21 97-34152
 CIP

A Sears Pocknell book
Editorial Direction, Roger Sears: Art Direction, David Pocknell: Layout Bob Slater, Pocknell Studio

Reproduction by Graphiscan: Printed and bound in Italy by Conti Tipocolor

10 9 8 7 6 5 4 3 2 1

Contents

Foreword

The mysterious quality of a work in progress: Henry Moore's own reference photograph taken as he was working on the Northampton Madonna and Child in 1943.

In 1958, John Hedgecoe walked into my office at *Queen* magazine fresh from the Guildford School of Art and said that he wanted to be my photographer. I have been working for him ever since.

One of our greatest collaborations was his classic book on Henry Moore. Having built himself a studio in the basement of my office, John asked me what I wanted him to do. I remember saying 'Do you know anyone famous?' When he replied that he knew Henry Moore, who lived near his home, I told him to take a series of photographs for the magazine. And so began a close life long friendship between the two men, one of the most surprising and happy working relationships I have ever witnessed. When John had accumulated enough photographs of Henry and his sculptures, the book was agreed and John asked me to edit the words. For a year John and I spent a day every week with Henry at his home where we talked, John took photographs and we recorded what Henry said. Whenever we stopped, even for a laugh or a gossip, Irina, Henry's wife who was in bed with a broken hip, would bang on the floor and shout at us to get on with the book. At lunchtime we would tiptoe out to the village pub with Henry worrying that we might not get a table if we did not hurry.

The stature of Henry Moore as one of the twentieth century's greatest artists is beyond dispute, but he is also part of a larger phenomenon, one that I was to witness later as Rector of the Royal College of Art, where Henry was a student and then taught at the outset of his career. During the latter half of this century, there was an extraordinary energy and creativity in British sculpture and there is no doubt in my mind that Henry was its inspiration. I do not mean that young sculptors were necessarily deriving ideas from his work - in fact, of course, it did not take long for his work to be seen by some as the established norm against which to rebel. I mean that he was an inspiration through the quality of his work and the astonishing status that he achieved. Besides, there was something very important about his Yorkshire mining background that made him different.

Looking through this book, you can see the steadfastness of Henry's originality and vision represented through John's photography, the clarity of artistic purpose that was to make him such a great artist. In this centenary year, it is a delight to enjoy again the extraordinary power of his work.

The hours that I spent with Henry and John working on that book were the most privileged hours in my life.

Sir Jocelyn Stevens CVO, Chairman, English Heritage

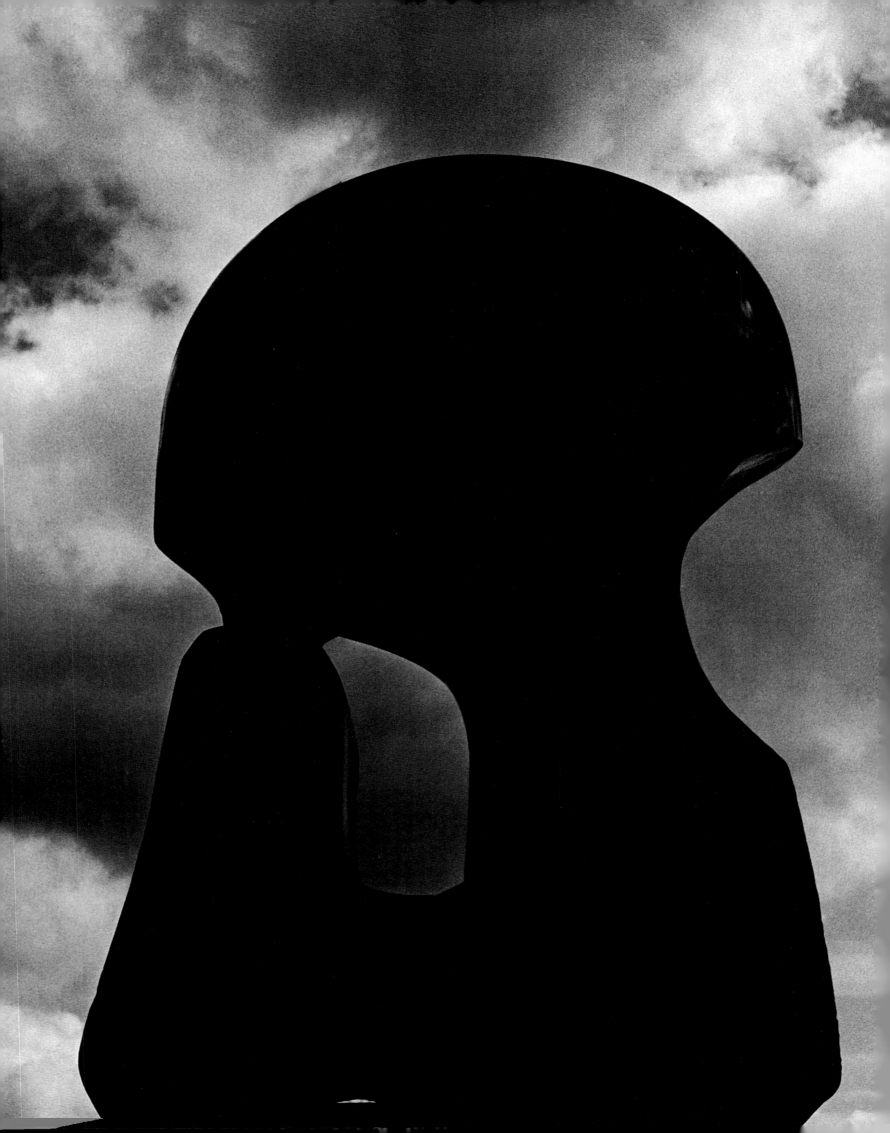

Part One : The Vision

I knew Henry Moore for over thirty-five years during the period when he became publicly acclaimed throughout the world. Through all these years of friendship, I came to understand various elements of his inspiration. Henry was a genuinely down to earth person; he would offer 'some theories and thoughts' on his work if asked, but the intellectual element was always secondary to the sensual, to a deep love of form as he would find it in nature, in the human body (especially the female form) the land and the rocks.

He was not a writer, but he was often required to express himself, simply because of his eminence as an artist. For obvious reasons, his most natural expression was when he was writing for himself, as he did in his early notebooks, or in *Heads, Figures and Ideas* in 1958, in which he wrote of an 18th Dynasty Egyptian head of a woman:

" *I would give everything if I could get into my sculpture the same amount of humanity and seriousness, nobility and experience, acceptance of life, distinction and aristocracy. With absolutely no tricks, no affectation, no self-consciousness, looking straight ahead, no movement, but more alive than a real person.*

The great, the continual, everlasting problem (for me) is to combine sculptural form (POWER) with human sensibility and meaning, i.e., to try to keep Primitive Power with humanist content. Not to bother about stone sculpture versus modelling - bronze versus plaster construction, welding, etc. - but finding the common essentials in all kinds of sculpture." [1]

Right: Henry in 1968

Overleaf: Kenilworth Castle; I took this picture because the tension and strength in the root systems reminded me of his words in our first book together: 'Besides the human form, I am tremendously excited by all natural forms, such as cloud formations, birds, trees and their roots, and mountains, which are to me the wrinkling of the earth's surface, like drapery.'

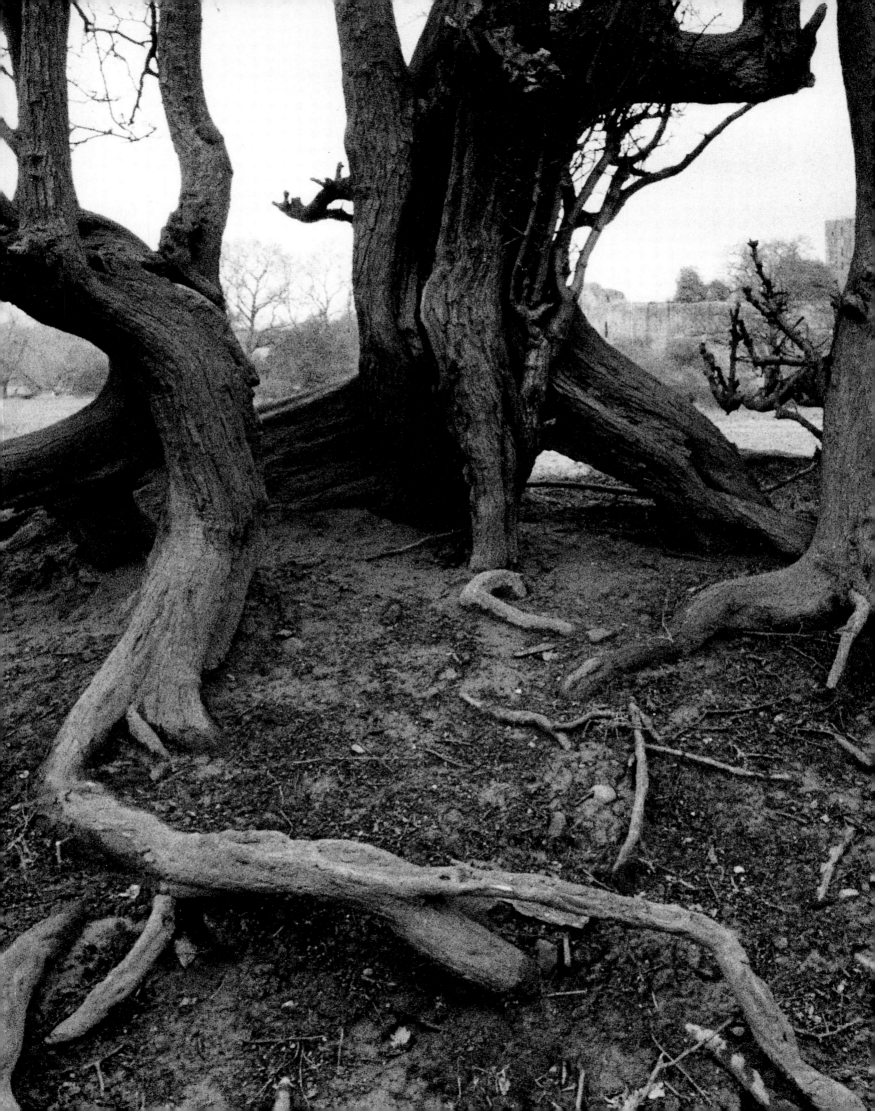

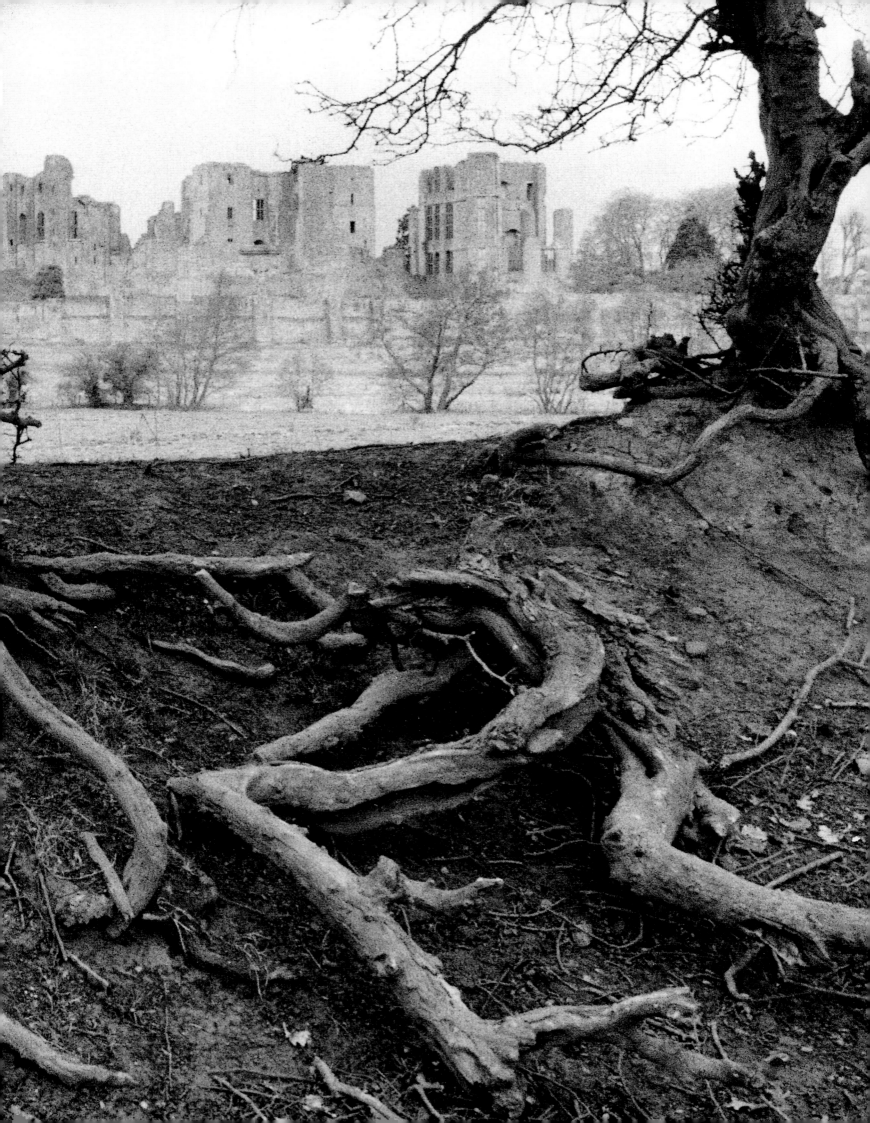

16

In the first part of this book, I have tried to express in words (a few of my own, but mainly Henry's), but more particularly through my photography, the roots of his vision. He was always attracted to the monumental and would often say that a monumental form need be only a few inches high. It is the reduction of a form to its essentials that creates the monumental element in a work. This is also a virtue that nature achieves unaided: Henry would find it in pebbles, in bones, in shells in miniature form, but also in animals and in the landscape itself. As he said in one of his most revealing interviews in 1964:

"...there is a difference between scale and size. A small sculpture only three or four inches big can have about it a monumental scale, so that if you photographed it against a blank wall in which you had nothing to refer it to but only itself - or you photographed it against the sky against infinite distance - a small thing only a few inches big might seem, if it has a monumental scale, to be any size. Now this is a quality that I personally think all really great sculpture has; it's a quality which, for me, all the great painters have - Rubens, Masaccio, Michelangelo - all the great painters, artists, and sculptors have this monumental sense. Perhaps it's because they don't allow detail to become important in itself: that is, they always keep the big things in their proper relationship and the detail is always subservient.

...an artist can have a monumental sense, and it's a very rare thing to have; what I'm saying is that it doesn't come from actual physical size. When the work has this monumentality about it, then you can enlarge it almost to any size you like, and it will be all right; it will be correct... As you make a thing bigger or smaller, you alter to keep true to the mental vision you've had of it. But I don't know; I can't explain what it is that gives monumental scale to something. I think it's an innate vision, a mental thing rather than a physical thing. It's in the mind rather than in the material.

A slag heap in Castleford, a familiar sight to Henry. He said of them:' ...they had as big a monumentality as any mountain, in fact perhaps more. Monumentality has always been important to me...Some works of art have it and others don't... the Cezanne bathers are monumental.'

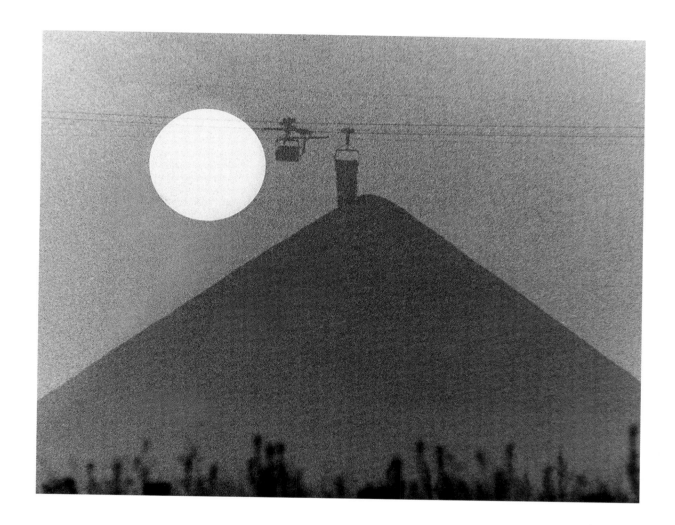

In trying to analyse what this big scale in a work come from, perhaps it is having an instinct so that the sculptor never forgets the big relevance of things, and no matter what amount of detail he puts into it, it is always subservient to the big general design of his form. For example, the Michelangelo Pieta in Saint Peter's in Rome is full of detail - the drapery, hands, faces. Everything in the sculpture is finished to the nth degree and yet the whole sculpture is monumental, mainly because I think that Michelangelo in doing the detail never forgot the whole big general design that he was making; so that to say, for example, that simplicity gives monumentality in itself isn't absolutely true. Simplicity alone, just leaving things out, will not produce monumentality; it may only produce emptiness. True simplicity is done not for simplicity's sake... It's done to keep the essentials and not because you like simplicity." [2]

Henry's great talent was in the vision of the monumental from a shape that he held in his hand, in seeing what was going to happen to a form even when vastly magnified. As he wrote for the Listener as early as 1937:

"There is right physical size for every idea. Pieces of stone have stood about my studio for long periods, because though I've had ideas which would fit their proportions and materials perfectly, their size was wrong.

There is a size to scale not to do with its actual physical size, its measurement in feet and inches - but connected with vision. A carving might be several times over life size and yet be petty and small in feeling - and a small carving only a few inches in height can give the feeling of huge size and monumental grandeur, because the vision behind it is big. Example, Michelangelo's drawings, or a Masaccio madonna - and the [non-monumental] Albert Memorial." [3]

Henry's studio in 1960, when he was working from the maquette on the model for Reclining Mother and Child, which was to be cast in bronze. He was particularly fond of this work, because it combines so many of his themes and ideas.

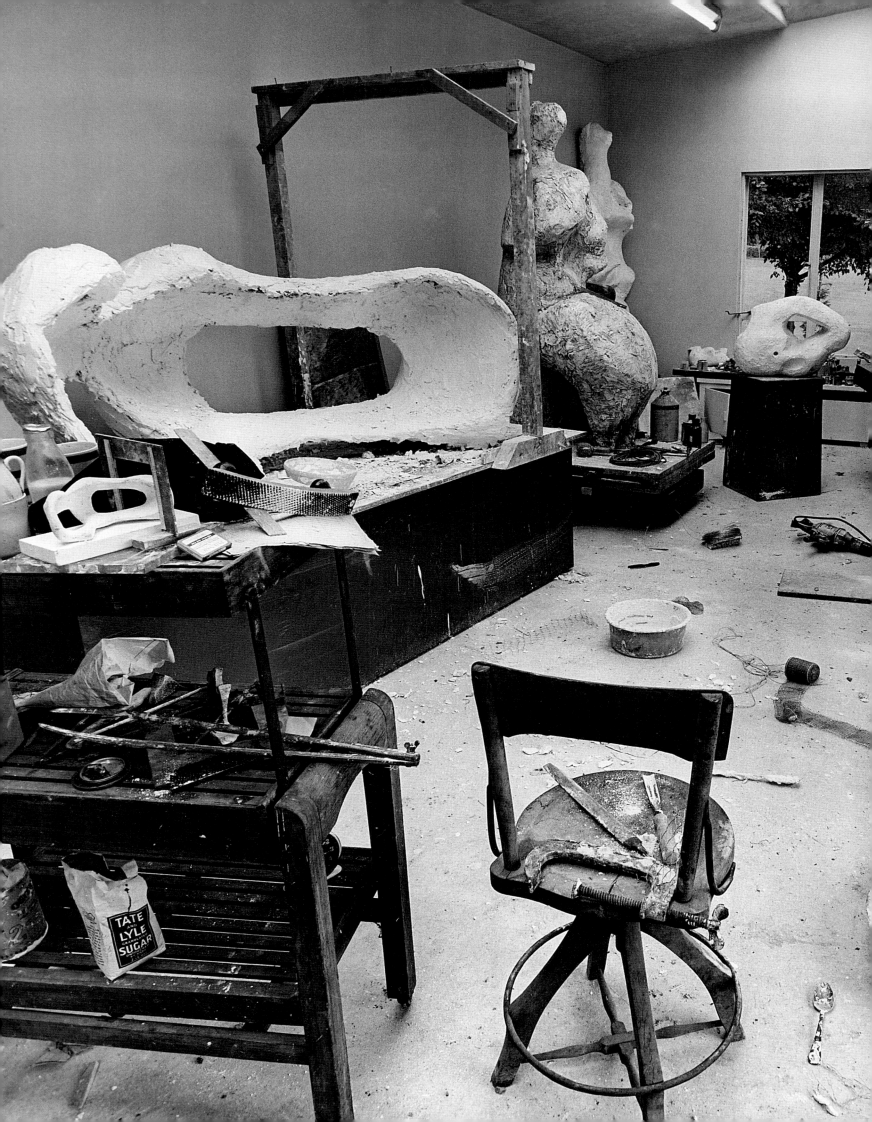

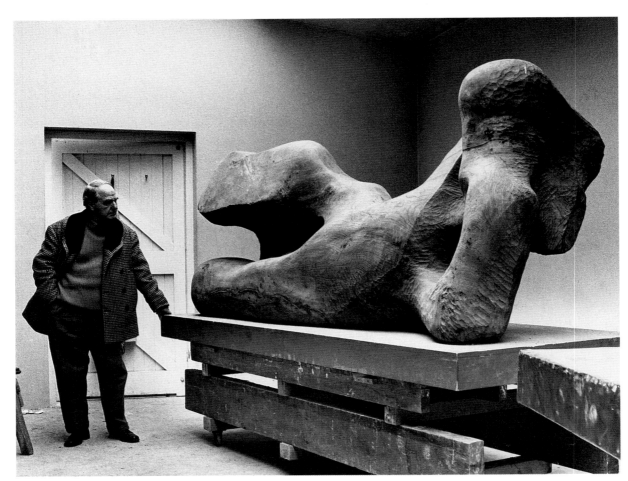

Henry with the elmwood reclining figure, which he worked on for five years - partly because the wood had cracked - between 1959 and 1964. He liked to take a long time over some works, anyway, constantly revisiting them. He said, 'I like working with elmwood because its big grain makes it suitable for large sculptures, and because of the cool greyness of the wood.'

Right: an outcrop on the Yorkshire Moors.

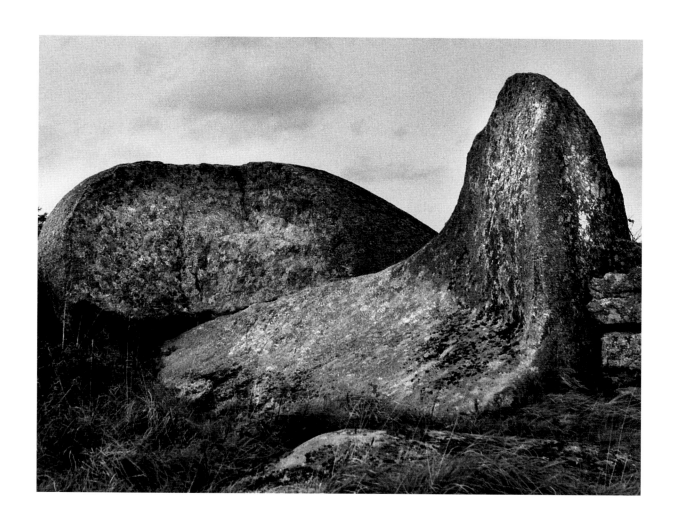

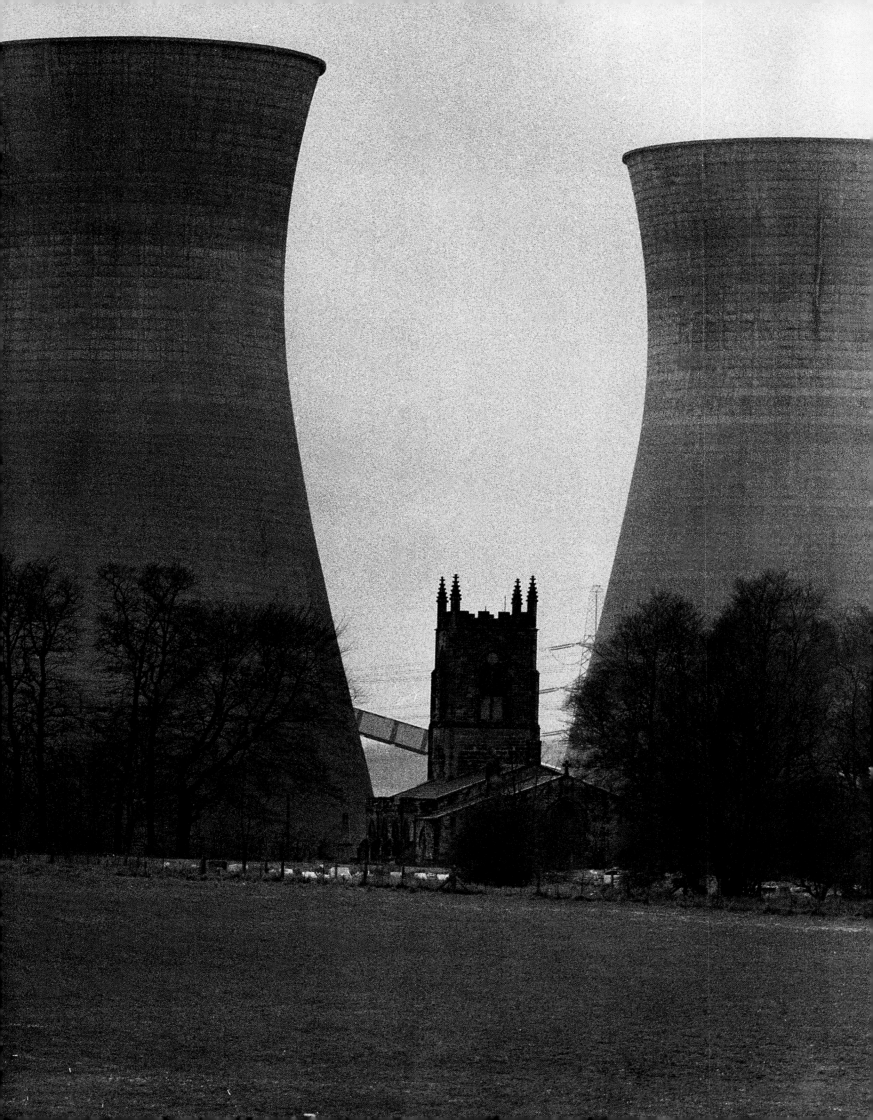

Left: the monumental
element is always present
in the cooling towers of
power stations.

Right and overleaf:
stonehenge in different
seasons; the greatest
of ancient monuments
always interested Henry
and is the subject of
numerous of his drawings.

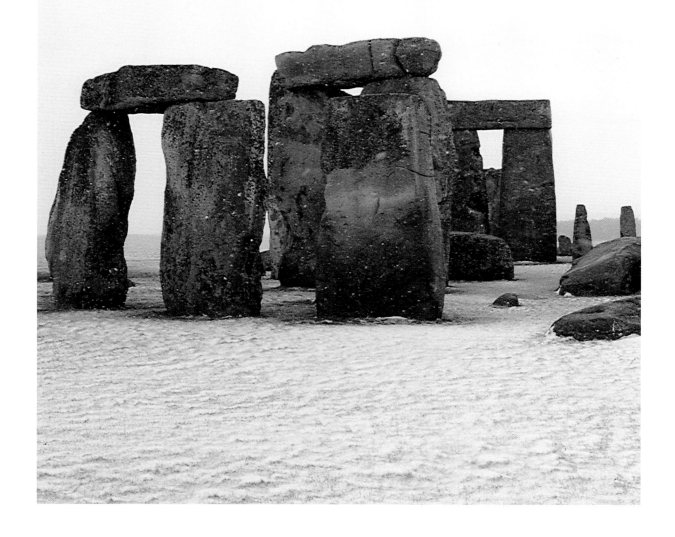

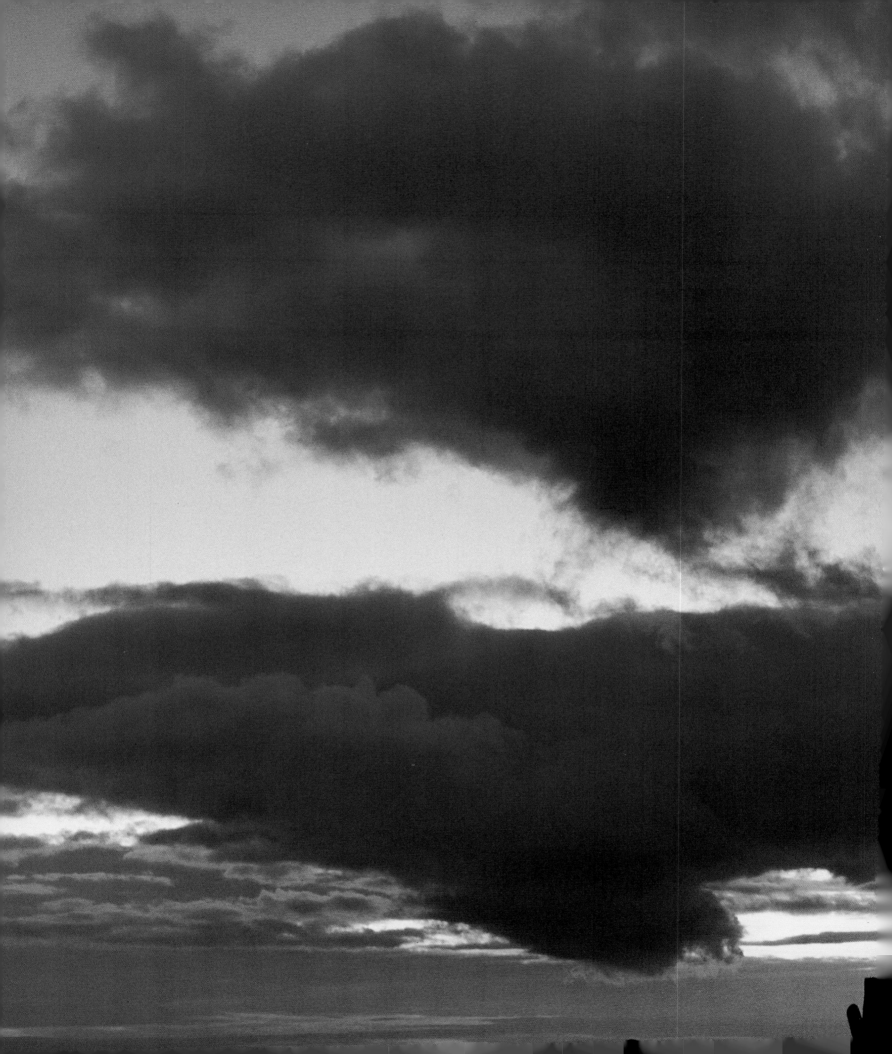

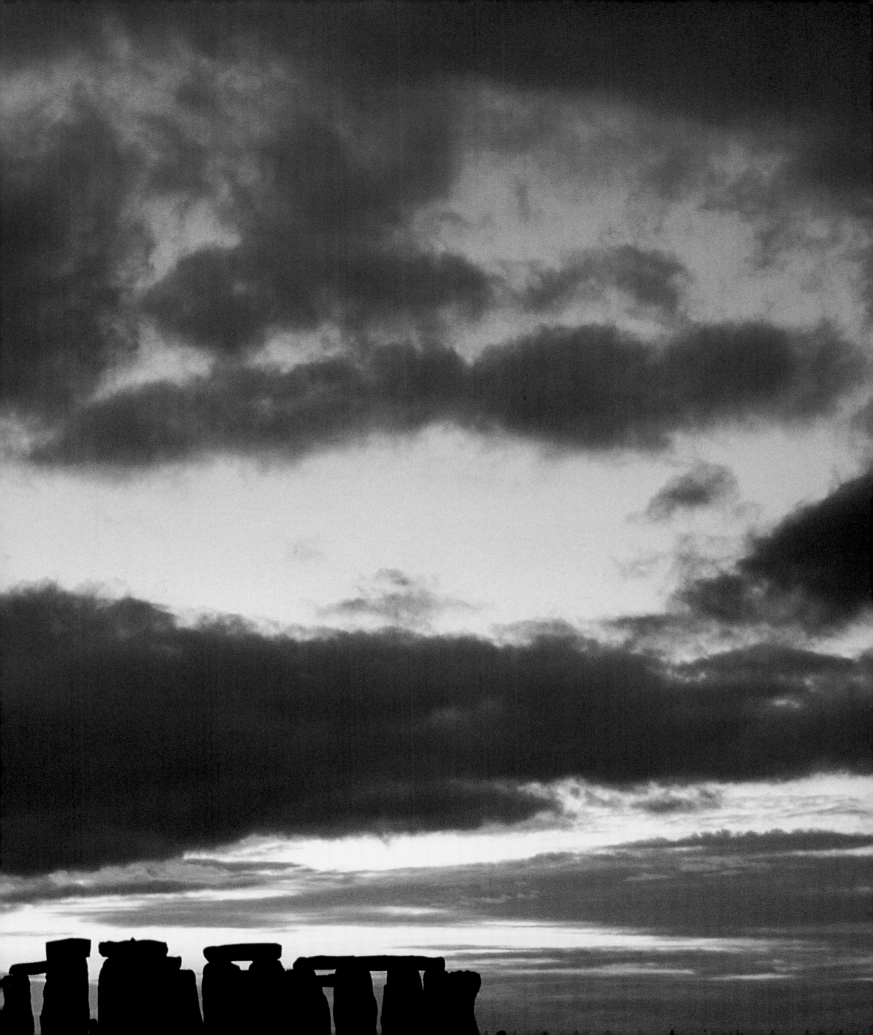

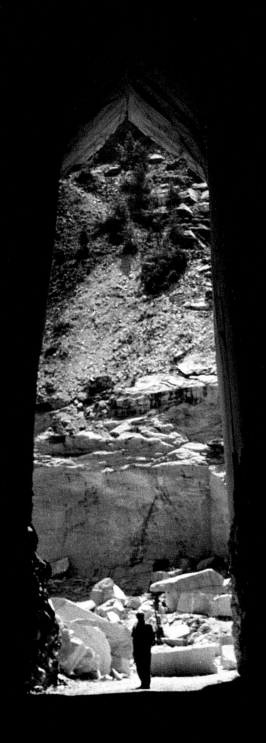

Left: Henry spent a lot of time in Henraux's quarry in Forte dei Marmi. Eventually he found a holiday home nearby. He said of this extraordinary monumental tunnel: 'As you go through this apparently Gothic entrance into one of Henraux's quarries, it is like passing down the nave of a great cathedral. In the beginning the top was merely an arched passage and over the years, as the marble has been dug out of the quarry beyond, the floor has been dropped until the roof is now sixty feet high.'

Right: Internal and External Forms, 1953-1954, is an example of a recurring motif: one form protected by another.

Overleaf: Henry's small studio: 'I like this little studio. I am always happy there. I like the disarray, the muddle and the profusion of possible ideas in it. It means that whenever I go there, within five minutes I can find something to do which may get me working in a way that I hadn't expected and cause something to happen that I hadn't foreseen.'

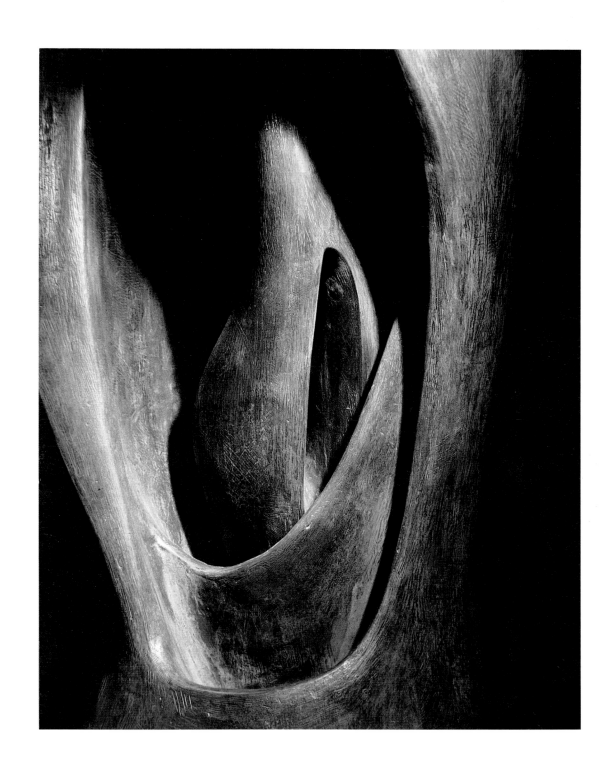

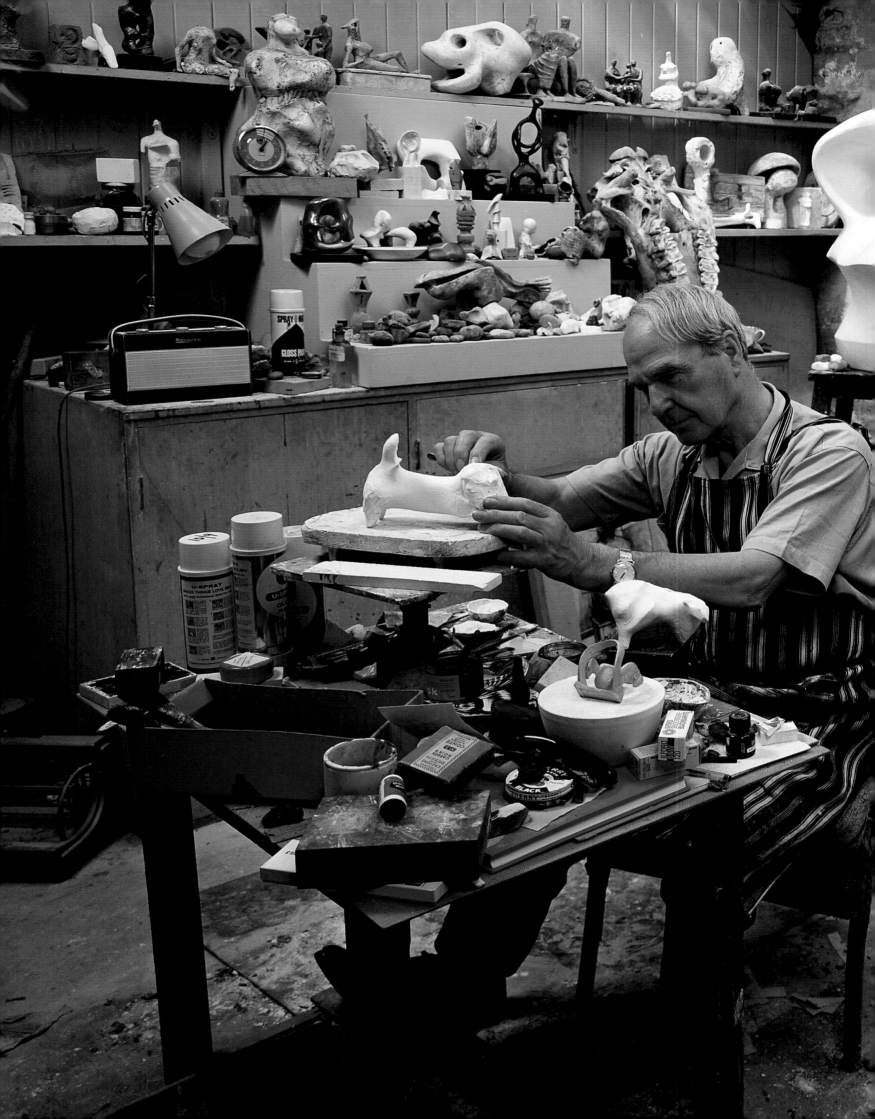

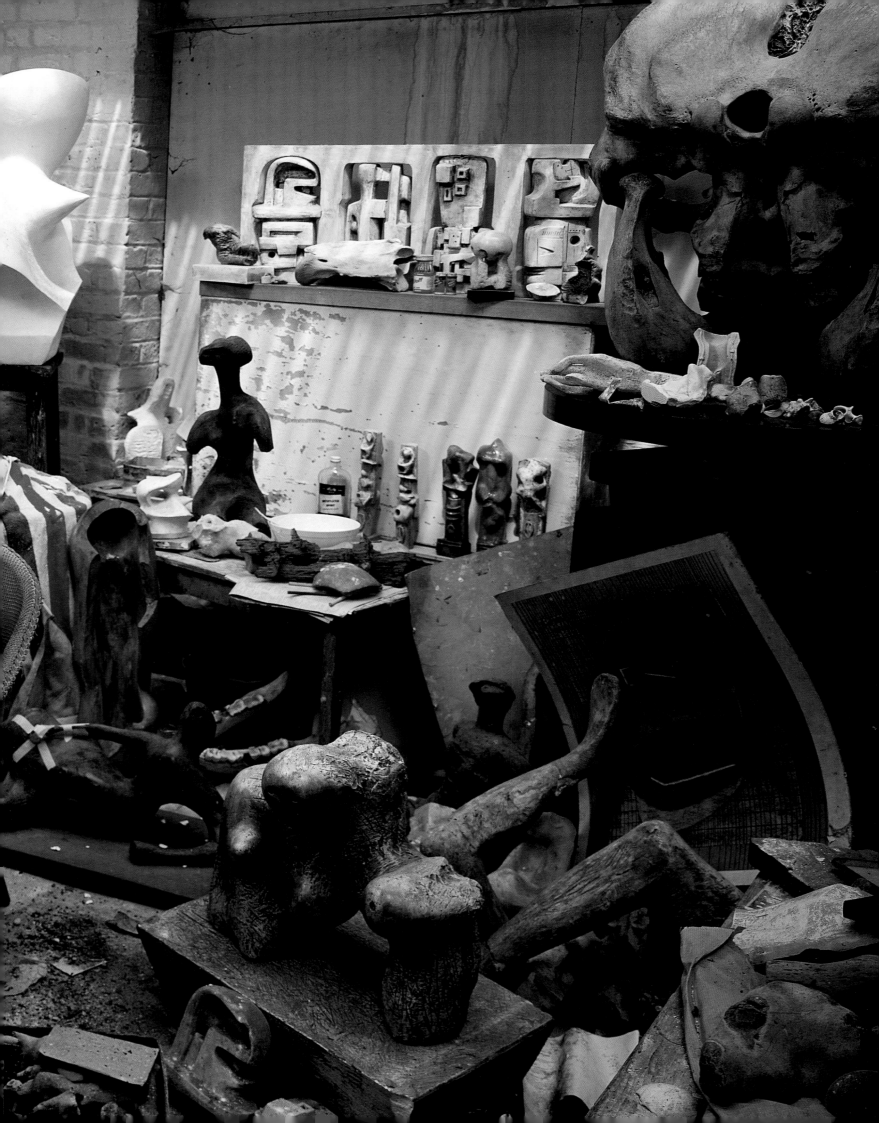

I was once given the task of photographing most of Picasso's sculptures. I did the work in the basement of the Tate Gallery in London, and I worked very intensively on it over a number of weeks. To take a break, I would go and stroll through the main galleries, where there is a lot of Henry's work. I suddenly found myself unable to look at it: the contrast between the way I had made myself look so intensely at Picasso's work, and the way one needs to look at Henry's work was too great. Picasso made sculpture out of firewood, out of children's toys; it is very direct, almost two-dimensional work, and it is always witty. I even found that I was lighting in hard, bright light, like the light of the Mediterranean where it had been made. Henry's work, on the other hand is all about form, and his forms are often very sexual, very delicate and emotional. He touched on this himself in an interview in 1964:

"I think a sculptor is a person who is interested in the shape of things. A poet is somebody who is interested in words; a musician is someone who is interested in or obsessed by sounds. But a sculptor is a person obsessed with the form and the shape of things, and it's not just the shape of any one thing, but the shape of anything and everything: the growth in a flower; the hard, tense strength, although delicate form of a bone; the strong, solid fleshiness of a beech tree trunk. All these things are just as much a lesson to a sculptor as a pretty girl - as a young girl's figure - and so on. They're all part of the experience of form and therefore, in my opinion, everything, every shape, every bit of natural form, animals, people, pebbles, shells, anything you like are all things that can help you to make a sculpture. And for me, I collect odd bits of driftwood - anything I find that has a shape that interests me - and keep it around in that little studio so that if any day I go in there, or evening, within five or ten minutes of being in that little room there will be something that I can pick up or look at that would give me the start for a new idea.

A detail from the bronze of the UNESCO Reclining Figure, 1957, where its close links to nature are clearly shown.

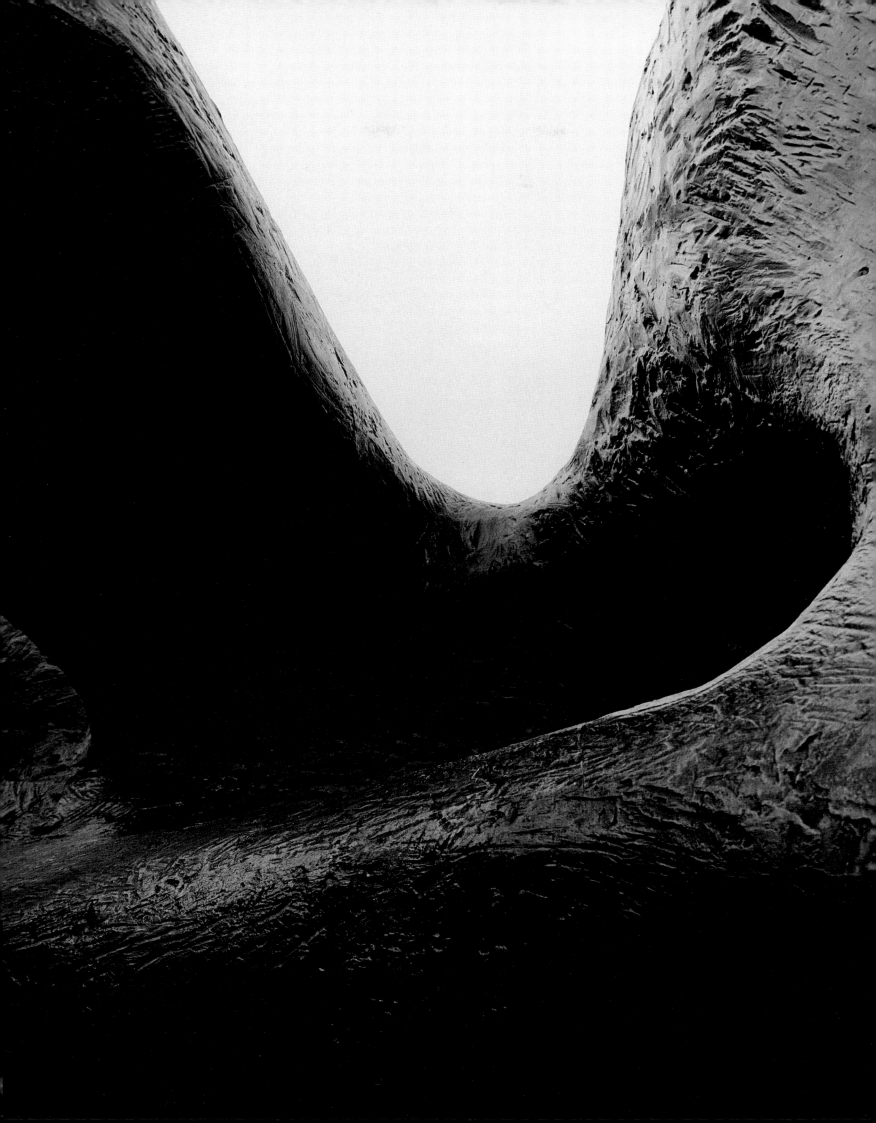

One of the things I would like to think my sculpture has is a force, is a strength, is a life, a vitality from inside it, so that you have a sense that the form is pressing from inside trying to give off the strength from inside itself, rather than having something which is just shaped from outside and stopped. It's as though you have something trying to make itself come to a shape from inside itself. This is, perhaps, what makes me interested in bones as much as in flesh because the bone is the inner structure of all living form. It's the bone that pushes out from inside; as you bend your leg the knee gets tautness over it, and it's there that the movement and the energy come from. If you clench a knuckle, you clench a fist, you get in that sense the bones, the knuckles pushing through, giving a force that if you open your hand and have it relaxed, you don't feel. And so the knee, the shoulder, the skull, the forehead, the part where from inside you get a sense of pressure of the bone outwards - those are the key points.

You can then, as it were, between those key points have a slack part, as you might between the bridge of a drapery and the hollow of it, so that in this way you get a feeling that the form is all inside it, and this is what makes me think that I prefer hard form to soft form. For me, sculpture should have a hardness, and because I think sculpture should have a hardness fundamentally I really like carving better than I like modelling. Although I do bronzes, I make the original which is turned into bronze in plaster, and although anyone can build a plaster up as soft mixture, that mixture hardens and I then file it and chop it and make it have its final shape as hard plaster, not as a soft material." [4]

Henry working on the
plaster model for Seated
Woman, 1958-1959.
'When working in plaster
for bronze I need to
visualise it as a bronze,
because on white plaster
the light and shade acts
quite differently, throwing
back a reflected light
on itself and making the
forms softer, less
powerful...even weightless.'

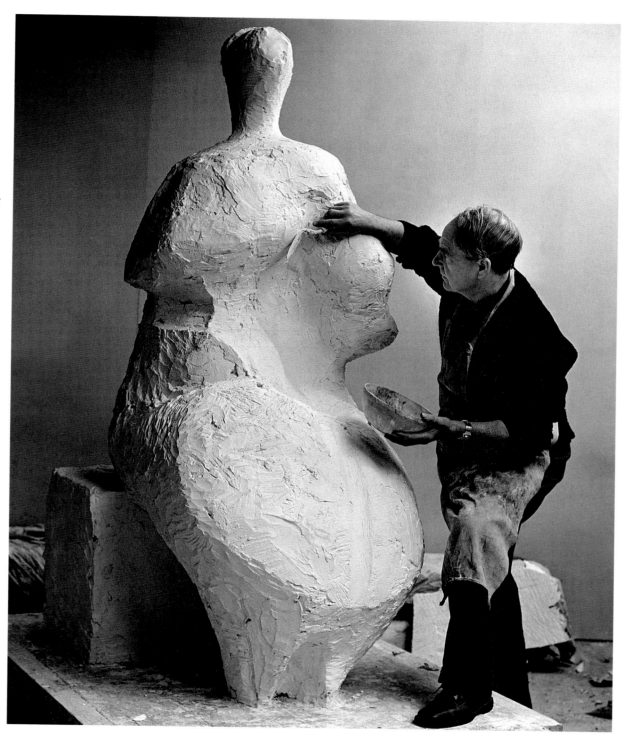

34

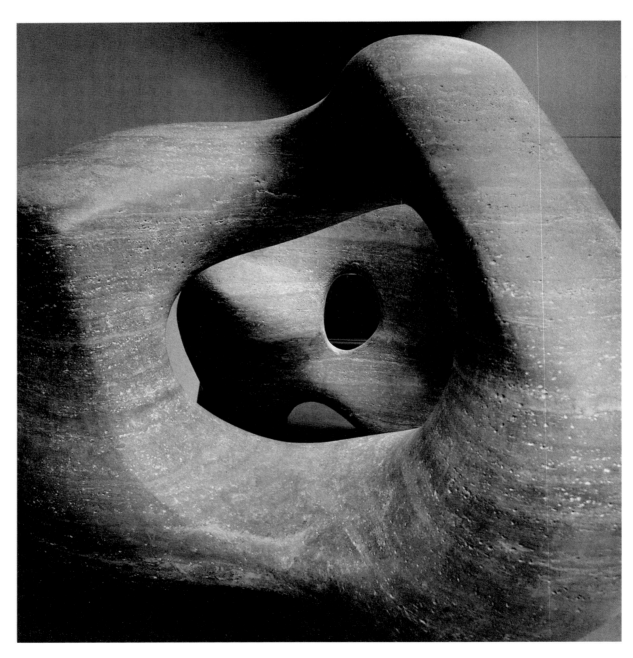

Two forms, 1966, in red
travertine marble, a
material that Henry
particularly liked because
of the fissures and
irregularities in the stone,
which you only discover
as you work on it.

Right: tree form, 1964.

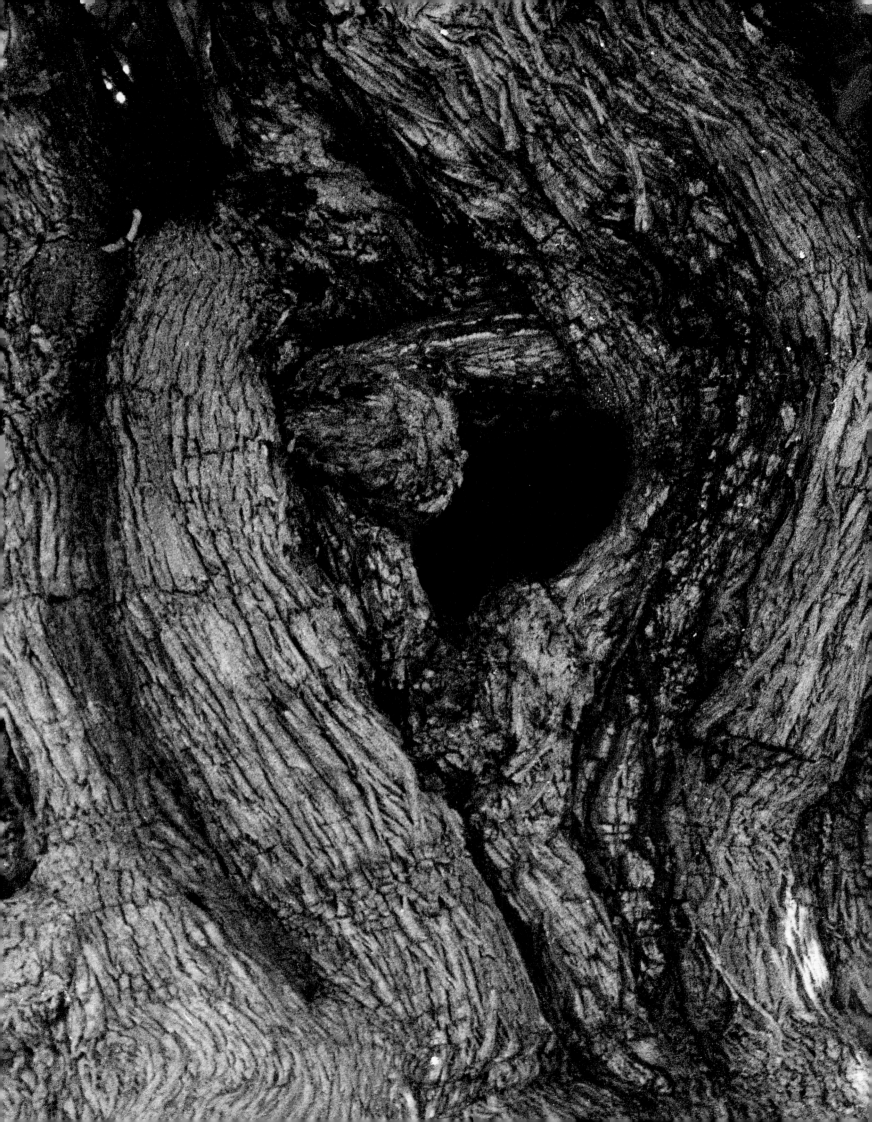

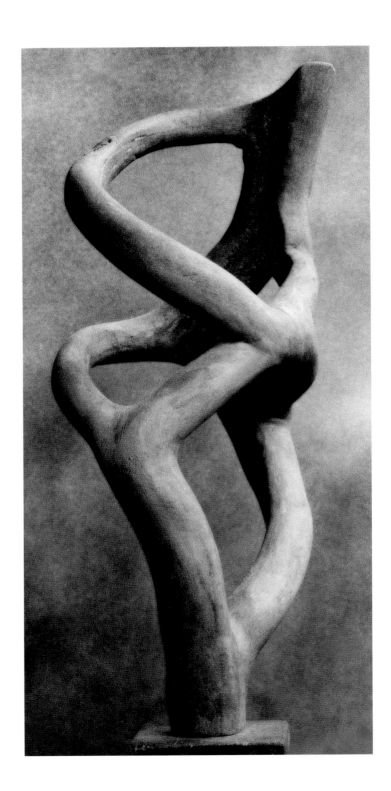

Left: a piece of driftwood that Henry had mounted on a stand. He considered it complete in itself, too perfect to be added to.

Right: Upright Figure, 1956-60, in elmwood. Henry took the idea of a reclining figure and, with changes, made it vertical, carving the vertical one in elmwood. He said that '...it shows the importance of gravity in sculpture. Lying down, the figure looked static, whilst upright it takes on movement, and because it is working against gravity it looks almost as though it is climbing.'

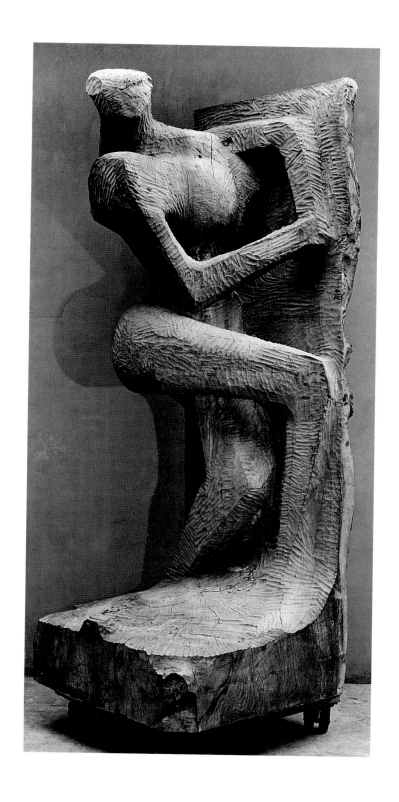

The experience with the Picasso sculptures also made me think about light. Henry spoke fondly of the English light, of the way it would reinforce subtleties in his work. He would usually work in a shadowless north light, and I found that I needed a directional light to bring out the contrast between surface and hollows, and to bring out the gentle but fulsome curves that Henry loved so much. In 1961, he contrasted English and Greek light:

"The Greek light is, as everyone says, something you can't imagine till you've experienced it. In England half the light is, as it were, absorbed into the object, but in Greece the object seems to give off light as if it were lit up from inside itself. But I think that the element of light can be over emphasised. The northern light can be just as beautiful as the Greek light and a wet day in England can be just as revealing as that wonderful translucent Mediterranean light." [5]

When we did our first book together in the 1960's, we agreed from the outset that we would try to evoke some of the sources of Henry's particular vision. He was always open about his major influences - the landscape, the body, primitive art, - and he would talk about them a great deal. For instance, he loved ruins, especially if nature had begun to take over, as it has with so many of the Yorkshire Abbeys. He would regard them as sculptures rather than as works of architecture. Henry once said of the Parthenon:

"...I would say that the Parthenon now is probably much more impressive than when it was first made. You feel the spaces much more, and the openings, and the fact that it's not solid throughout and that the light comes in, makes it into a piece of sculpture, and not, as it was before, a building with four external sides. It's completely spatial now - a different object altogether. " [6]

Right: Dramatic light over the Cornish coast, and overleaf, over an English landscape. The coast of Britain provided Henry with much inspiration and material for his sculptures. The sea constantly pounding the cliffs and the rocks, the hollows and caves that it forms, the constant smoothing of the pebbles, and the quality and the colours of the light created a vast array of sources for him.

42

Left: stalactites in the caves in Cheddar Gorge, and, right, Roche Rock, outside Truro in Cornwall; Henry saw architectural and natural forms as equivalent.

Overleaf: Whitby Abbey, Yorkshire, at dusk.

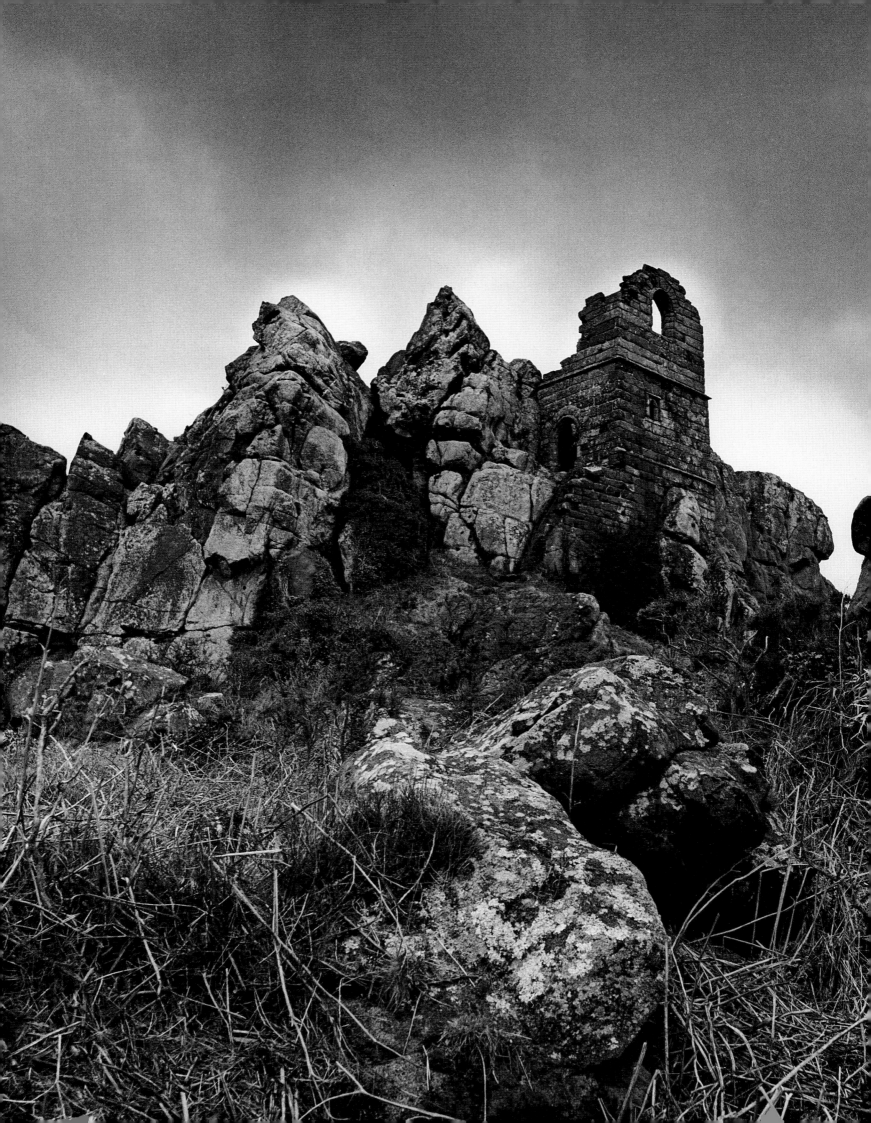

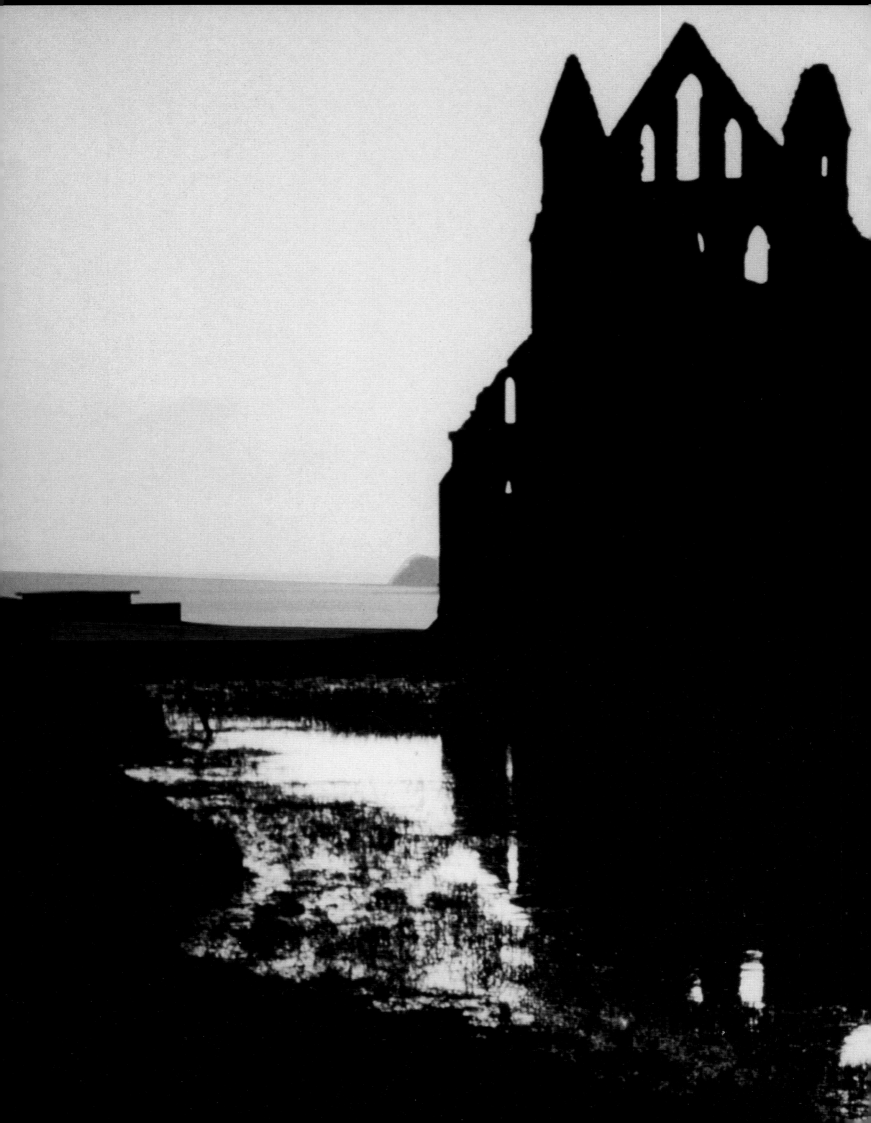

46

His admiration for what was then called primitive art was constant, but like many of Henry's enthusiasms it was emotional far more than intellectual. In 1941, he wrote:

"Primitive art is a mine of information for the historian and the anthropologist, but to understand and appreciate it, it is more important to look at it than to learn the history of primitive peoples, their religions and social customs. Some such knowledge may be useful and help us to look more sympathetically, and the interesting tit-bits of information on the labels attached to the carvings in the museum can serve a useful purpose by giving the mind a needful rest from the concentration of intense looking. But all that is really needed is response to the carvings themselves, which have a constant life of their own, independent of whenever and however they came to be made, and remain as full of sculptural meaning today to those open and sensitive enough to receive it, as on the day they were finished." [7]

This concern with the primitive also fitted in his early work with a concern for direct carving, a practice that he loved, but did less and less of in later years. When I interviewed him for our book, he said:

"I began believing in direct stone carving, in being true to the material by not making stone look like flesh or making wood behave like metal. This is the tenet that I took over from sculptors like Brancusi and Modigliani. It made me hesitate to make material do what I wanted until I began to realise this was a limitation in sculpture so that often the forms were all buried inside each other and heads were given no necks. As a result you will find that in some of my early work there is no neck simply because I was a frightened to weaken the stone. Out of an exaggerated respect for the material, I was reducing the power of the form.

Then I became aware that in some examples of primitive art, the sculptor had been bold enough to make three-dimensional form out of a solid block, and it gave me the courage to do it in my own

An African mask from Henry's collection. It was the sculptor Jacob Epstein who first introduced Henry as a young student to so-called primitive art, and it was to become a consuming interest.

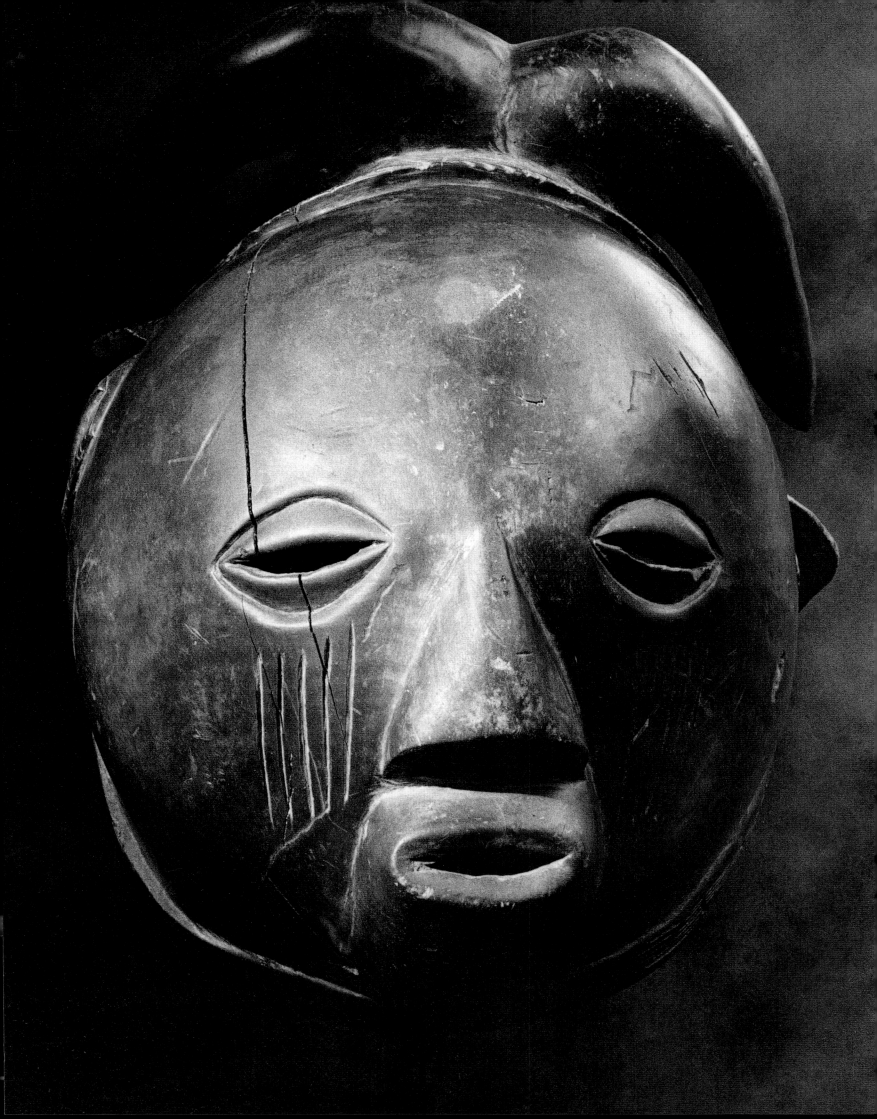

48

sculpture. I found it very surprising that they had dared to make the necks as long as they had. Some of their carvings are so thin from the side that often you find them broken. Their vision had not been restricted by the material, and certainly some of the little figures of Cycladic times are remarkable examples of early sculptors being so concerned with realising their sculptural ideas that they had taken greater liberties with the material than I had thought were possible." (8)

He was deliberate in this choice of the so-called primitive over the models of Greece and the Italian Renaissance, but he never lost his love of the Romanesque simplicity, or of the force of Gothic statuary. Journeys to Italy were to open his eyes to Italian art, and he became enraptured by the work of Giovanni Pisano, about whom he spoke in 1946:

"...it's amazing how much [Giovanni Pisano] contributed - how different any one of his figures is from one by Nicola Pisano, his father, how they are static and dynamic at the same time, how he makes you see that the pelvis can move in an opposite direction from the thorax, and that the neck is not just an extension of the body, and so on. And yet, beside all this sculptural originality, there's a warm human dignity and a kind of grandeur and nobility in his figures that bring him, to my mind, into the same world as Masaccio. When I saw these sculptures I realised that here was someone putting into the stone everything that the human figure can teach us, and yet at the same time also having just the view of humanity that one most warms to." (9)

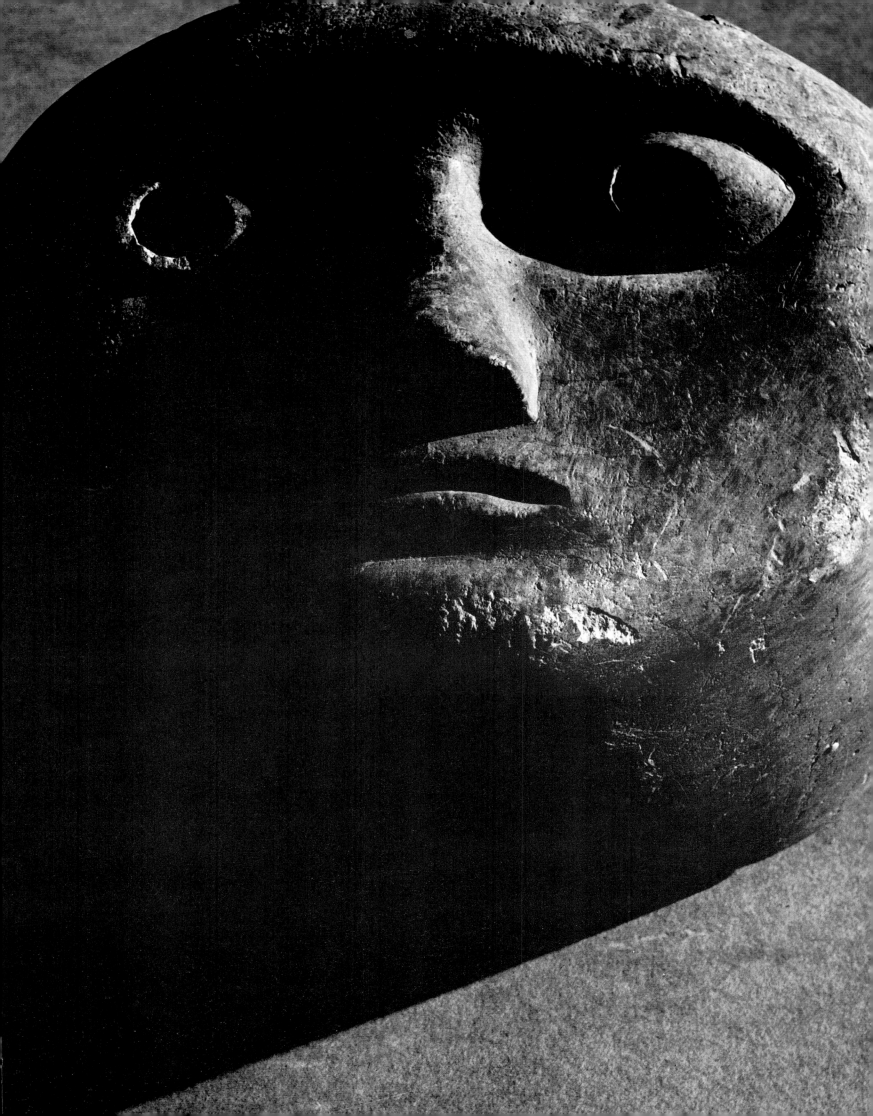

Right: Head, 1984, which
was the penultimate work
to be cast in bronze in
Henry's lifetime. From first
to last, the monumental
nature of so-called
primitive art pervaded his
imagination. The authority
and beauty of this piece
compare to that of the
African work (left) from
Henry's collection.

But, as is well known, the two most important sources of inspiration were the land and the body, especially the female body. Oddly, although Henry had an undying love of rugged landscape, he chose to live most of his adult life in the gentler country of the South of England, but he would often speak of the force of mountains, and he never ceased to look at landscape. He told me that he couldn't read on a train in case he missed an element of the view. As early as 1930, he wrote: [10]

"The sculpture which moves me most is full blooded and self supporting, fully in the round, that is, its component forms are completely realised and work as masses in opposition, not being merely indicated by surface cutting in relief; it is not perfectly symmetrical, it is static and it is strong and vital, giving out something of the energy and power of great mountains. It has a life of its own, independent of the object it represents."

He loved to see his work sited in the open air, in the landscape, and away from the buildings that so much of his public work adorns. It truly excited him when Tony Keswick, a major collector, began to put Henry's work - most famously the King and Queen - onto the hillsides of his estate in Scotland. Henry would often speak of his enjoyment of seeing shapes and forms silhouetted against a sky, particularly a sky that was tense with rain. He loved photographs that reflected the form of a tree or a rock in this way. He spoke about this in 1964:

"Perhaps what influenced me most over wanting to do sculpture in the open air and to relate my sculpture to landscape come from my youth in Yorkshire; seeing the Yorkshire moors, seeing, I remember, a huge natural outcrop of stone at a place near Leeds which as a young boy impressed me tremendously - it had a powerful stone, something like Stonehenge has - and also the slag heaps of the Yorkshire mining villages, the slag heaps which for me as a boy, as a young child, were like mountains. They had the scale of the pyramids;

The Lanyon quoit: a Cornish dolmen, the remains of a longbarrow burial chamber.

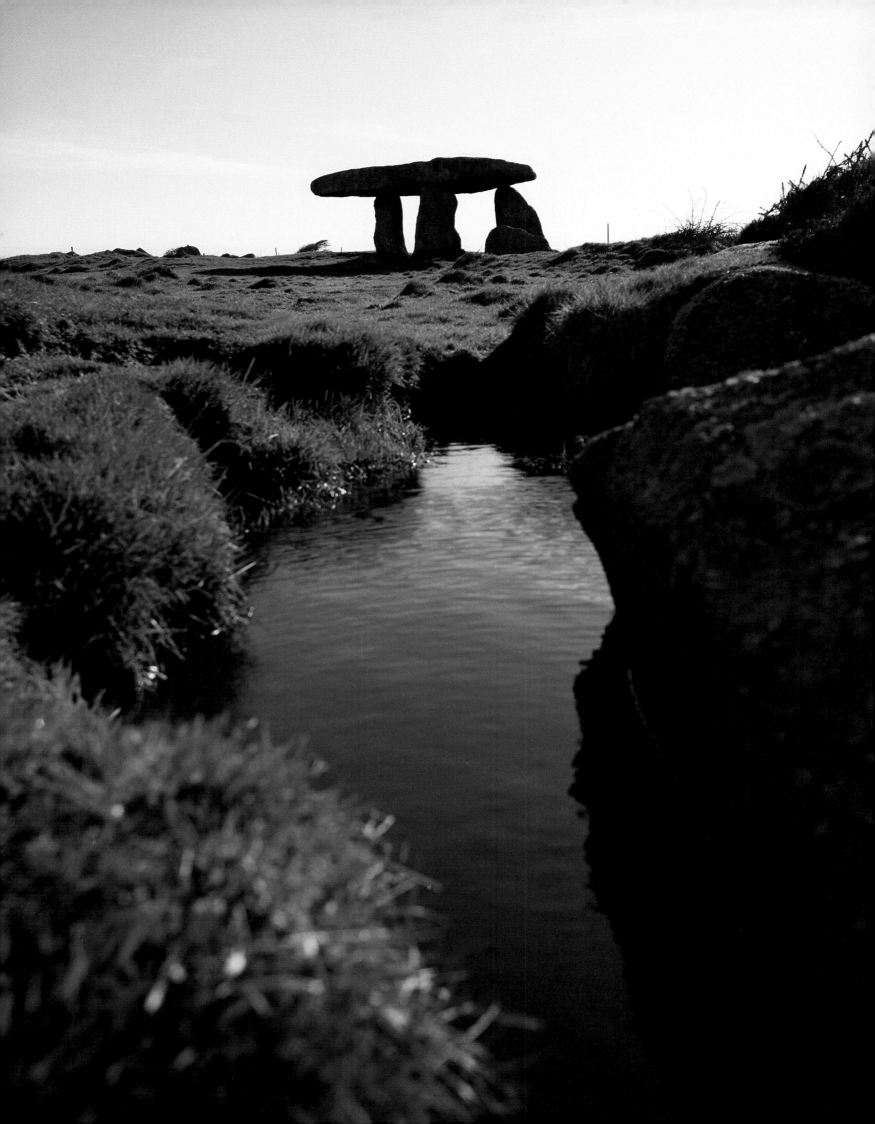

they had this triangular, bare stark quality that was just as though one were in the Alps. Perhaps those impressions when you're young are what count." [11]

When I interviewed him, he said:

"Besides the human form, I am tremendously excited by all natural forms, such as cloud formations, birds, trees and their roots, and mountains, which are to me the wrinkling of the earth's surface, like drapery. It is extraordinary how closely ripples in the sand on the seashore resemble the gouge marks in wood carving... I have always been excited about natural strata and the actual forms of stone. Photographs of places such as the rocky coast of Brittany and big, natural rocks in river beds have always excited me. I have often drawn rock strata and been influenced by its formations." [12]

King and Queen, 1952-1953 in bronze; 'The siting of all my sculptures at Glenkiln, Dumfries, is marvellously varied and is, to me, ideal. It proves why I prefer Nature to any other setting for my sculptures.'

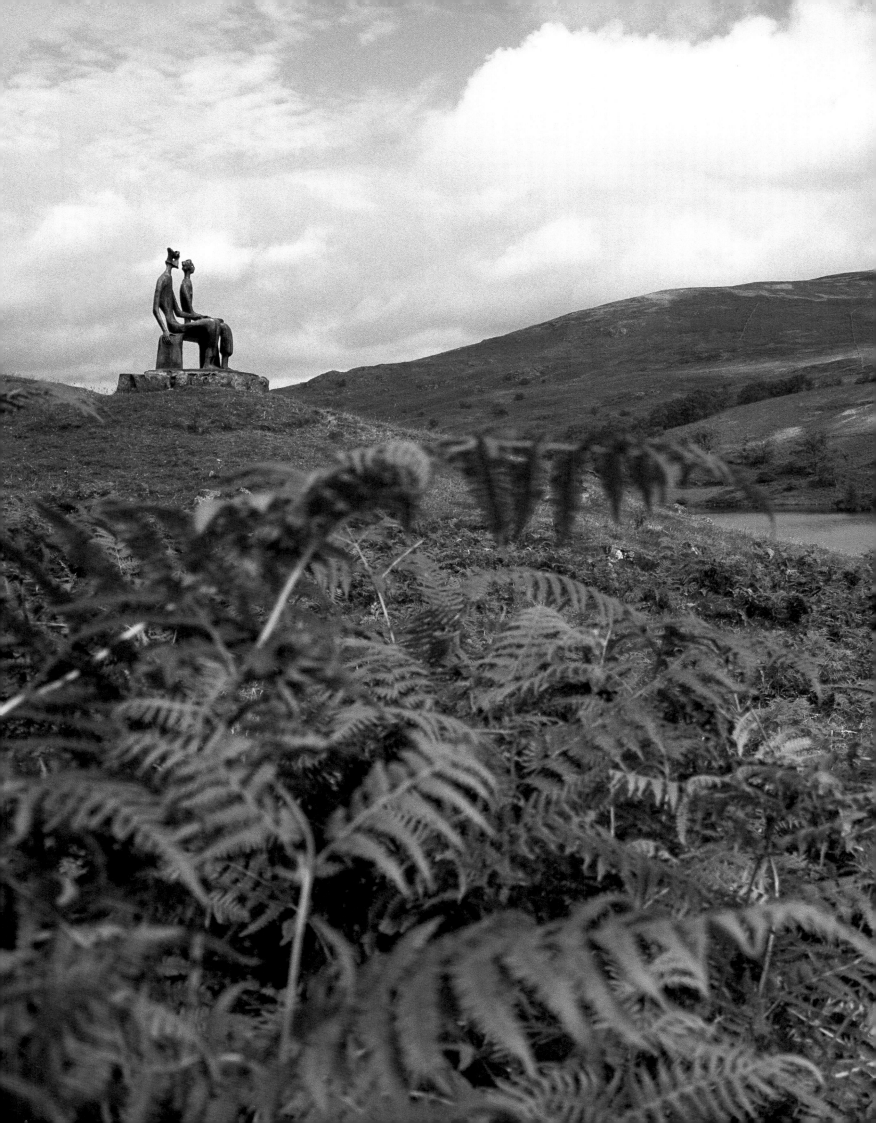

Left: industrial architecture in Henry's native Yorkshire.

Right: a 'stack' off the Yorkshire coast; 'I have always been excited about natural strata and the actual forms of stone. Photographs of places such as the Grand Canyon, the rocky coast of Brittany and big, natural rocks in river beds have always excited me. I have often drawn rock strata and been influenced by its formations.'

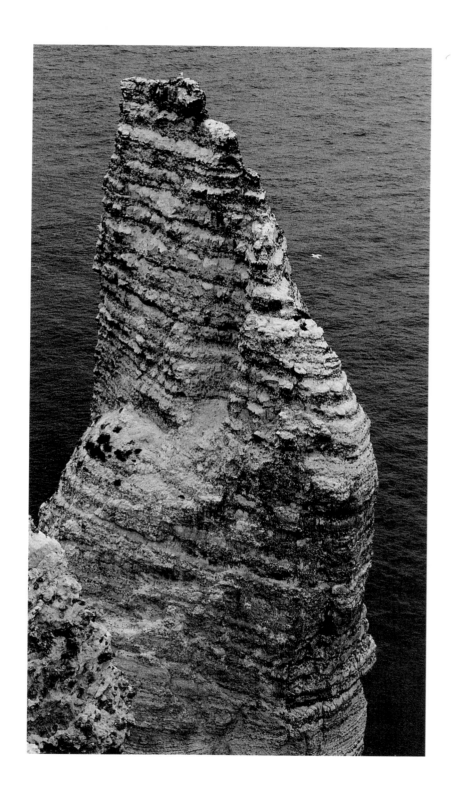

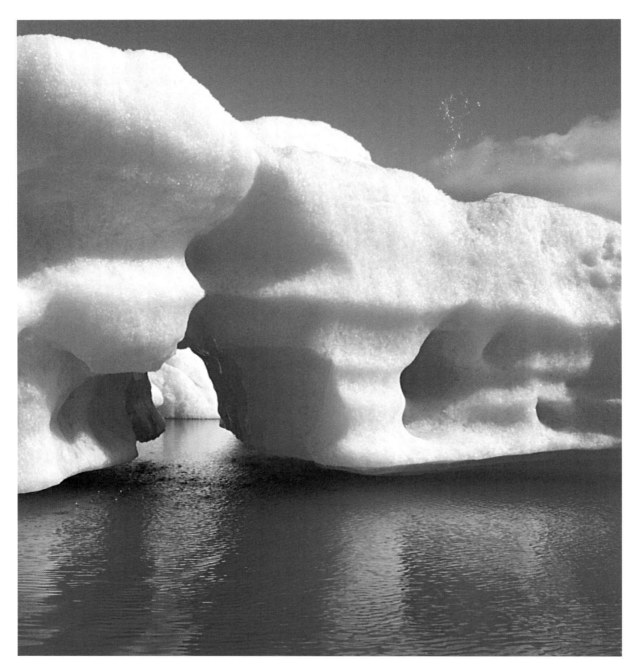

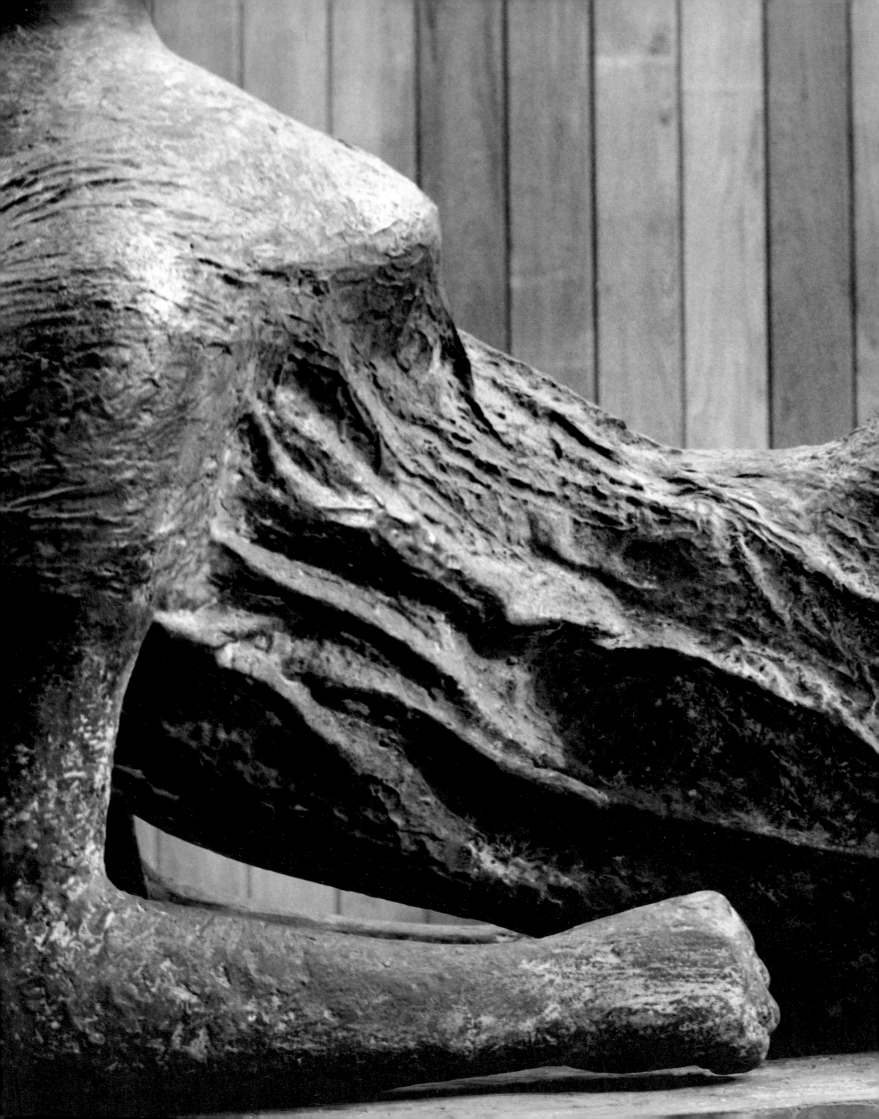

But in the end, it is the living form, especially the female body, that dominates so much of Henry's work. The 'living' element in his work was crucially important to him, and he would often speak of a moment when he was creating a maquette when the form 'came alive'; if this didn't happen, he would usually put the idea aside. In 1951, he wrote:

"In my opinion, long and intense study of the human figure is the necessary foundation for a sculptor. The human figure is most complex and subtle and difficult to grasp in form and construction, and so it makes the most exacting form for study and comprehension. A moderate ability to 'draw' will pass muster in a landscape or tree, but even the untrained eye is more critical of the human figure - because it is ourselves." [13]

In his efforts to reduce and yet elevate the forms of his work to a monumental stature, he was often described as an abstract artist, yet that is clearly the opposite of what he is. He expressed this himself in 1970:

"In my own work I have produced carvings which perhaps might seem to most people purely abstract. This means that in those works I have been mainly concerned to try to solve problems of design and composition. But these carvings have not really satisfied me because I have not had the same sort of grip or hold over them that I have as soon as a thing takes on a kind of organic idea. And in almost all my carvings there has been an organic idea in my mind. I think of it as having a head, body, limbs, and as the piece of stone or wood I carve evolves from the first roughing-out stages, it begins to take on a definite human personality and character. From then on one begins to be critical - satisfied or dissatisfied with its progress - in a deeper way than from only a sense of pleasant shape or formal design, and a more active relationship gets going, which calls upon the same sort of feelings one has about people in real life. And to bring the work to its final conclusion involves one's whole psychological make-up and whatever one can draw upon and make use of from the sum total of one's human and form experience." [14]

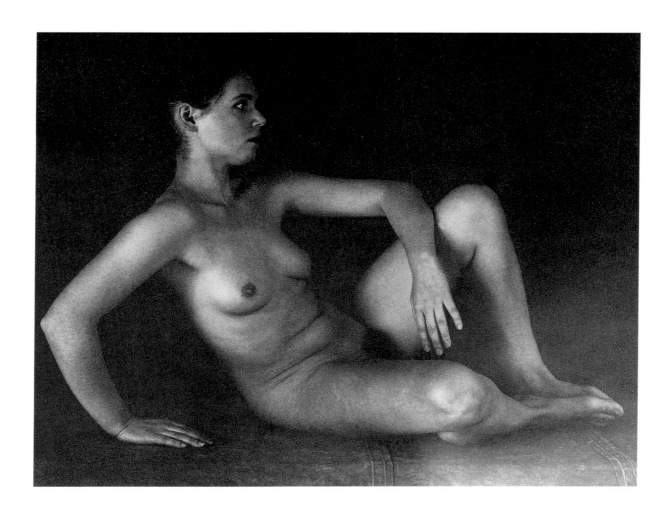

Of Henry Moore the man, whom I knew for so many years, I can say that he was a generous but determined individual; there was a high seriousness about him. He had great depth, but he never lost his Yorkshire roots and his love of a steady routine. He became a wealthy man, but it changed little other than the facilities he was able to create around him for his work. I well remember walking into Hoglands, Henry's home for the last forty years of his life, and being drawn aside by Irina, Henry's wife, with a whisper. In the next room Henry was in good-natured but determined conversation with Tony Keswick, the major collector. She told me just to listen and enjoy what she described as one of life's more amusing experiences: a Yorkshireman and a Scot in a discussion over the price of a sculpture.

But Henry was first and last a sculptor. He gave an address in Venice in 1952 in which he spoke of this in eloquent terms:

"Some become sculptors because they like using their hands, or because they love particular materials, wood or stone, clay or metal and like working in those materials - that is they like the craft of sculpture - I do. But beyond this one is a sculptor because one has a special kind of sensibility for shapes and forms, in their solid physical actuality. I feel that I can best express myself, that I can best give outward form to certain inward feelings or ambitions by the manipulation of solid materials - wood, stone and metal. The problems that arise in the manipulation of such materials, problems of mass and volume, of light in relation to form and of volume in relation to space, the problem of continually learning to grasp and understand form more completely in its full spatial reality, all these are problems that interest me as an artist and which I believe I can solve by cutting down, building up or welding together solid three-dimensional materials."

Reclining Figure:
Festival, 1951 in bronze;
a quintessential work,
made by Henry for the
Festival of Britain.

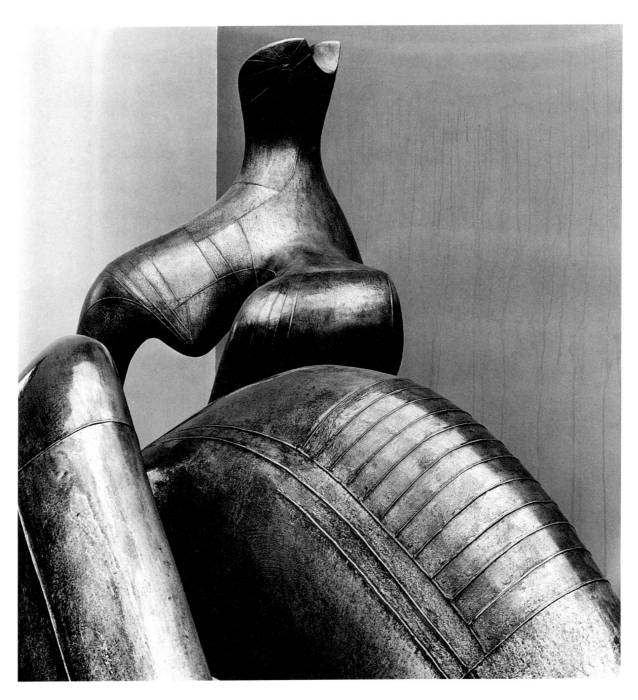

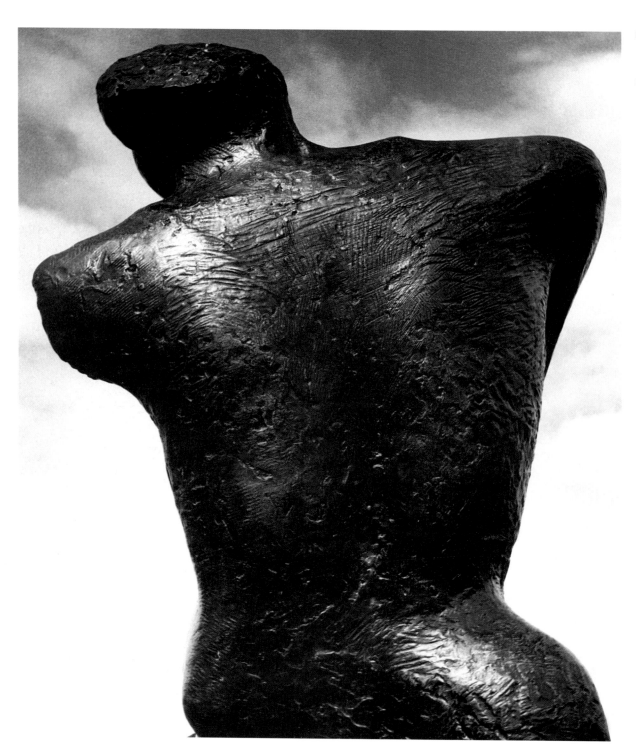

Left: Warrior with Shield,
1953-1954 in bronze.

Right: Nude, 1966.

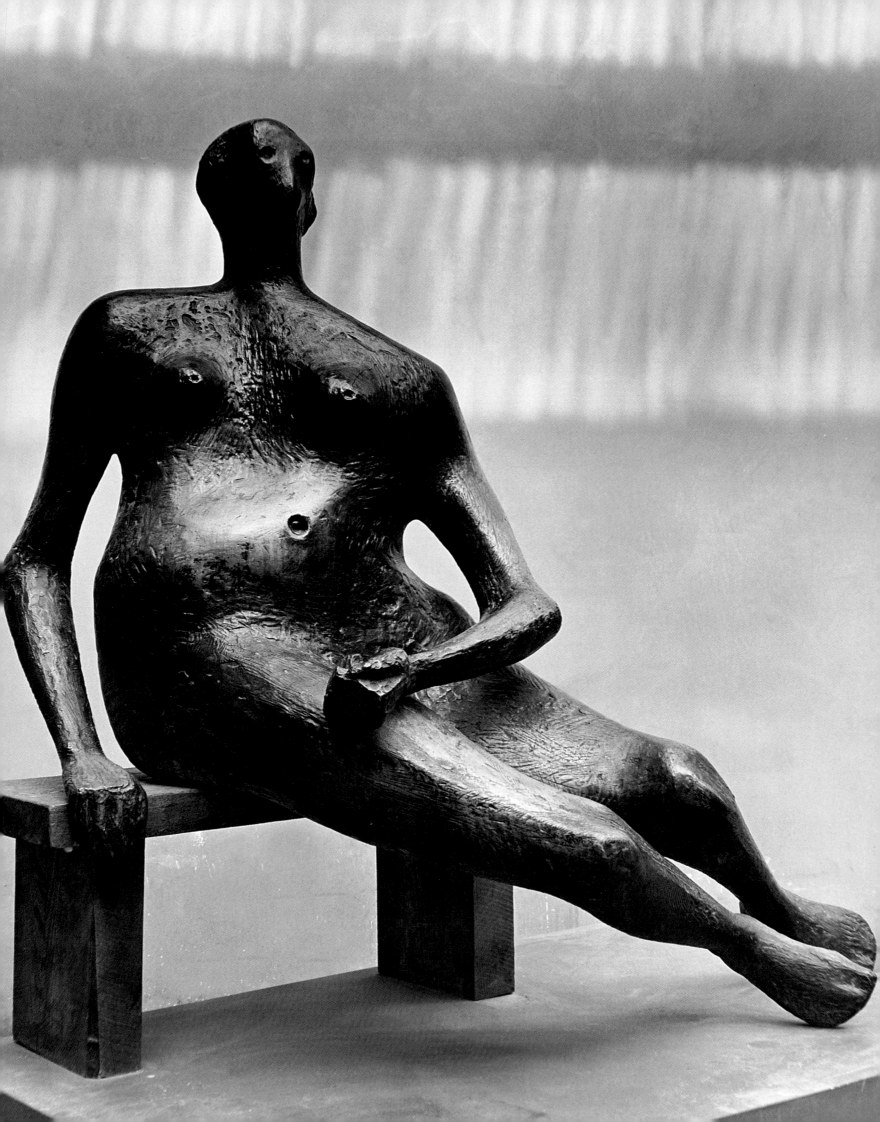

Seated Woman, 1957, in bronze; 'Seated Woman, particularly her back view, kept reminding me of my mother, whose back I used to rub as a boy when she was suffering from rheumatism. She had a strong, solid figure, and I remember, as I massaged her with some embarrassment, the sensation it gave me going across her shoulder blades and then down and across her backbone. I had the sense of an expanse of flatness yet within it a hard projection of bone. My mother's back meant a lot to me.'

Right: Nude, 1966.

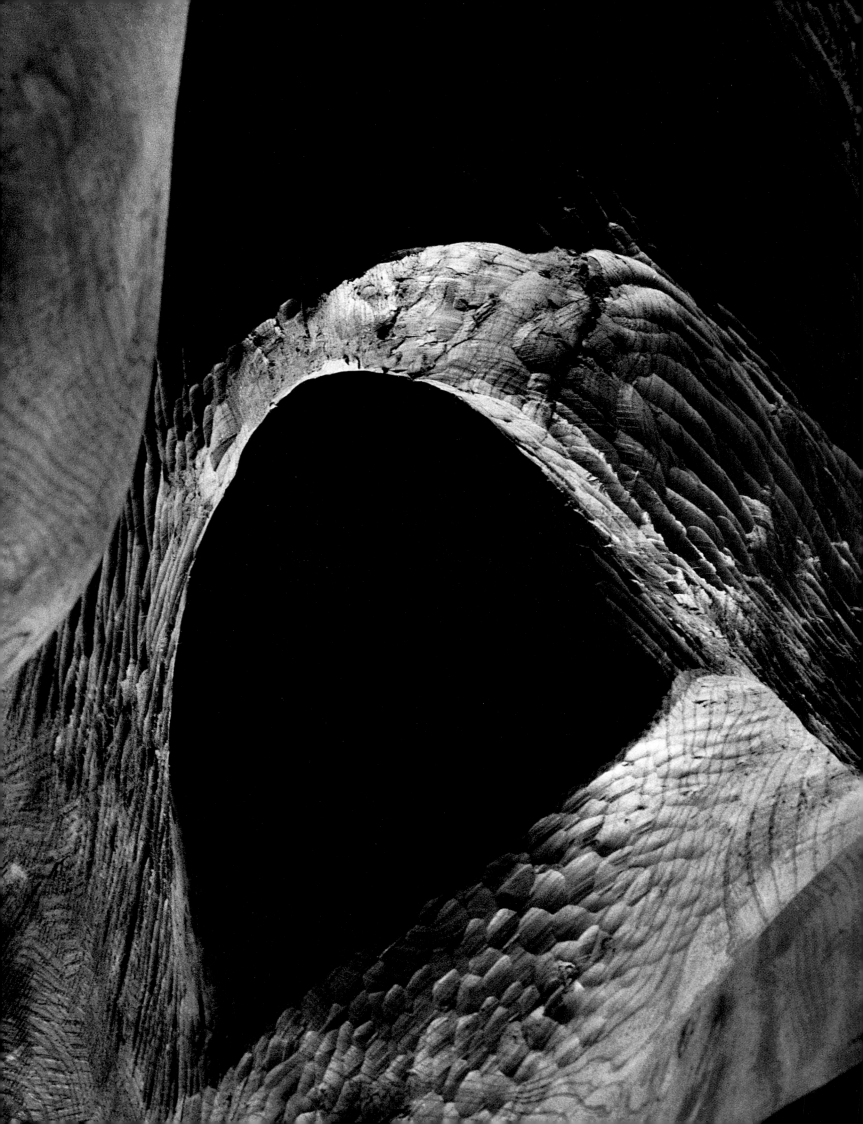

Part Two : The Sculptor

In this section, I have picked out various of Henry's works that I consider to be particularly significant, and I have incorporated related sketches and pages from the notebooks that Henry kept throughout his life. He was always drawing, right up to his death, though the hand became less sure. The sketches, particularly the earlier ones on which he would often jot notes to himself, are very revealing.

Artists' careers are often divided by critics and art historians into stages and periods, and it can be a very helpful device in placing work into a context. With Henry, however, there is an extraordinary consistency that makes this very difficult. He had created his own voice, and his own vision very early in his career, and he stayed with it. Certain forms, such as the reclining figure, he would return to repeatedly, and with renewed vision. His work appears unaffected by either the critical vilification that the early work received, or the adulatory tones that were to be adopted when he became acknowledged as the greatest sculptor of his times. He just kept going, in a way that indicated the great strength of his personality. Not everything was great work, but he was always striving.

In this selection are important works from each phase of his career. In the early work, where carving was most often the medium, the influences of what was then called primitive art are clearest; there is an obvious correlation between his first reclining figure and the famous Mexican figure that he had studied in pictures. His hours in the British Museum, studying the art of Egypt, of Mexico and sub-Saharan Africa, were put to constant use. Before the end of the twenties, he had produced the first reclining figures and the first mother and child groups: motifs to which he would return again and again.

Henry at work in the 'open-air' studio, 1968
'I built this open-air studio of plastic for the Lincoln Center sculpture, intending to remove it afterwards. Now, not only have I come to accept it, but I also find it most useful. It means that I can make large sculptures in natural light and see them from all around at all times.'

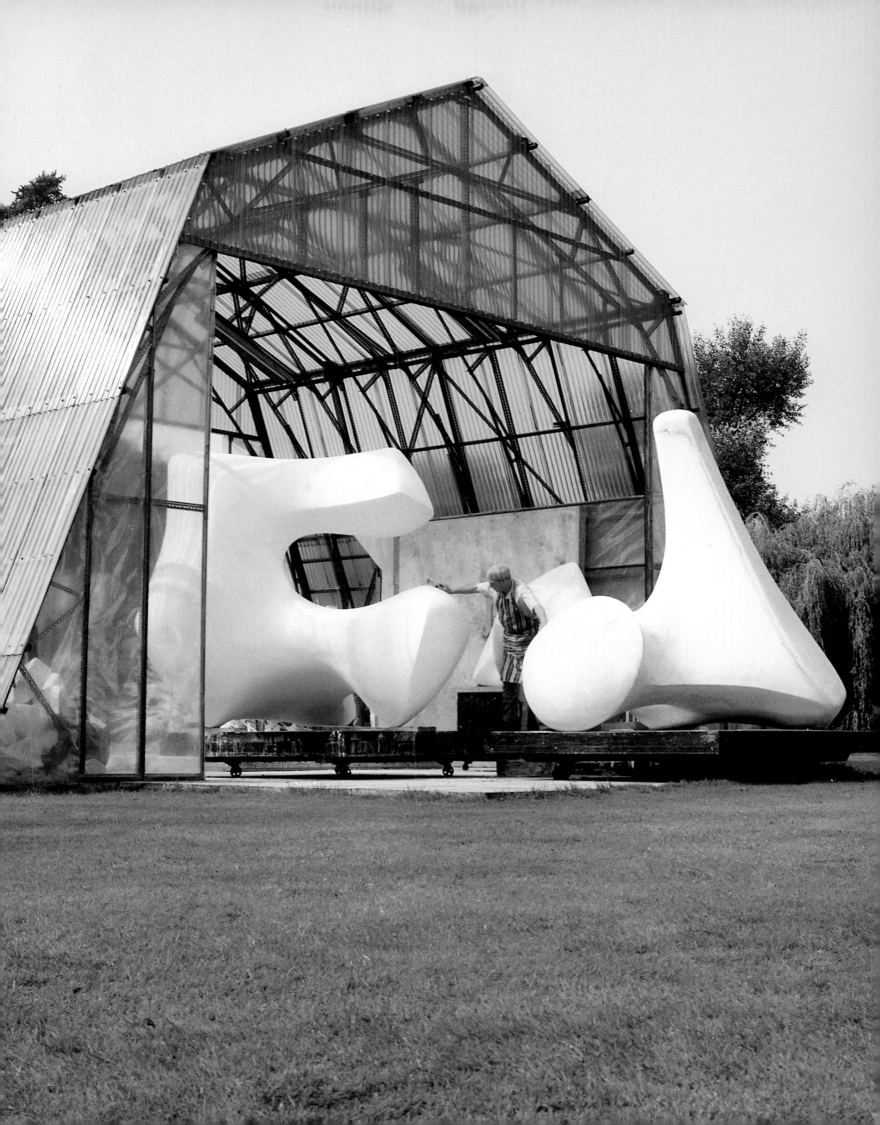

In the late twenties, and the thirties, he was regarded as a key member of the *avant-garde,* receiving a great deal of popular abuse, and involved with the 'isms' of the age, with abstraction and surrealism, often exhibiting as part of 'leading edge' groups. The driving nature of the work towards greater and greater abstraction is apparent, and seems to culminate in the stringed figures of the late thirties. Yet Henry's attitude towards the more theoretical side of art seemed summed up by what he ultimately said about the stringed pieces, when interviewed for the *Listener* in the 1960's: "I could have done hundreds. They were fun, but too much in the nature of experiments to be really satisfying. It became a matter of ingenuity rather than a fundamental human experience."

During the war, drawing was his main activity, in the form of his work as an official war artist. This role also played a part in broadening public awareness of his work. It was during the post-war years that he produced the key works that were to make him internationally famous. The critics and artists of the pre-war *avant-garde* in Britain were fast to become the art establishment of the next era, even though complete public acceptance of their views was still some time off. It is quickly forgotten how Henry's work was reviled by elements of the popular and the more serious press. Things have changed: in retrospect, Alfred Munning's outraged attack upon Henry and his contemporaries, spoken as it was as part of the 1949 Presidential address at the Royal Academy, can now be seen as the nadir of that institution's fortunes.

Certainly, Henry felt that many of the sculptures from the post-war period were important to him: the Northampton Madonna, the King and Queen and the Family Group. He also created more work in the form of interior and exterior forms,

a form which he first tried for The Helmet in 1940. In the mid-fifties, he created another form to which he would return a number of times, that of the Upright Motive.

It is difficult to exaggerate the importance of the UNESCO commission. This appears to inaugurate the phase in Henry's career when he became above all *the* sculptor for work in public spaces. He completed this enormous work in 1958, and it is surely no coincidence that for the following twenty-five years there was an extraordinary proliferation of large-scale Moore's throughout North America and Europe. It was as though all of the thinking and the refinement of a monumental vision that had occupied his career until then was preparation for its massive expression around the world, in countless architectural spaces and in galleries. He was also to find a new form for this period - the two piece figures that enabled him to create yet more spatial effects. At first these public works were still based on the body, but in the seventies they tended to become more abstract, and even more monumental, reminiscent of the work of the thirties.

With the passing of time, it is the last phase of Henry's career that stays in people's minds, the phase when a quiet man had become a public figure almost without equal in the art world. In reviewing work from the whole career, however, it is the integrity that shines through, and which seems to have made his final astonishing status almost inevitable.

74

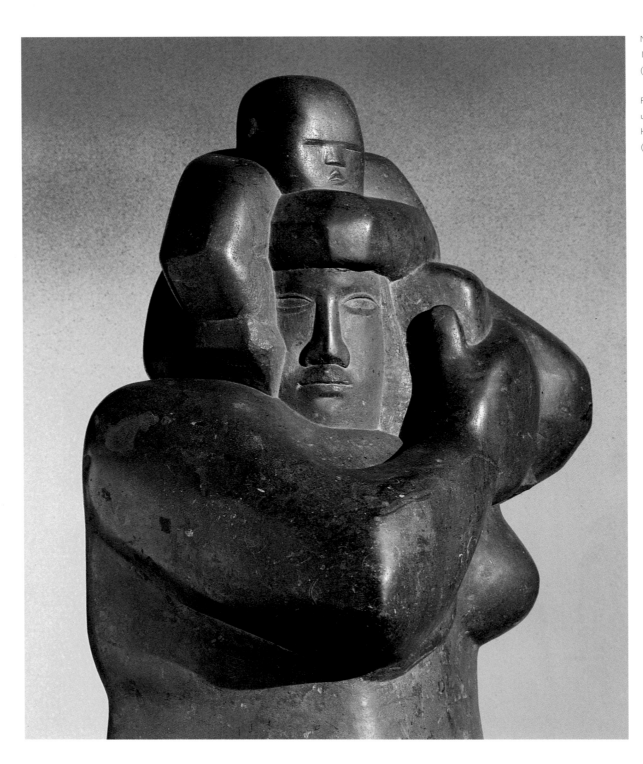

Mother and Child,
1924/5, Hornton Stone
(57 cm high, LH 26)

Right: Woman with
upraised arms, 1924/5,
Hopton Wood Stone
(43 cm high, LH 23)

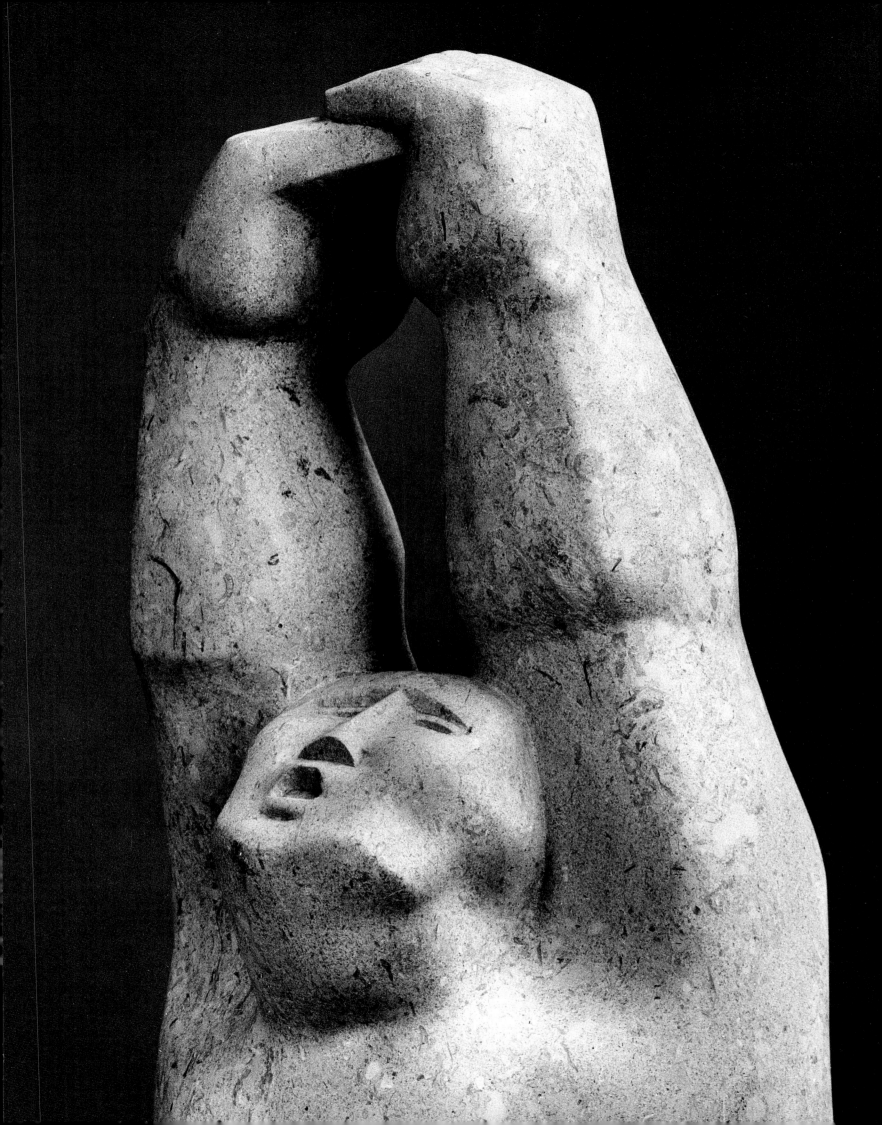

76

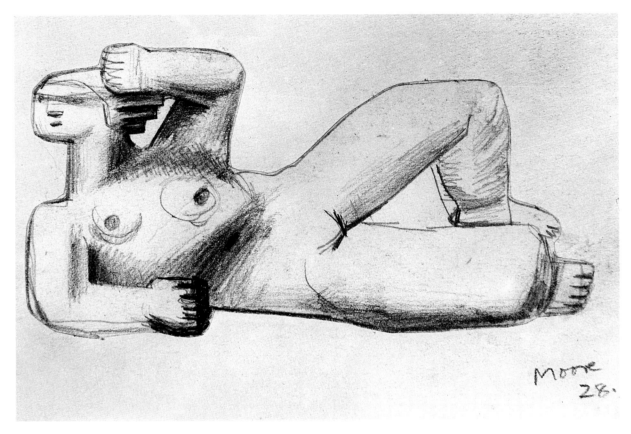

Reclining Figure,
(fragment), c. 1928,
Oil, pen and ink
on canvas (199mm wide)

Reclining figure, 1929,
Brown Hornton Stone
(84 cm long, LH 59)

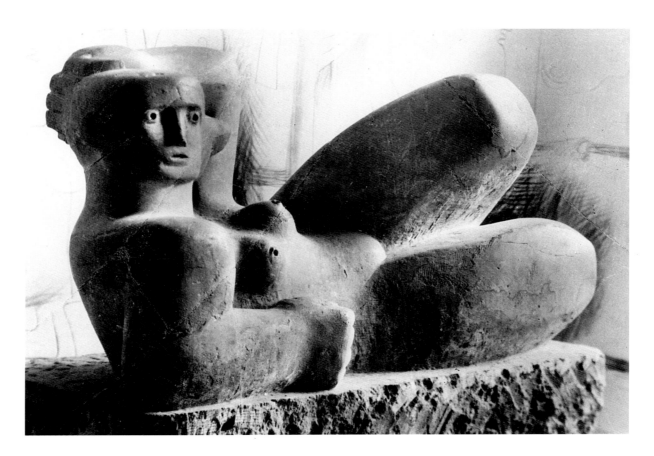

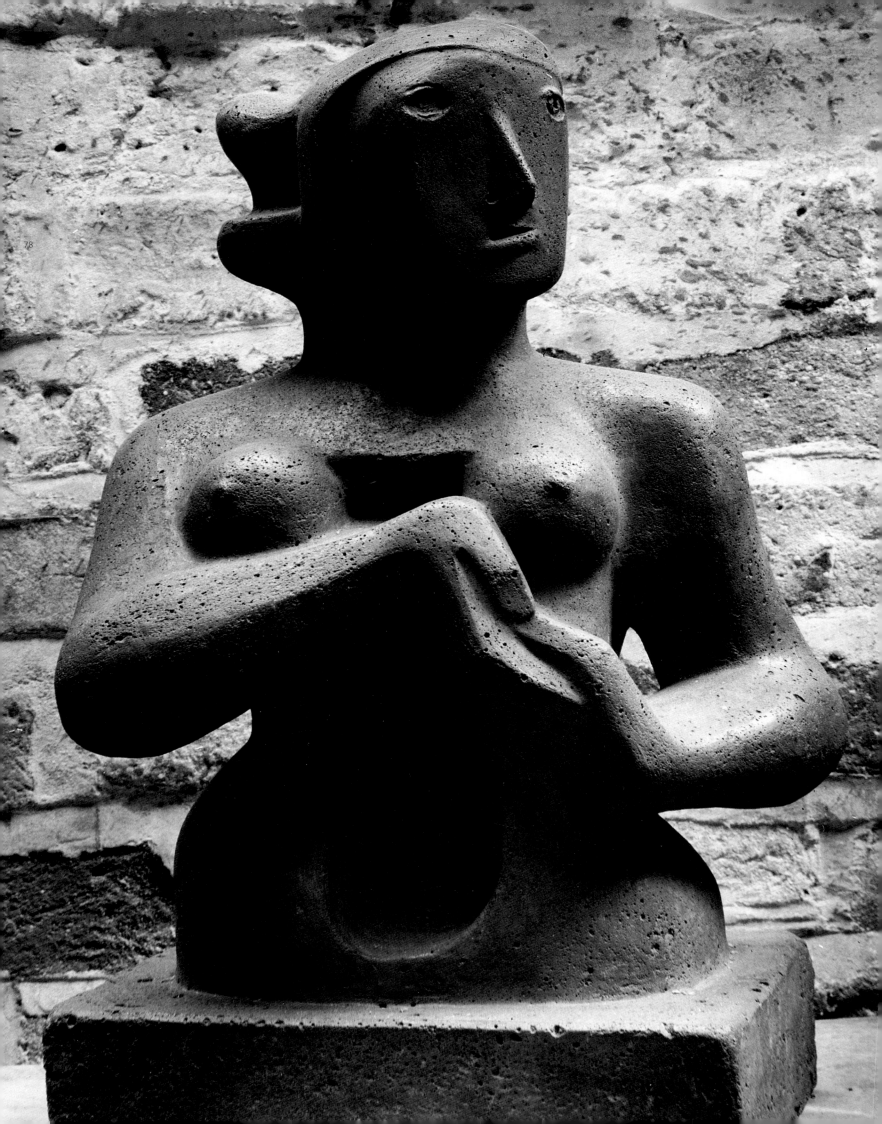

Left: Half-figure, 1929,
Cast Concrete
(37 cm high, LH 67)
'... reinforced concrete
was the new material for
architecture. As I have
always been interested in
materials, I thought I
ought to learn about the
use of concrete for
sculpture in case I ever
wanted to connect a
piece of sculpture with a
concrete building. The
first method of using
concrete I tried was
building it up on an
armature and then
rubbing it down after it
had set. This I had to do
very quickly because the
cement and the gritty
aggregate mixed with it
set so hard that all my
tools used to wear out.
Secondly, I tried casting...'

Seated Figure and Faces,
1926, Sketchbook No. 6,
225 mm high

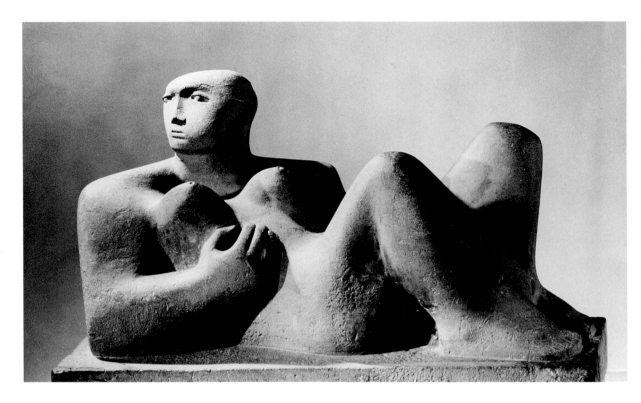

Reclining woman, 1930,
Green Hornton Stone
(79 cm long, LH 84)

Reclining Figure, 1928,
Ink, wash, 394 mm wide

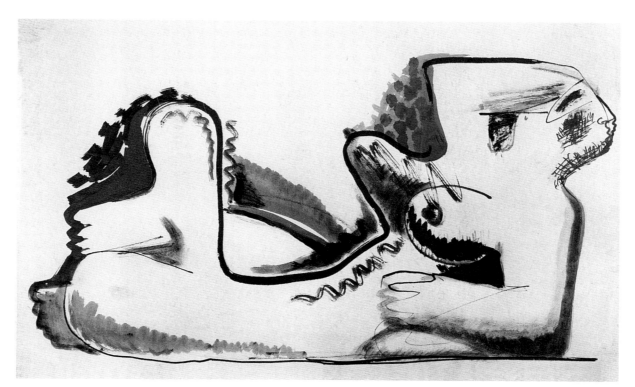

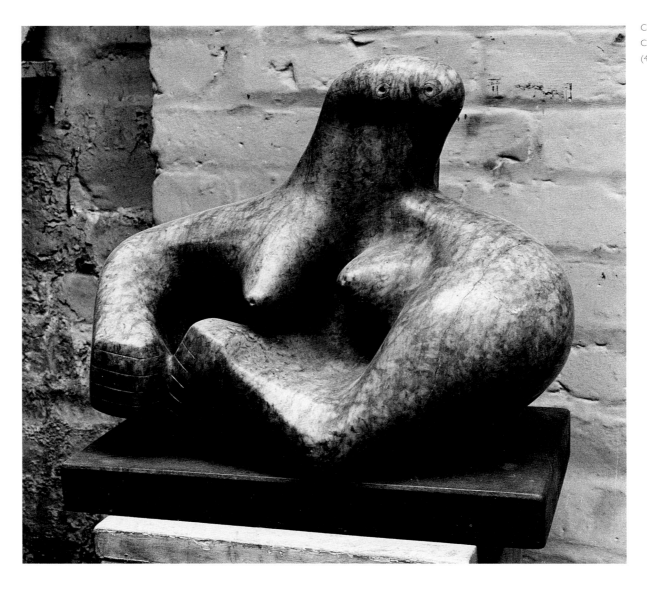

Girl, 1931,
Ancaster Stone
(74 cm high, LH 109)

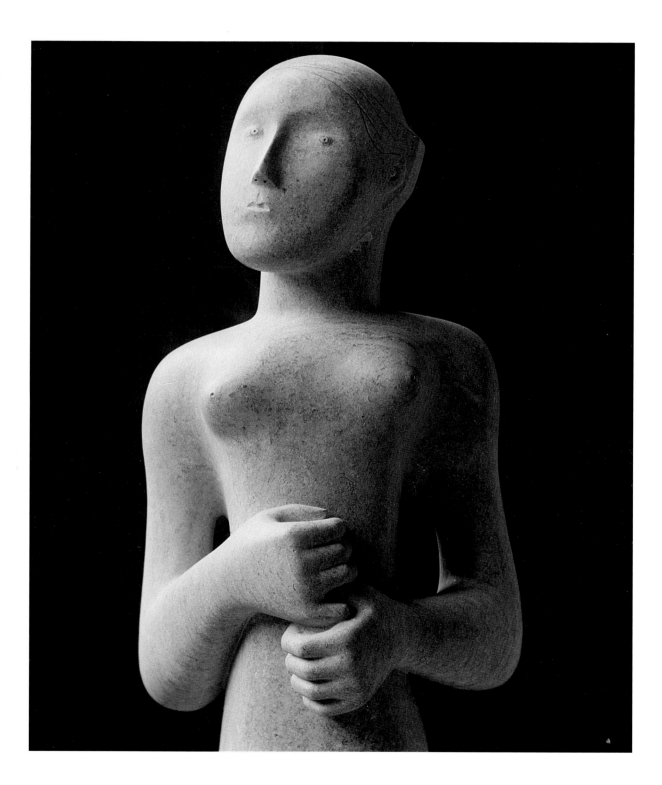

Mother and Child,
1928, Green chalk,
(260 mm high)

Right: Mother and child,
1932, Green
Hornton Stone,
(89 cm high, LH 121)
'From very early on I
have had an obsession
with the Mother and
Child theme. It has been
a universal theme from
the beginning of time
and some of the earliest
sculptures we've found
from the Neolithic
Age are of a Mother
and Child'

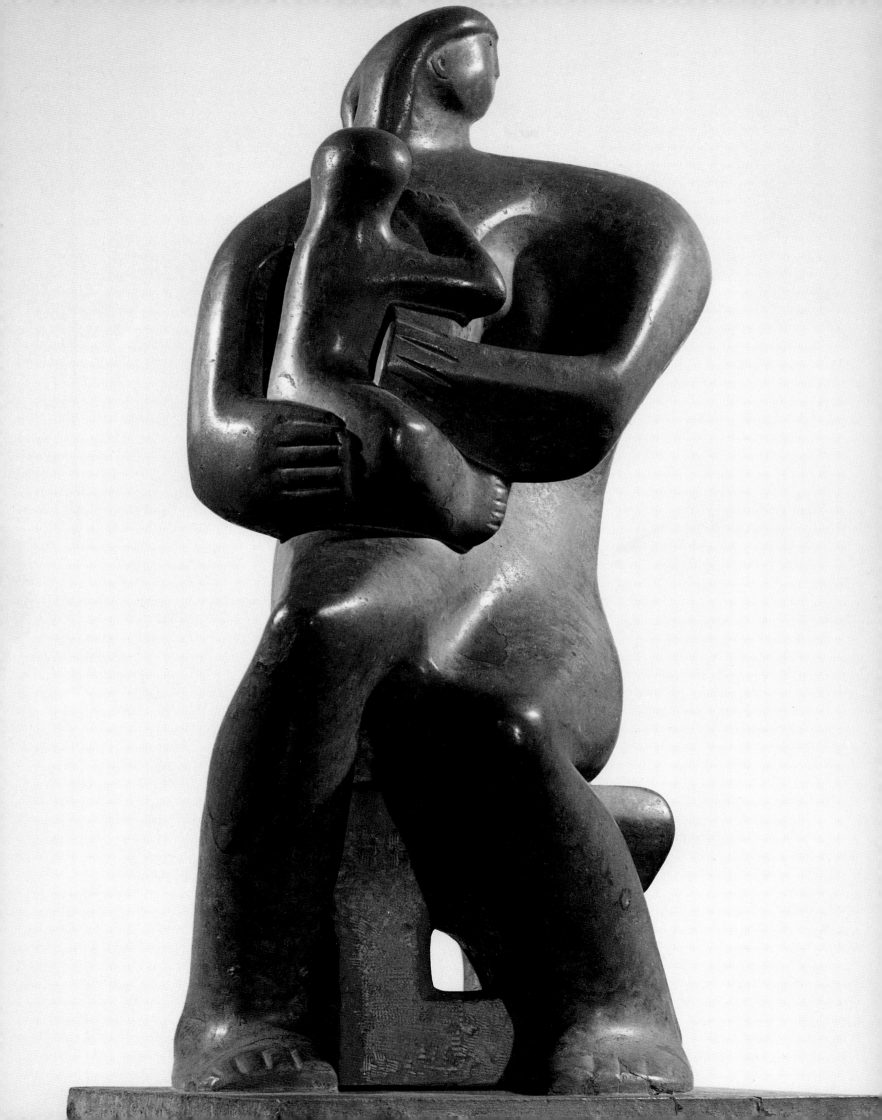

Carving, probably 1936,
Travertine Marble
(46cm high, LH 164)

Right: Square Form, 1934,
Burgundy Stone
(32cm high, LH 154b)
'I went to the stone
quarries in Derbyshire
and bought a lot of
random blocks of
Hopton Wood stone. I
had room and space
enough at Burcroft to let
the stones stand around
in the landscape, and
seeing them daily gave
me fresh ideas for
sculpture...this was very
much a stone period in
my life. In fact up to the
war, nine out of ten
sculptures I did were in
stone. I still love stone.'

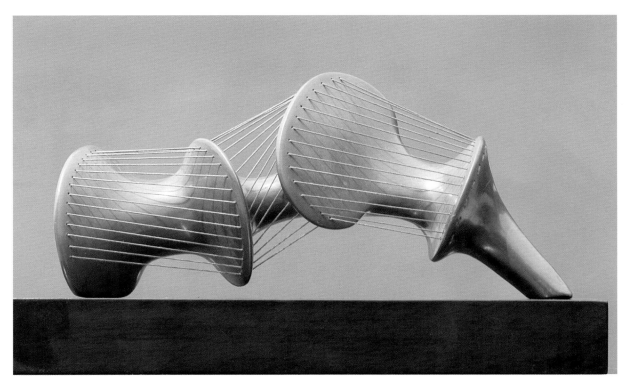

Stringed Figure, 1939,
Lead and Wire
(25 cm long, LH 206)
'Undoubtedly the source
of my stringed figures
was the Science
Museum... I was
fascinated by the
mathematical models I
saw there, which had
been made to illustrate
the difference of the
form that is halfway
between a square and a
circle... It wasn't the
scientific study of these
models but the ability
to look through the
strings as with a bird
cage and to see one
form within another
which excited me.'

Ideas for stringed figures,
1938, Pencil (279 mm high)
This drawing incorporates a
note of the Paris address of
the celebrated printmaker,
Stanley William Hayter.

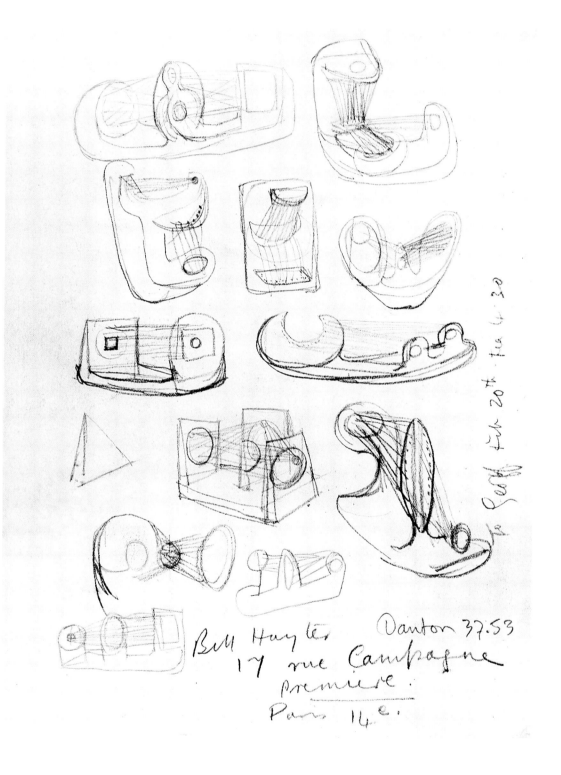

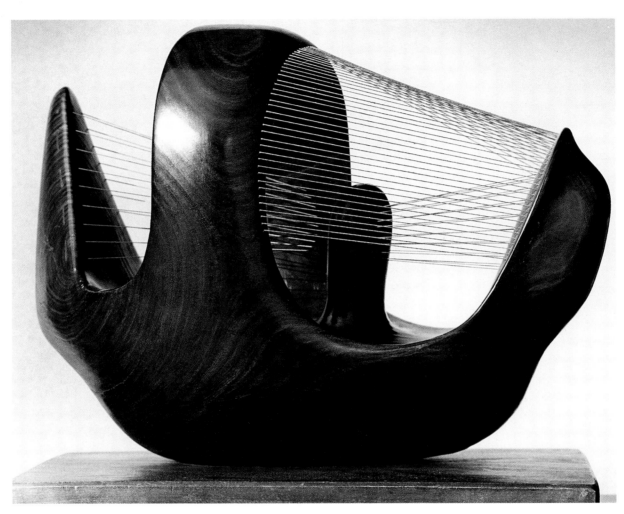

Bird Basket, 1939,
Lignum Vitae and String
(42 cm long, LH 20)
'I don't give my
sculptures high-falutin' or
abstruse Greek titles. I
prefer to call
them...simple descriptive
names...Take the
sculpture 'Bird Basket'. It
has got an organic form
to it although the strings
are abstract straight
lines... at one end is the
head and the other end
the tail. when I was
working on it, I used to
pick it up like a basket
by the loop over the
top. So the two words
'Bird' and 'Basket' are
significant because they
were arrived at in a
practical way.'

Overleaf: Reclining
Figure, 1939, Elmwood
(206 cm long, LH 210)

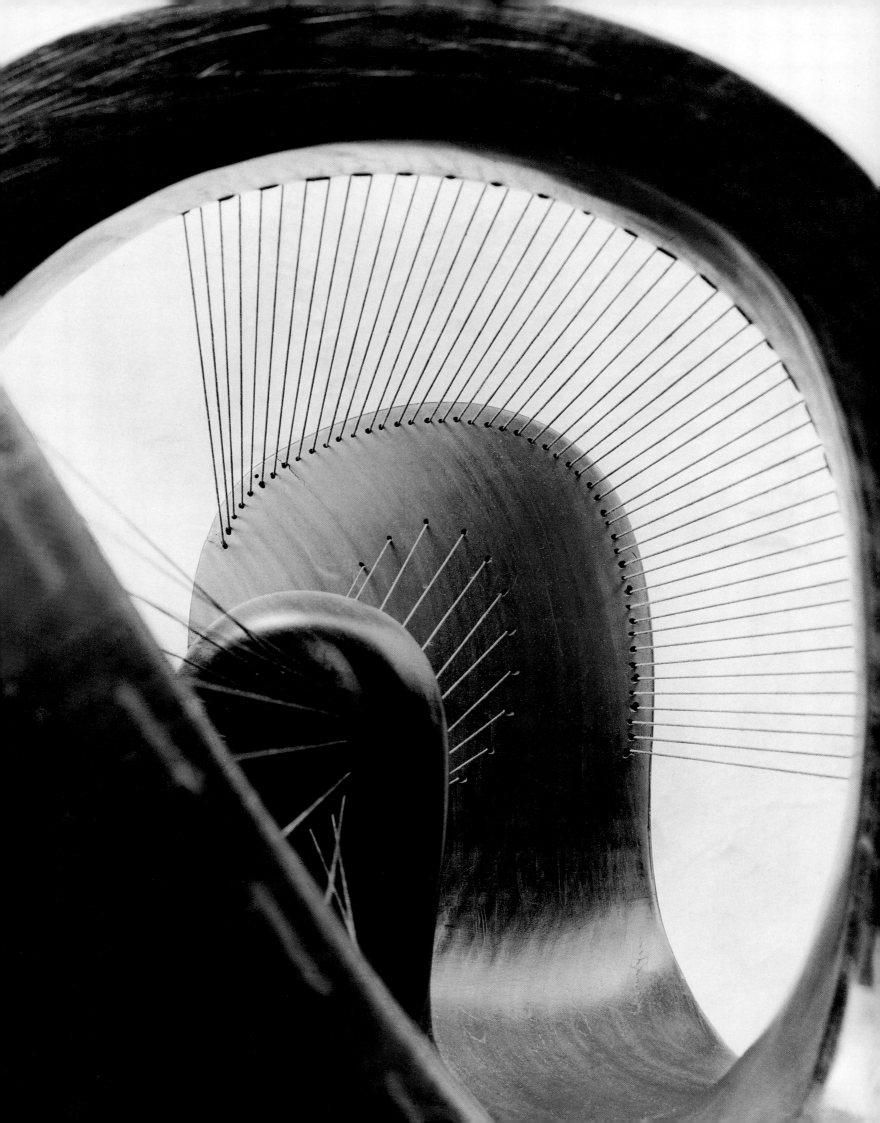

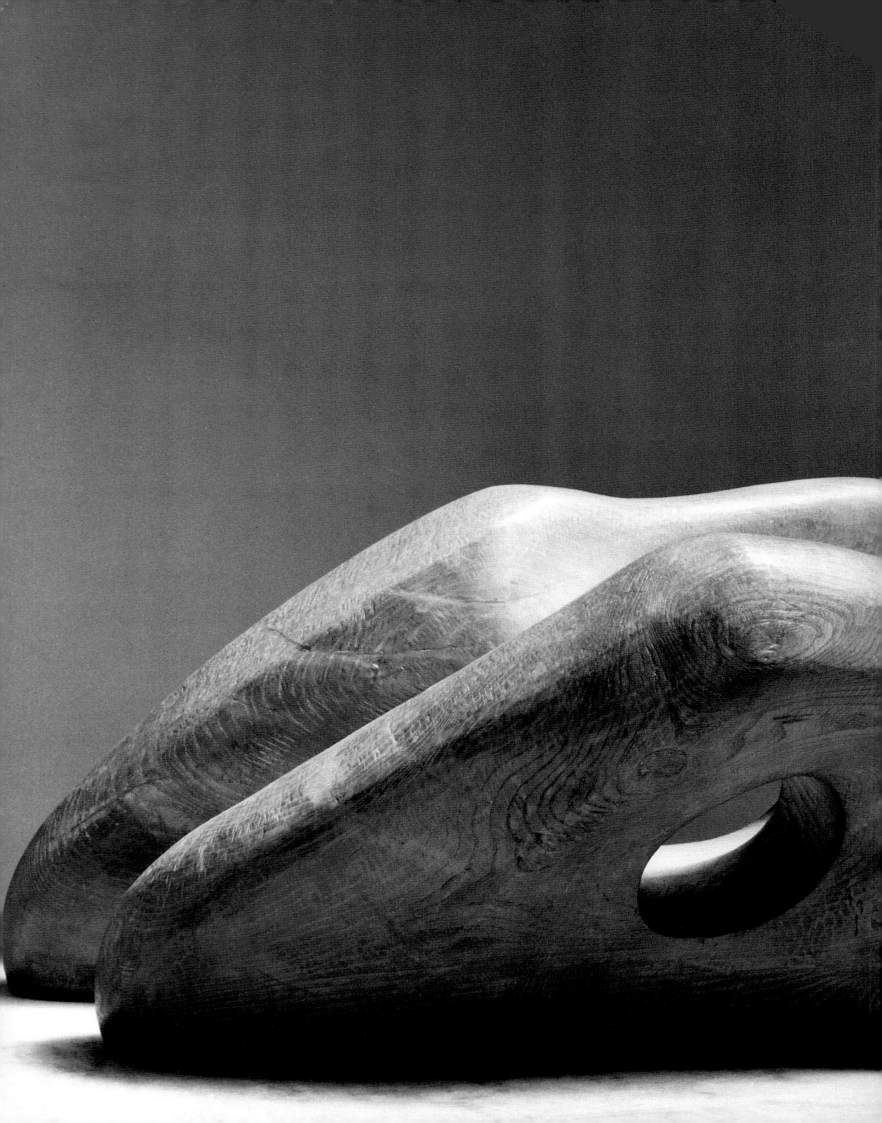

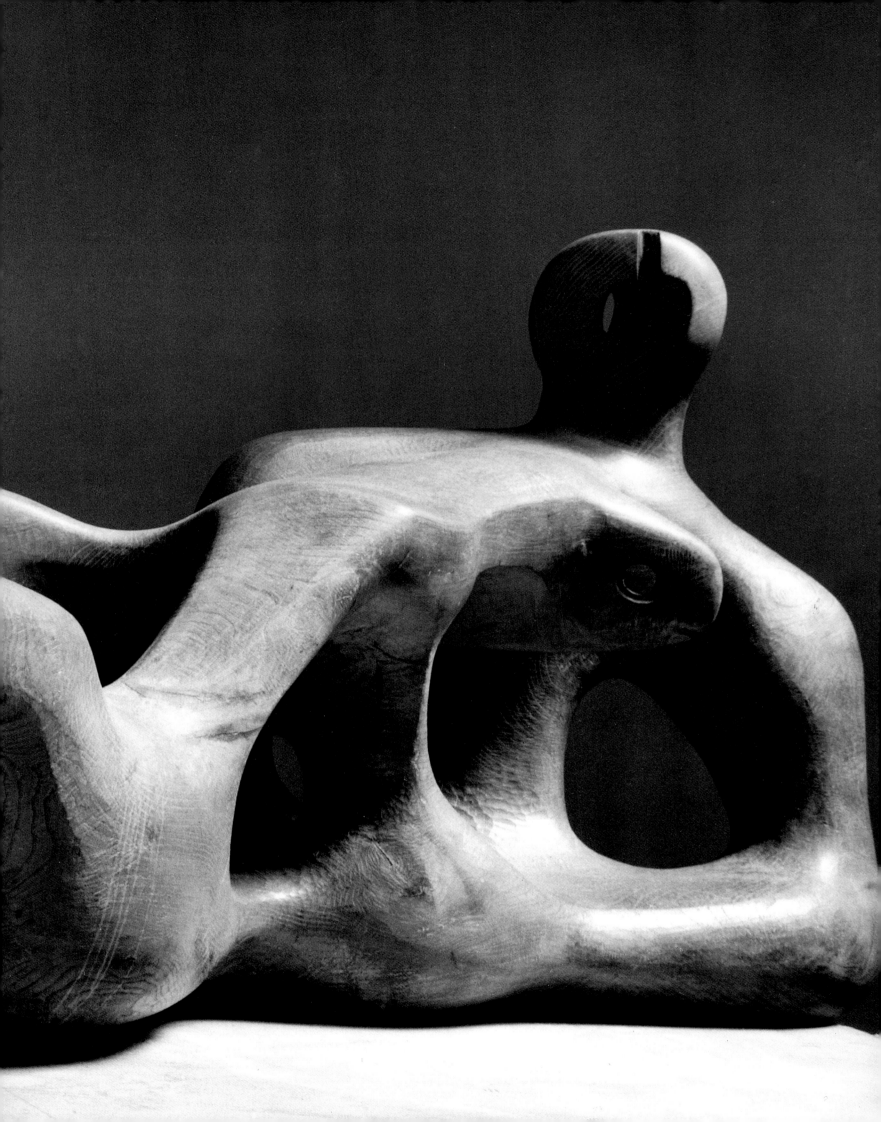

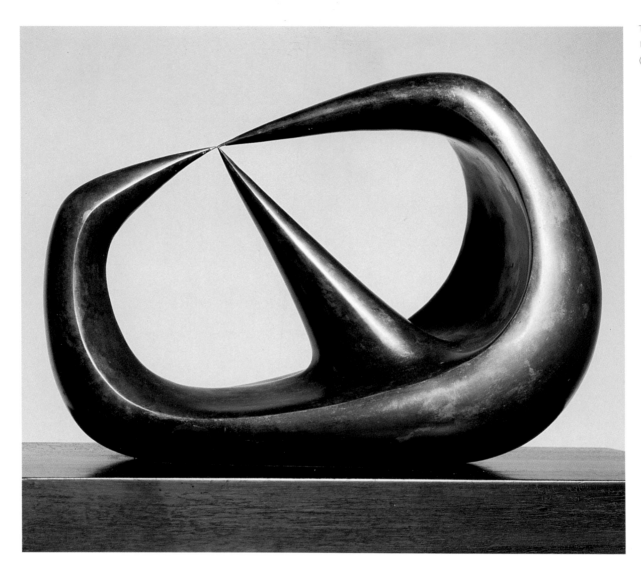

Pointed Forms, 1940,
Pencil, pen and ink,
chalk, wax crayon
and watercolour,
(432 mm wide)

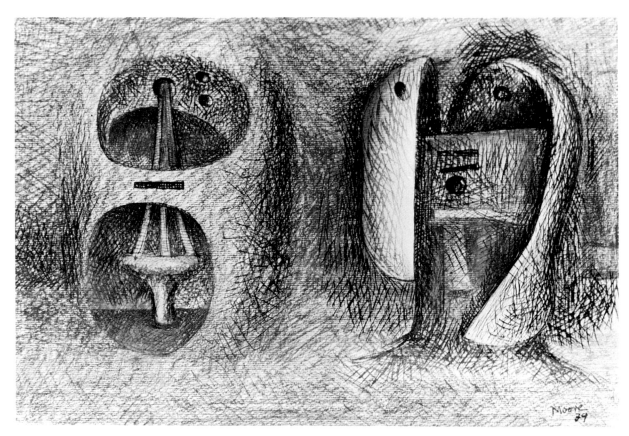

Drawing for metal sculpture: Two heads, 1939, Charcoal and wash, pen and ink, (381 mm wide)

Right: The Helmet, 1939 - 40, Lead (29 cm high, LH 212) 'This sculpture 'Helmet Head' is intended to be sinister, like a face peering out from inside a prison. There are two versions, one in bronze and one in lead. The lead version, I think, is more expressive because lead has a kind of poisonous quality; you feel that if you licked it you might die.'

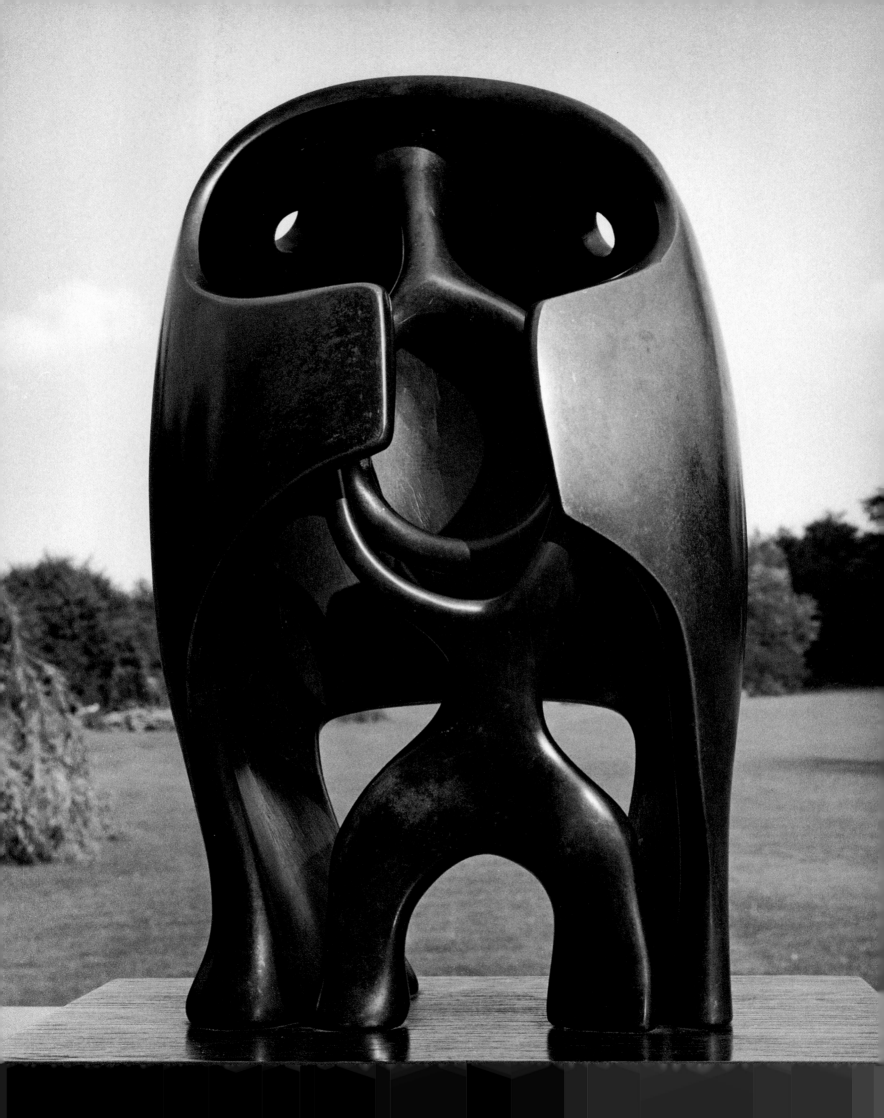

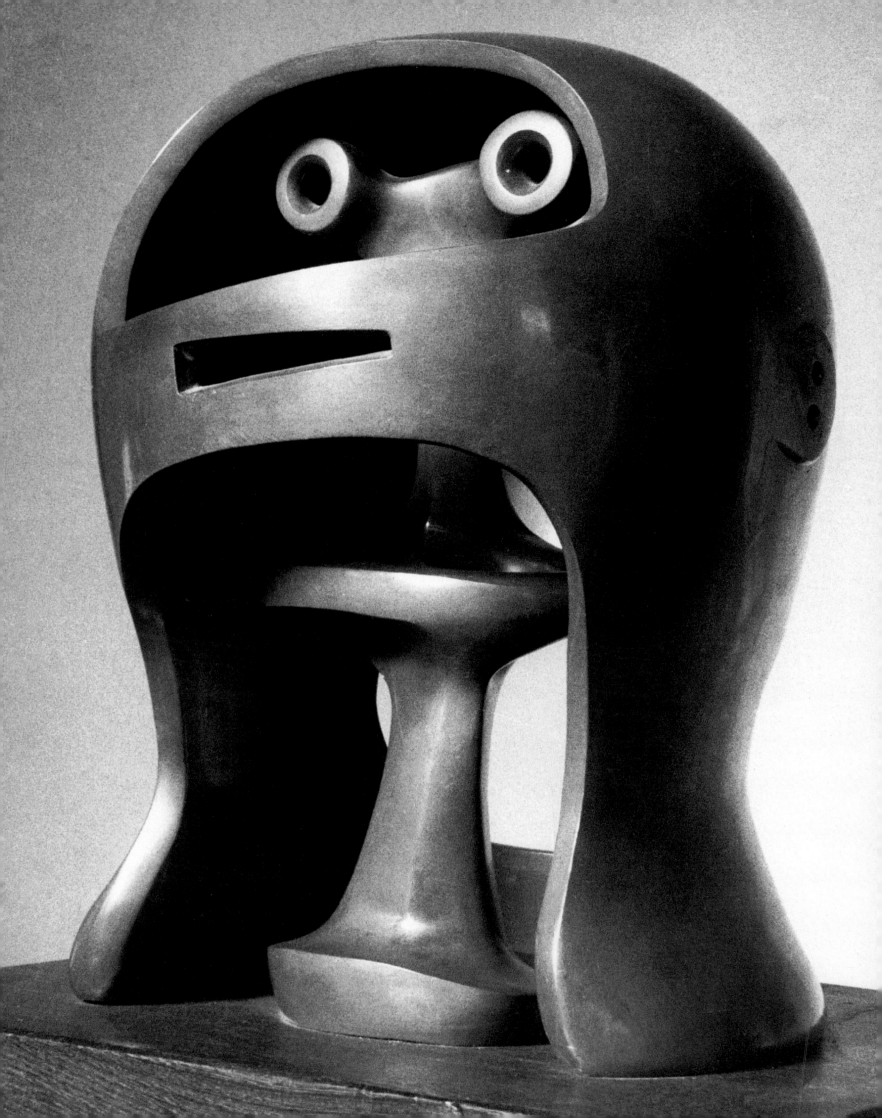

Reclining Figure: External Form, 1953 - 4, Bronze (213 cm long, LH 299) 'The working model [had] an interior piece, and in translating it into full size the internal form was also included. The two forms were, of course, made separately, although I continually fitted them together and related the shapes to each other. Later I decided the external form made a better sculpture on its own. The interesting result for me is that the interior form remains by implication.'

Left: Helmet Head No. 2, 1950, Bronze (34 cm high, LH 281)

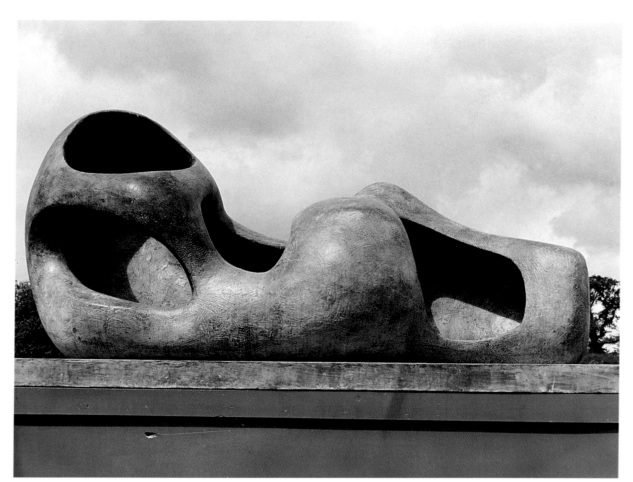

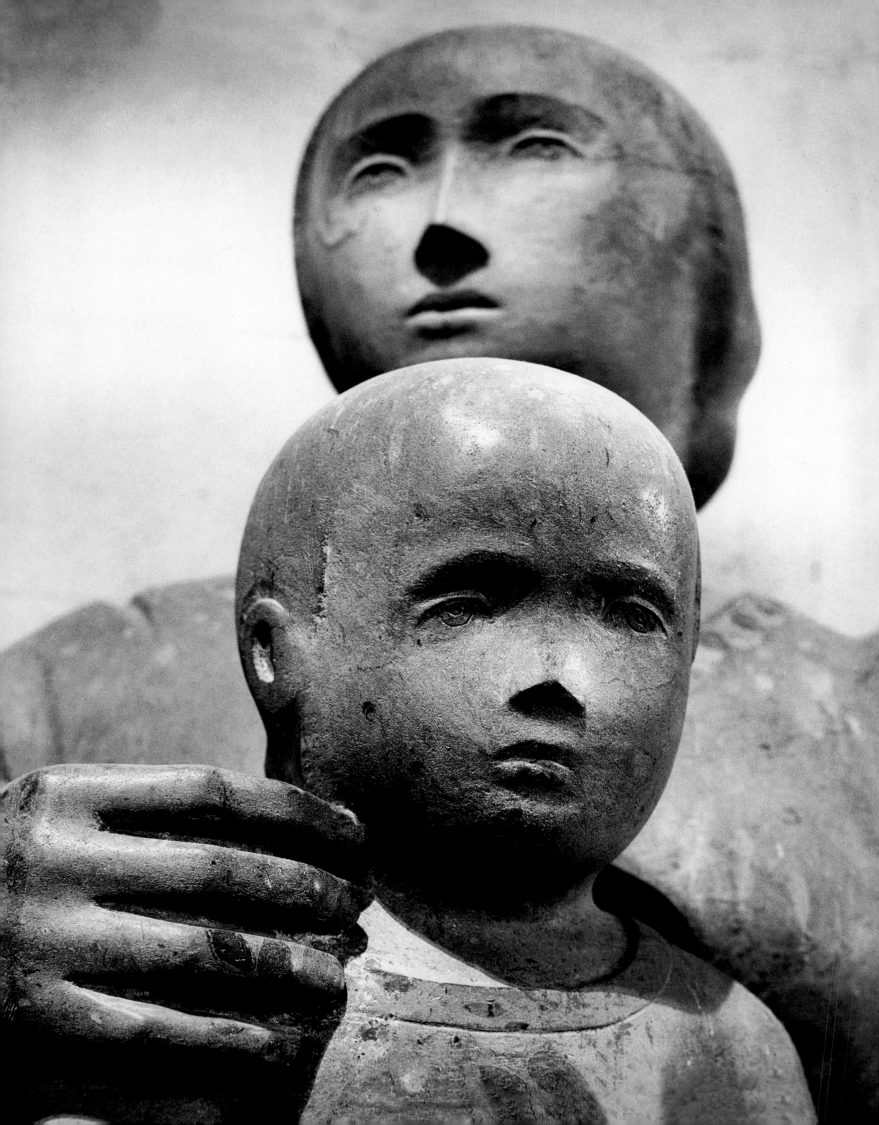

Madonna and Child, 1943
Pen and ink, crayon and
wash, from sketchbook,
(225 mm high)

Left: Madonna and Child,
1943, Hornton Stone
(150 cm high, LH 226)
'The Northampton
Madonna and Child was
one of the most difficult
and heart-searching
sculptures that I ever
tried to do...I doubt if I
would ever have
attempted a religious
subject had it not been
for the continuous
pressure and
encouragement from
Canon Hussey. The
Mother and Child theme
had been a common one
to nearly half my work.
Yet I hesitated over his
request because I
realised that I should not
do an ordinary Mother
and Child...'

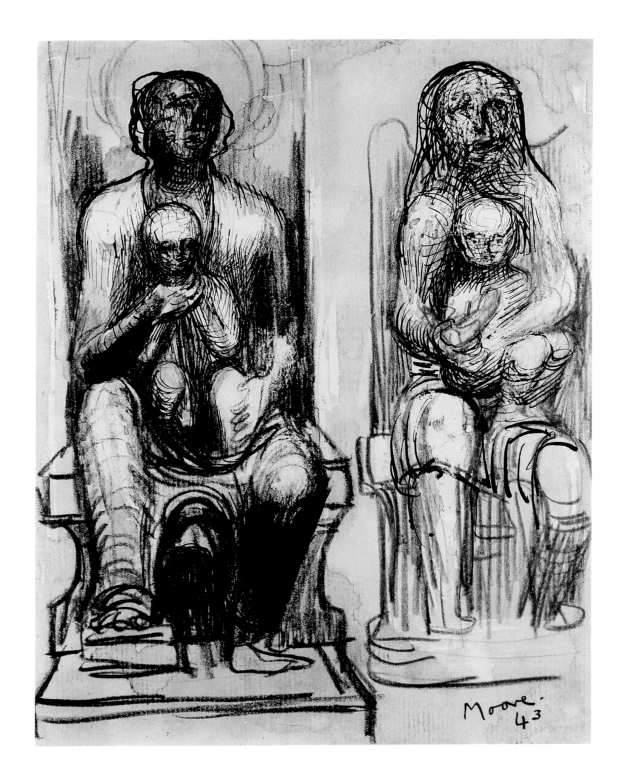

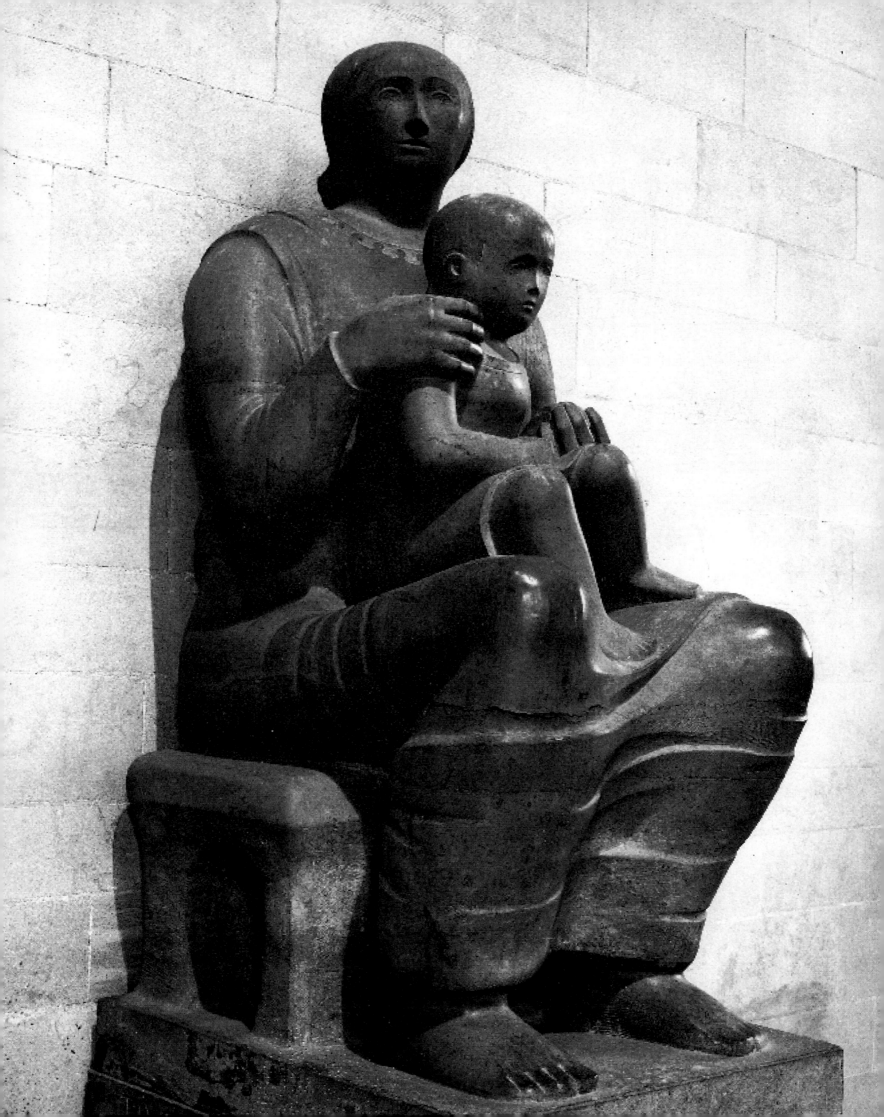

Family Group,
1944, Bronze
(17 cm high, LH 230)

Left: Madonna and Child,
1943, Hornton Stone
(150 cm high, LH 226)

Overleaf: Reclining
Figure, 1945 - 46,
Elmwood
(190 cm long, LH 263)

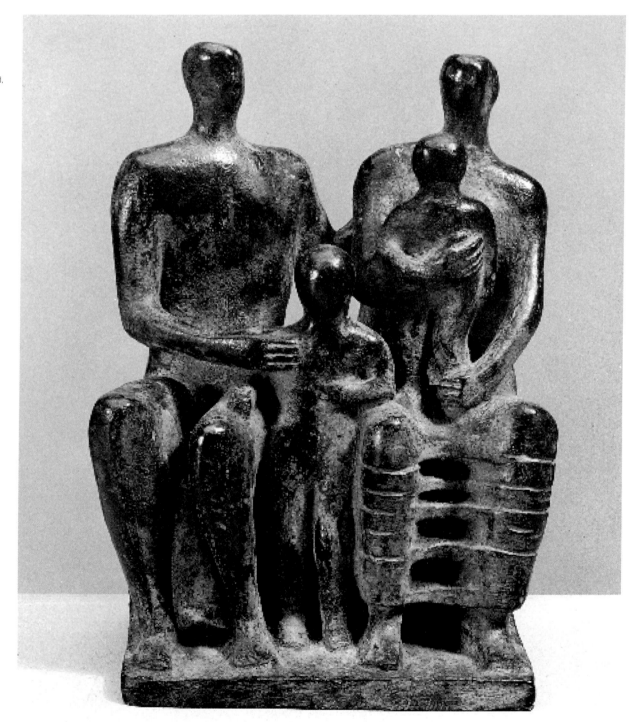

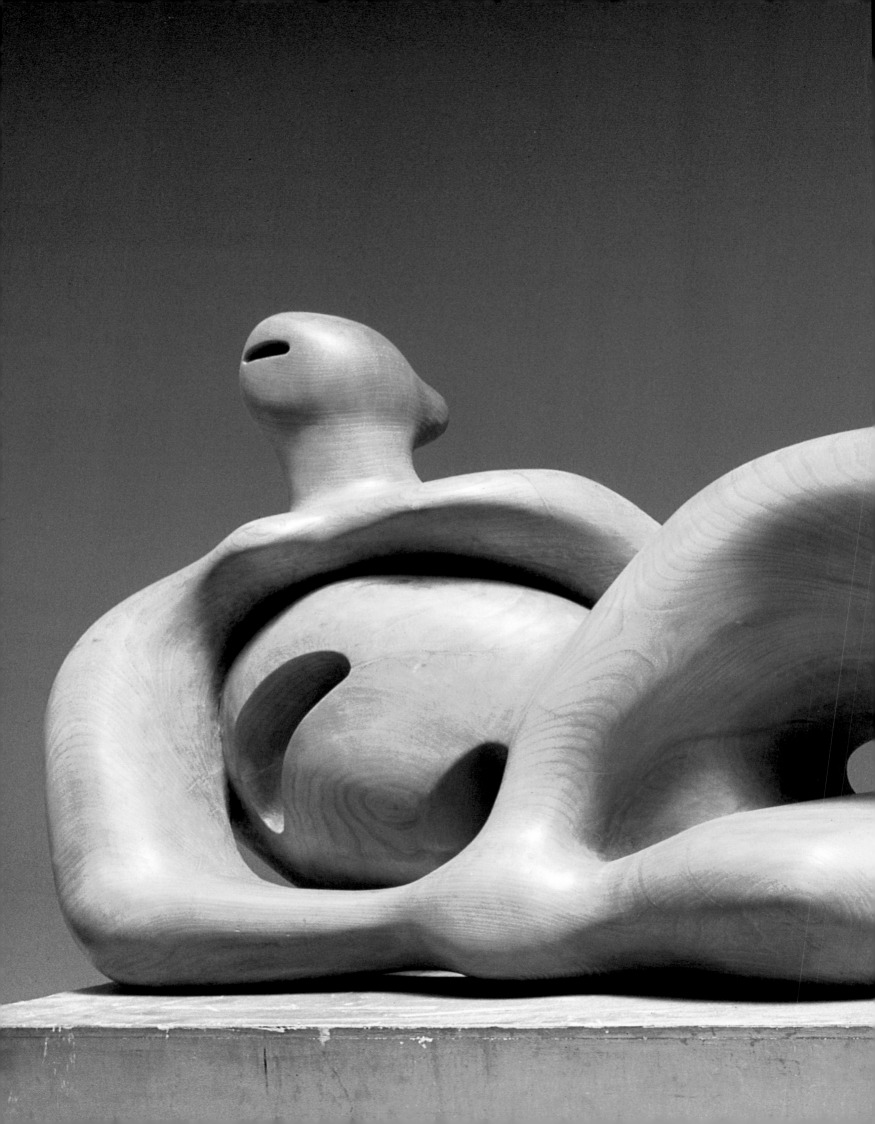

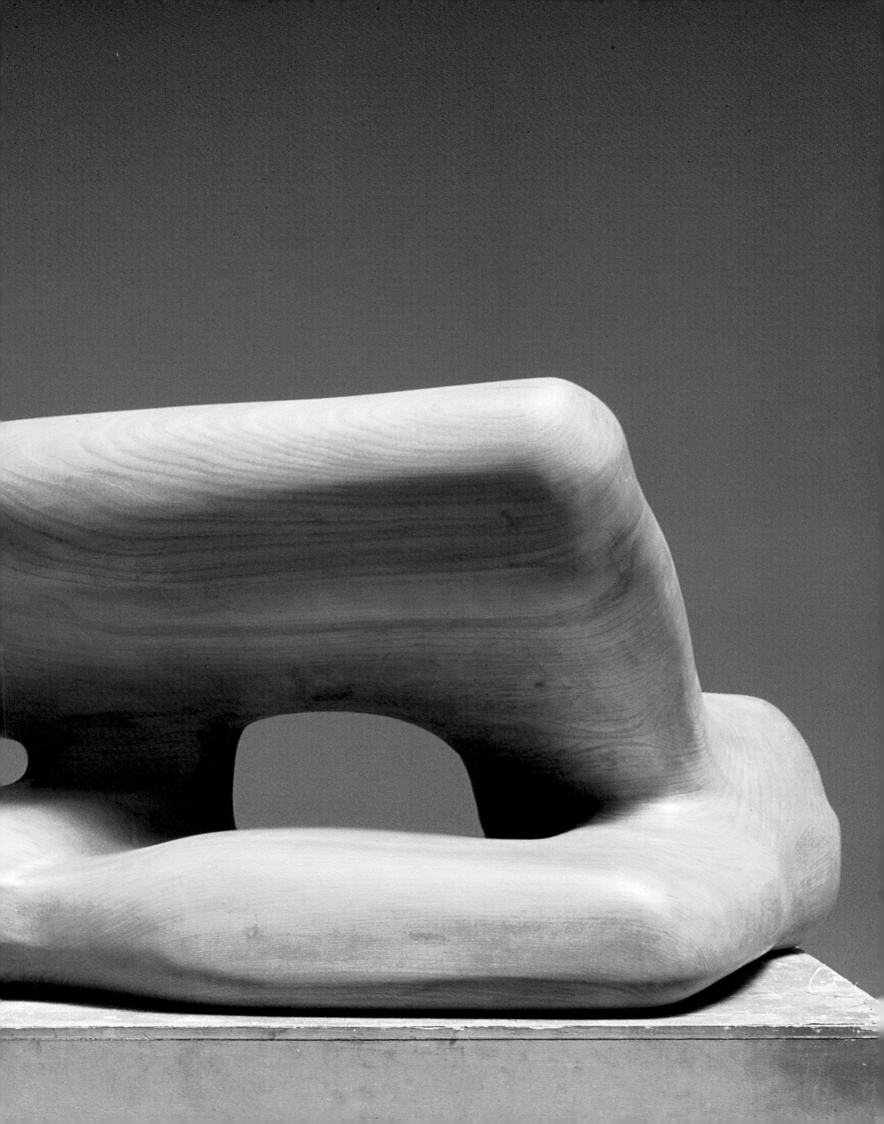

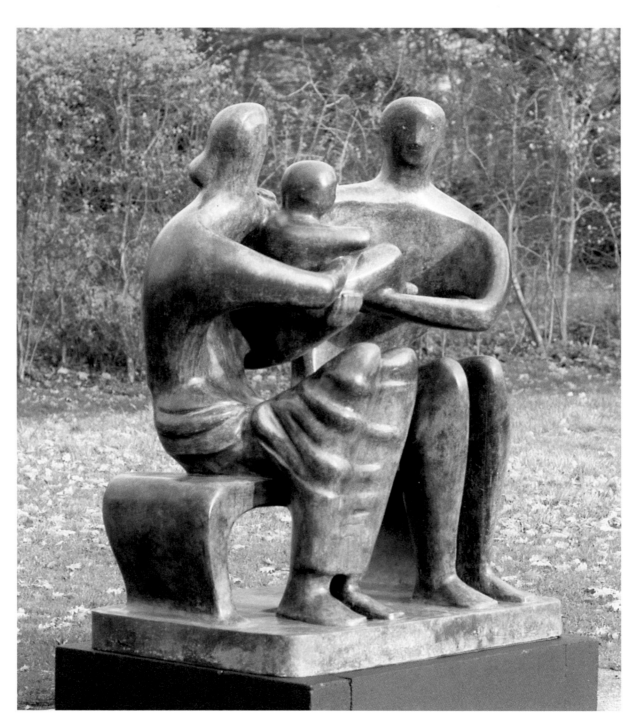

Family Group,
1948 - 49, Bronze
(152 cm high, LH 269)
'The idea of the family
group crystallised before
the war. Henry Morris,
the Director of Education
for Cambridgeshire,
asked me to do a
sculpture for the
Impington Village College,
the first of the modern
schools in England. It was
designed by Walter
Gropius. As the College
was going to be used for
adult education as well,
the idea of connecting
parents to children came
into my mind.'

Four Family Groups,
1944, Pencil, wax crayon,
watercolour and chalk,
from sketchbook,
(227 mm high)

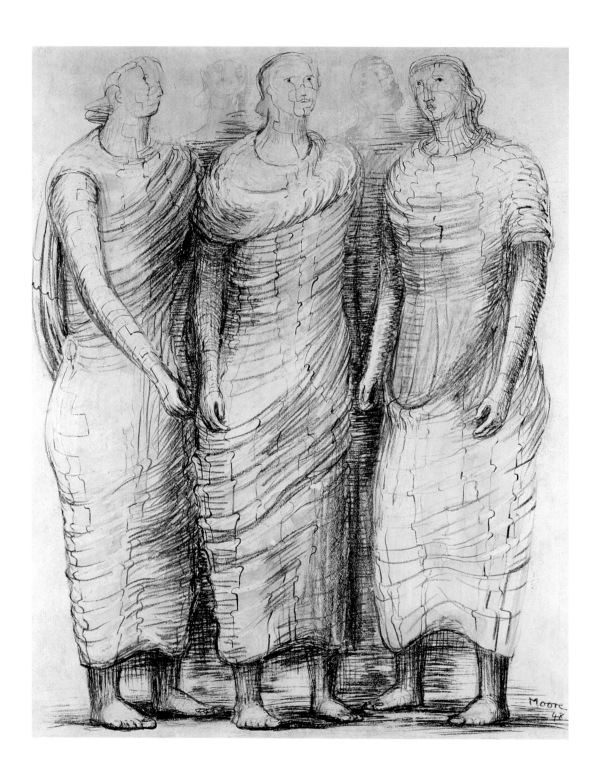

Five Standing Women,
1948, Pencil, pen and ink,
crayon and watercolour,
(711 mm high)

Left: Three Standing
Figures, 1947,
Darley Dale Stone
(213 cm high, LH 268)
'...probably the first big
sculptures that showed
the influence of my war
drawings. Although the
figures are static, I made
them look into the
distance, as if they were
expecting something
dramatic to happen.
Drama can be implied
without the appearance
of physical action.'

Mother and Child, 1962,
Pencil and coloured inks,
from sketchbook,
(292mm high)

Right: Mother and Child,
1953, Bronze,
(51cm high, LH 315)

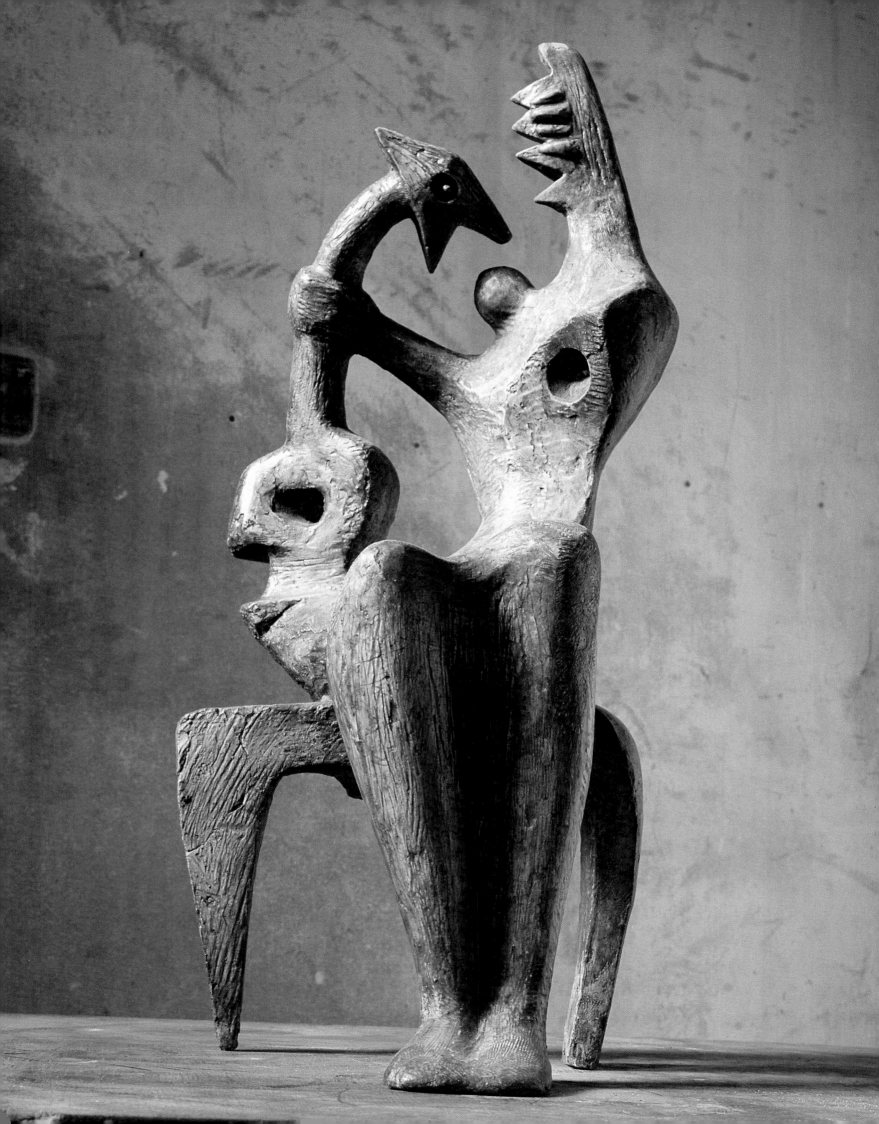

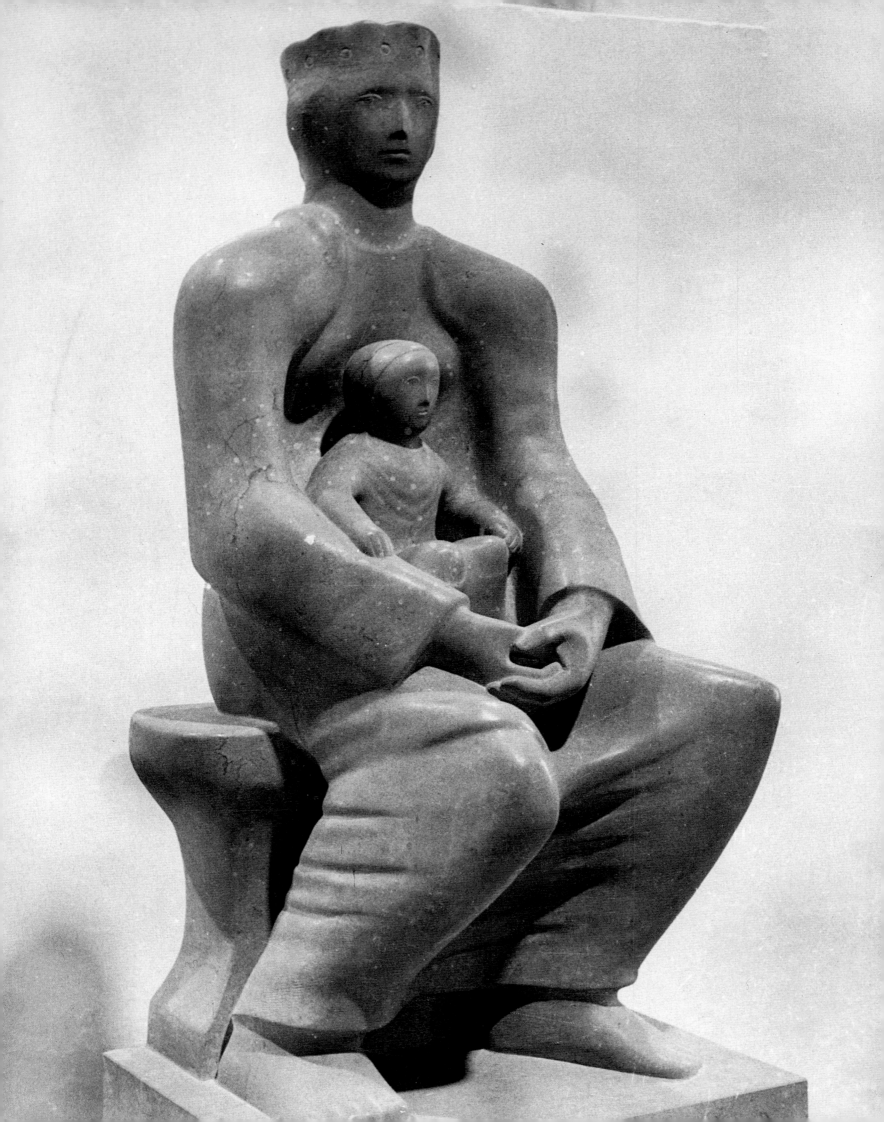

Memorial Figure,
1945 - 46,
Hornton Stone
(142 cm long, LH 262)
'The Dartington Hall
'Reclining Figure' was
done as a memorial to
Christopher Martin, an
old friend of mine who
had been art director at
Dartington. I chose an
idea which was calm
and peaceful...'

Left: Claydon Madonna
and Child, 1948 - 49,
Hornton Stone
(122 cm high, LH 270)
'Religion no longer seems
to provide inspiration or
impetus for many artists.
And yet all art is religious
in a sense that no artist
would work unless he
believed that there was
something in life worth
glorifying. That is what
art is about.'

Overleaf: Standing Figure,
1950, Bronze
(221 cm high, LH 290)
'This standing figure, like
a sentinel, with an
echoing double-head, is
beautifully placed on a
natural outcrop of rock
on this Scottish moor.'

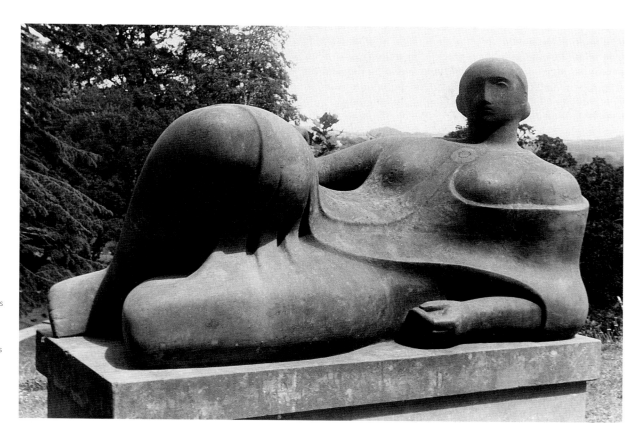

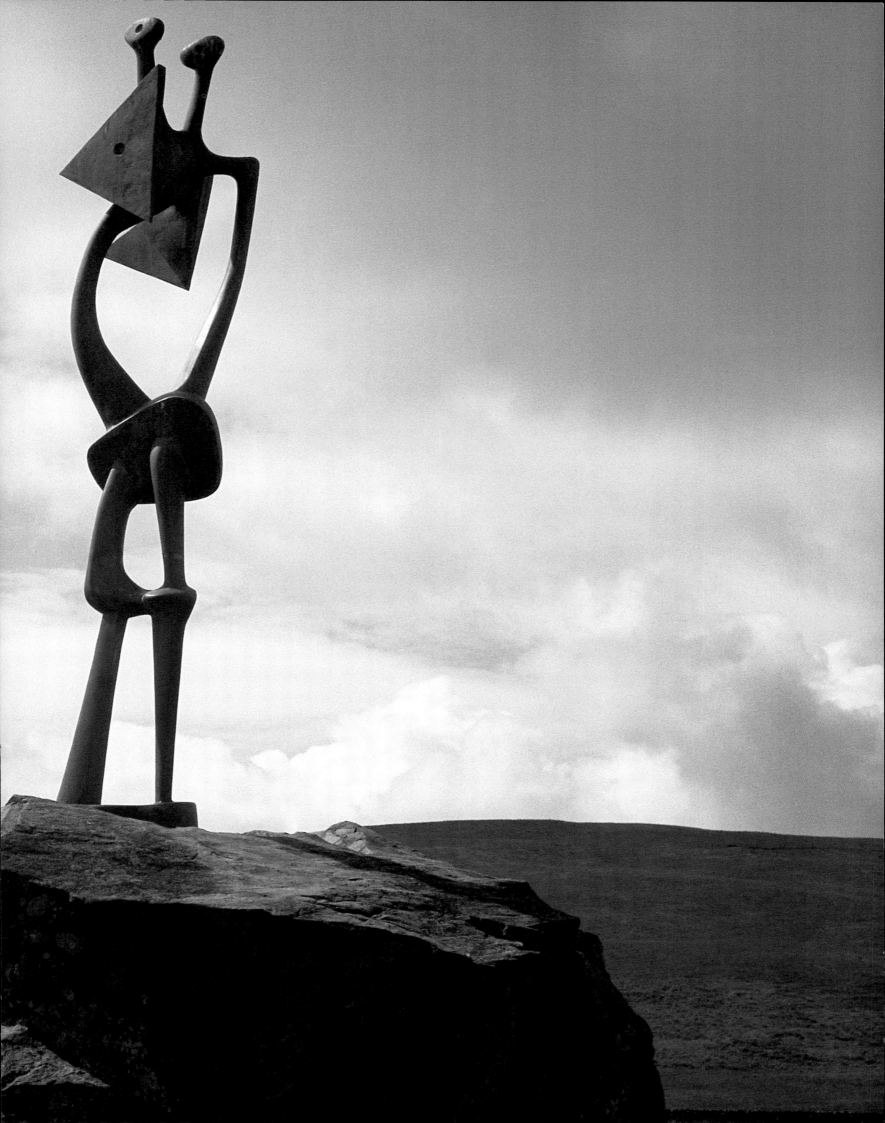

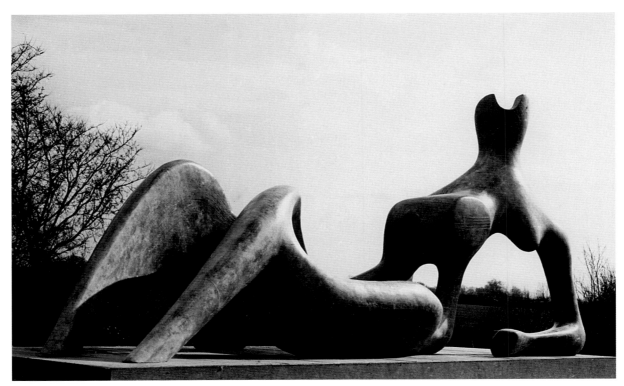

Reclining Figure, Festival,
1951, Bronze
(228 cm long, LH 293)
'... perhaps my first
sculpture where the
space and the form are
completely dependent
on and inseparable from
each other. I had reached
the stage where I wanted
my sculpture to be truly
three dimensional. In my
earliest use of holes in
sculpture, the holes were
features in themselves.
Now the space and the
form are so naturally
fused that they are one.'

Reclining Figures, 1948,
Pencil, pen and ink,
crayon and watercolour,
from sketchbook,
(292 mm high)

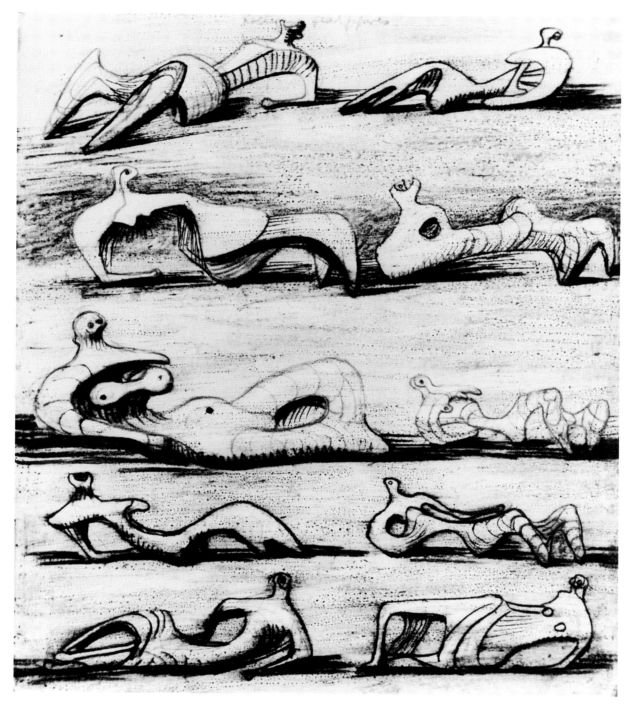

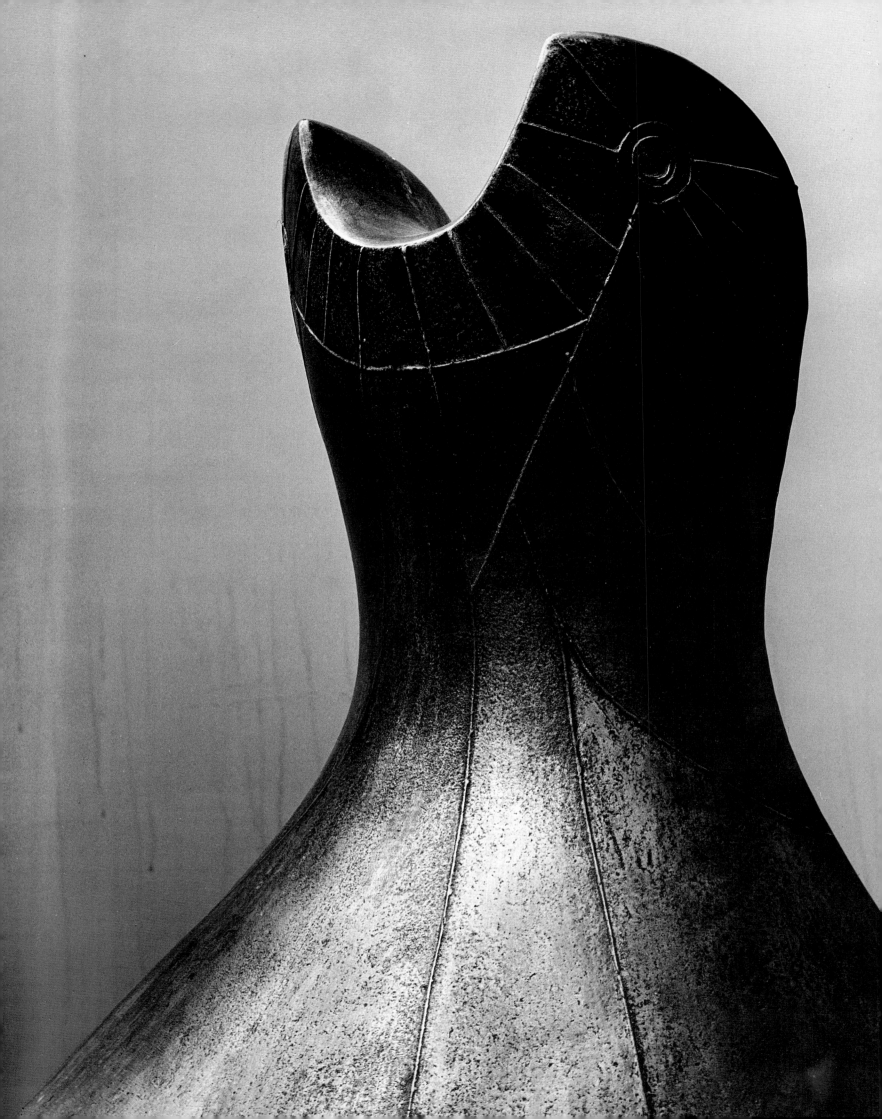

Reclining Figure, Festival,
1951, Bronze
(228 cm long, LH 293)

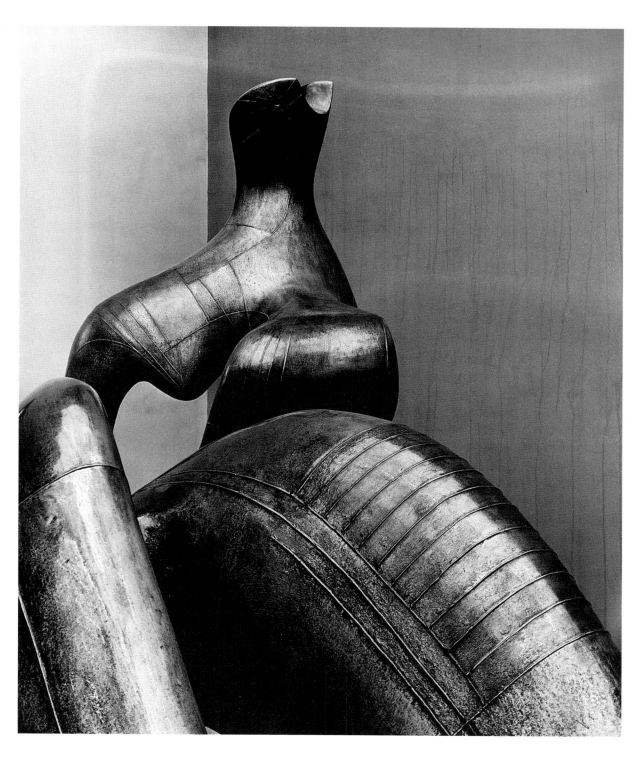

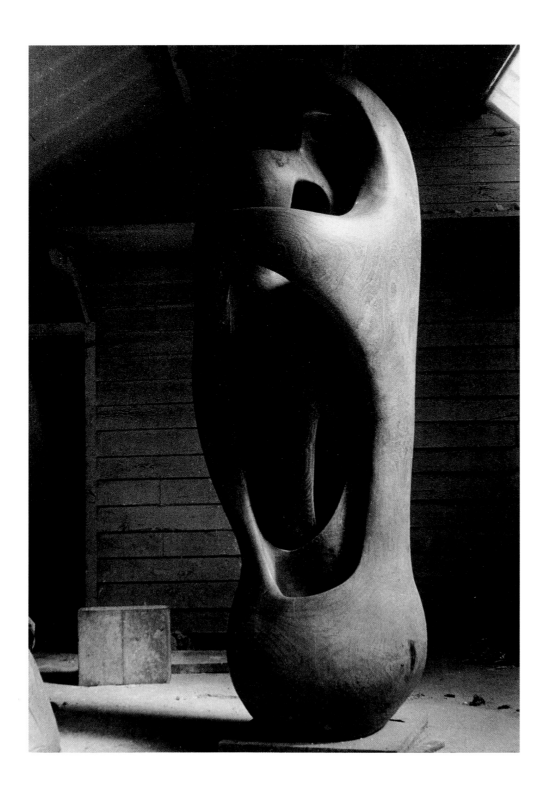

Upright Internal/External
Form, 1953 - 54,
Elmwood
(261 cm high, LH 297)
'I have done other
sculptures based on this
idea of one form being
protected by
another...some of the
helmets I did in 1939 in
which the interior of the
helmet is really a figure
and the casing of it is like
the armour by which it
might be protected in
battle. I suppose in my
mind was also the
Mother and Child idea...
of birth and the child
in embryo. All these
things are connected
in this interior and
exterior idea.'

Upright internal/external
forms, 1938 - 39,
Pencil and crayon, from
sketchbook, (275 mm high)

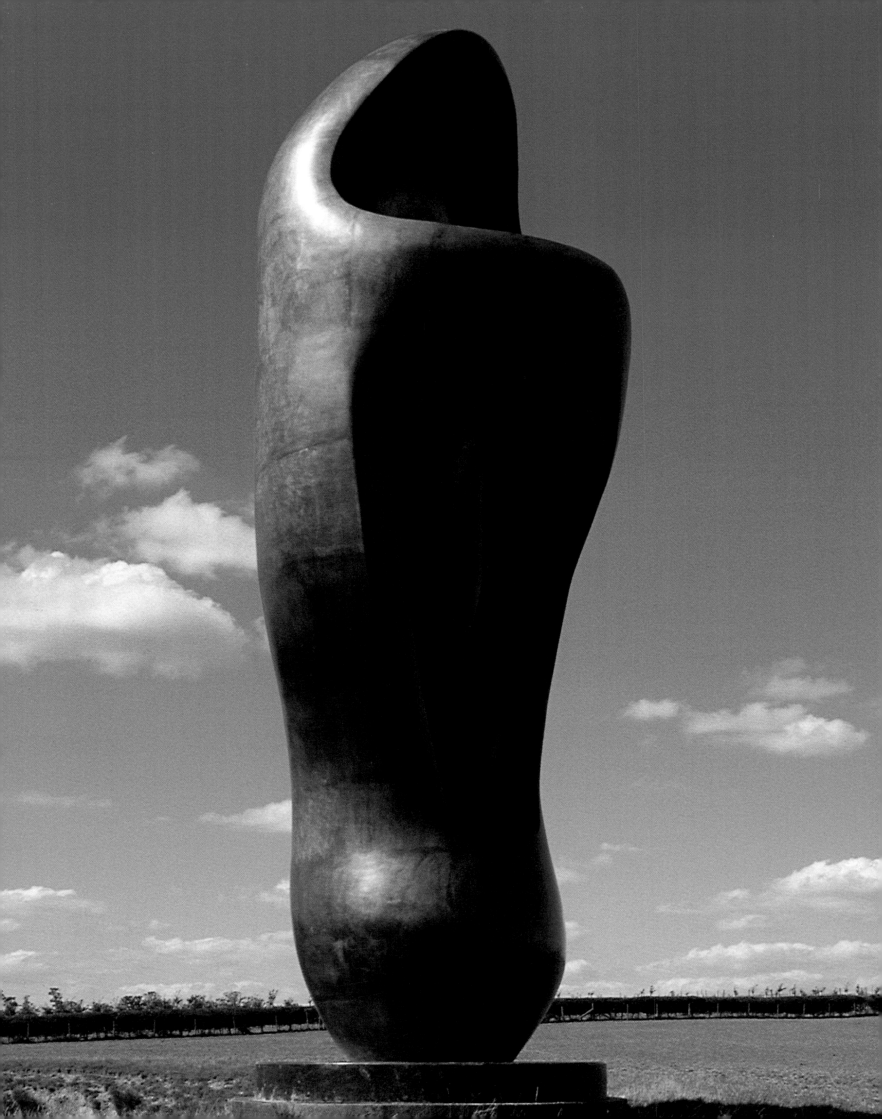

Upright Internal/External
Form: Flower, 1951,
Bronze
(76cm high, LH 293b)

Left: Large Upright
Internal/External Form,
1981-82, Bronze
(673cm high, LH 279a)

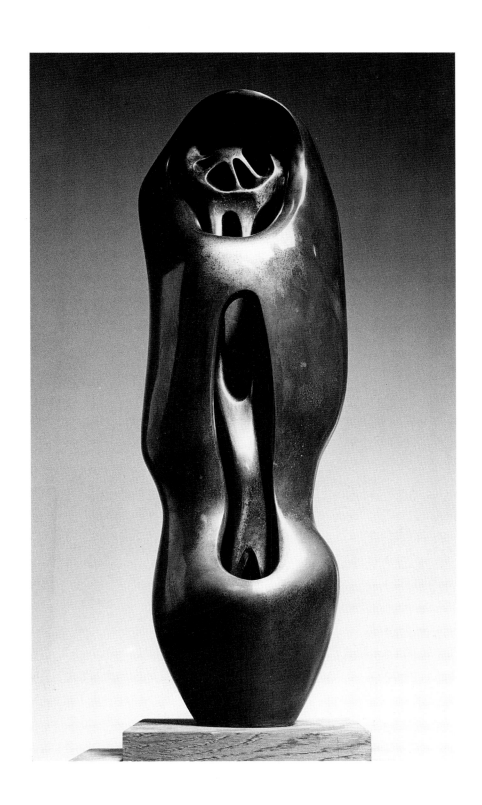

Draped Torso,
1953, Bronze
(89 cm high, LH 338)

Right: Warrior with
Shield, 1953 - 54, Bronze
(152 cm high, LH 360)
'The idea... evolved from
a pebble I found on the
sea-shore. It reminded
me of a stump of a leg
amputated at the hip. Just
as Leonardo says in his
notebooks that the
painter can find a battle
scene in lichen on the
wall, so this gave me the
idea for my warrior, a
figure which, though
wounded, is still defiant.'

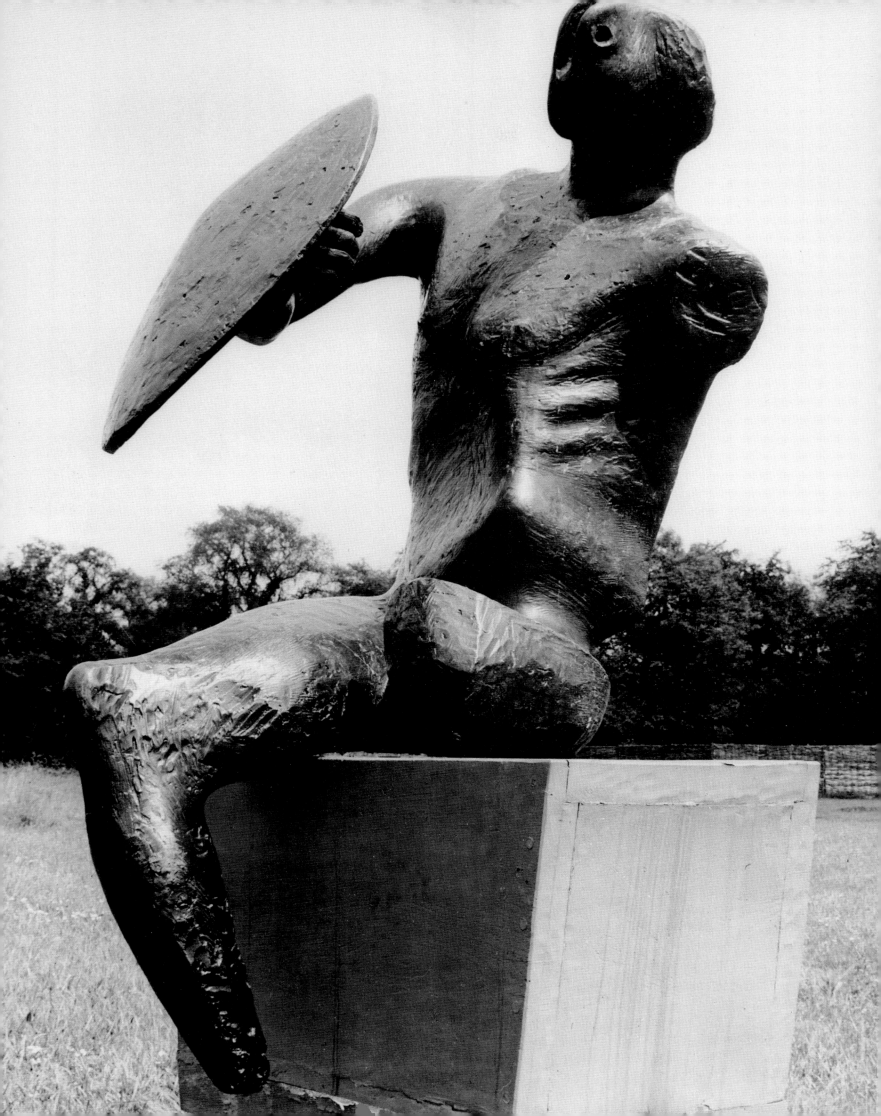

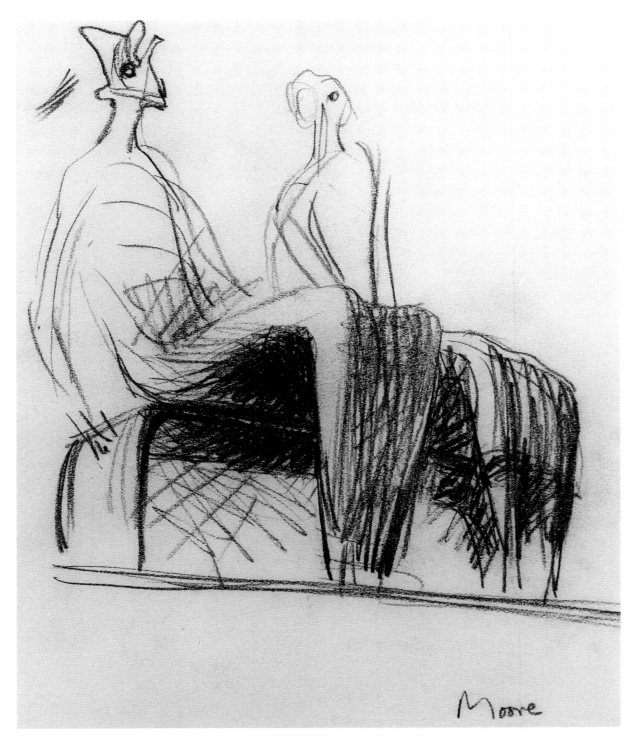

King and Queen, 1952
Chalk, (286 mm high)

Right: King and Queen,
1952 - 53, Bronze
(164 cm high, LH 350)
'The head of the King is
the clue to the whole
sculpture... Anything can
start me off on a
sculpture idea, and in this
case it was playing with a
small piece of modelling
wax... it began to look
like a horned, Pan-like,
bearded head. Then it
grew a crown and I
recognised it immediately
as the head of a king. I
continued, and gave it a
body. When wax hardens,
it is almost as strong as
metal. I used this special
strength to repeat in the
body the aristocratic
refinement I found in
the head. Then I added
a second figure to it
and it became a 'King
and Queen'.'

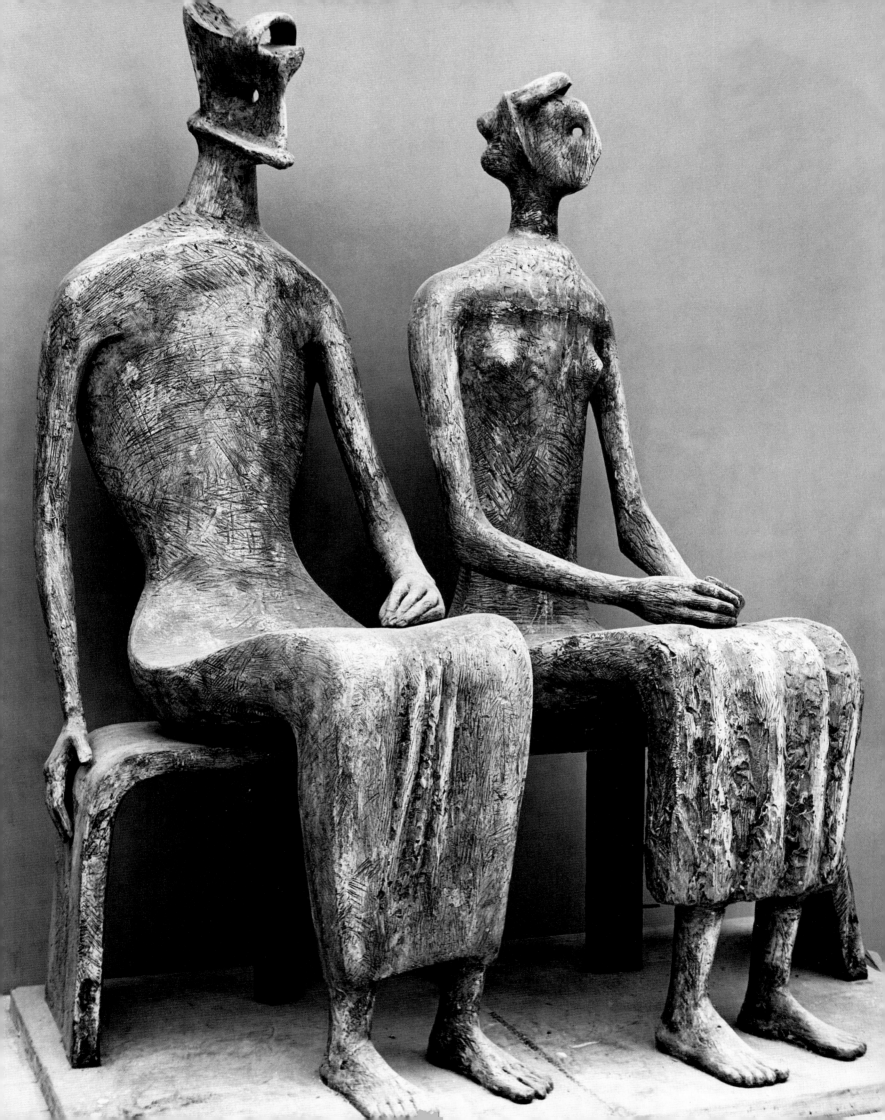

Idea for Crucifixion
Sculpture, 1954
Pencil and wash,
(292 mm high)

Right: Upright Motive
No. I: Glenkiln Cross,
1955 - 56, Bronze
(335 cm high, LH 377)
'... the Glenkiln Cross is a
crucifix, although I didn't
deliberately set out to
make it that. It was an
upright motif idea which
developed into a worn-
down rudimentary
cross... the Crucifixion is
such a universal theme
that I may attempt it
one day.'

Overleaf: Falling Warrior,
1956 - 57, Bronze
(147 cm long, LH405)
'I wanted a figure that
was still alive. The pose in
the first maquette was
that of a completely dead
figure and so I altered it
to make the action that
of a figure in the act of
falling, and the shield
became a support for the
warrior, emphasising the
dramatic movement that
precedes death.'

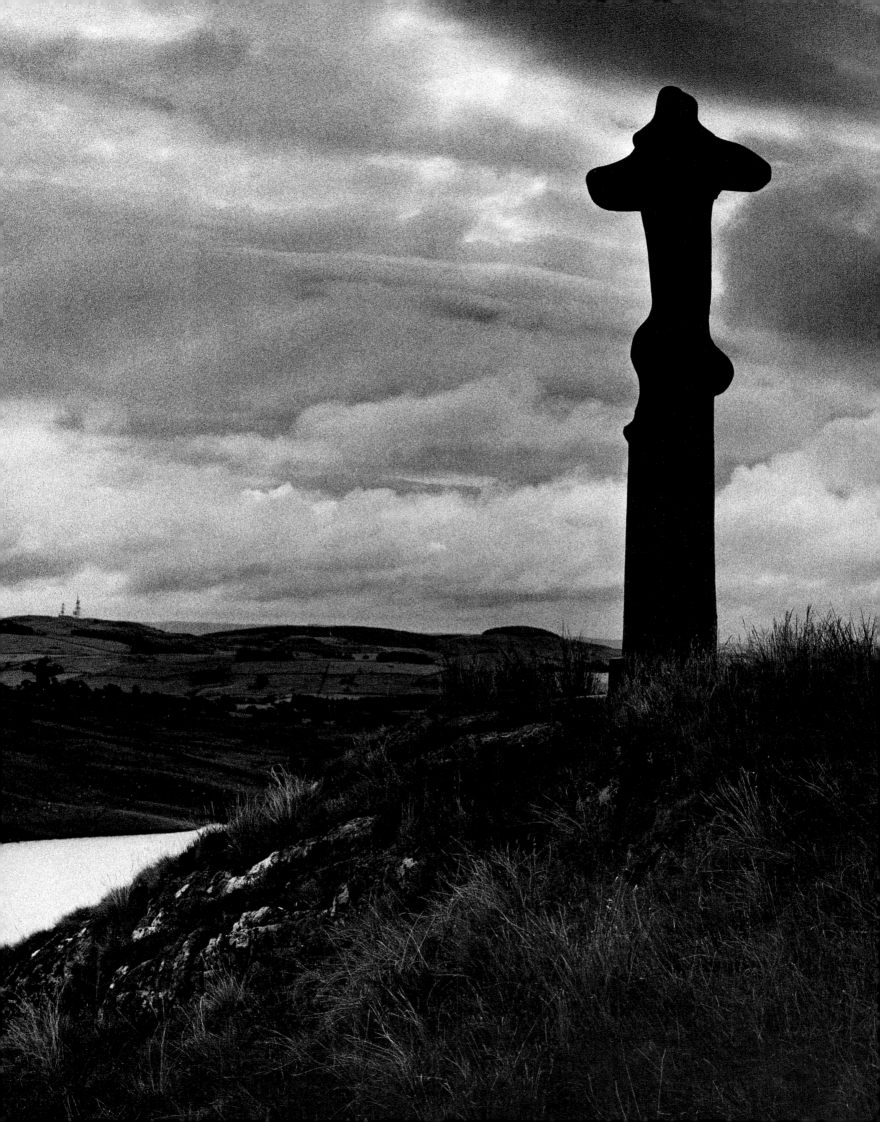

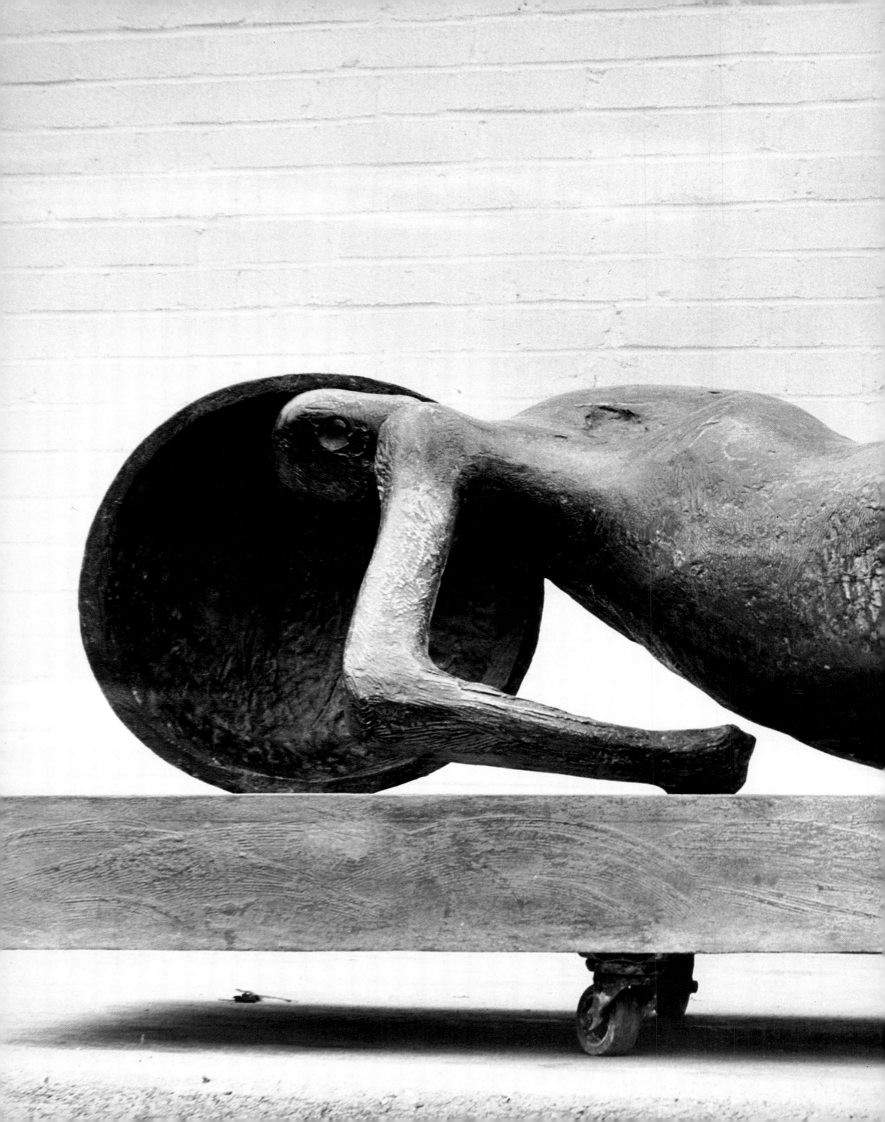

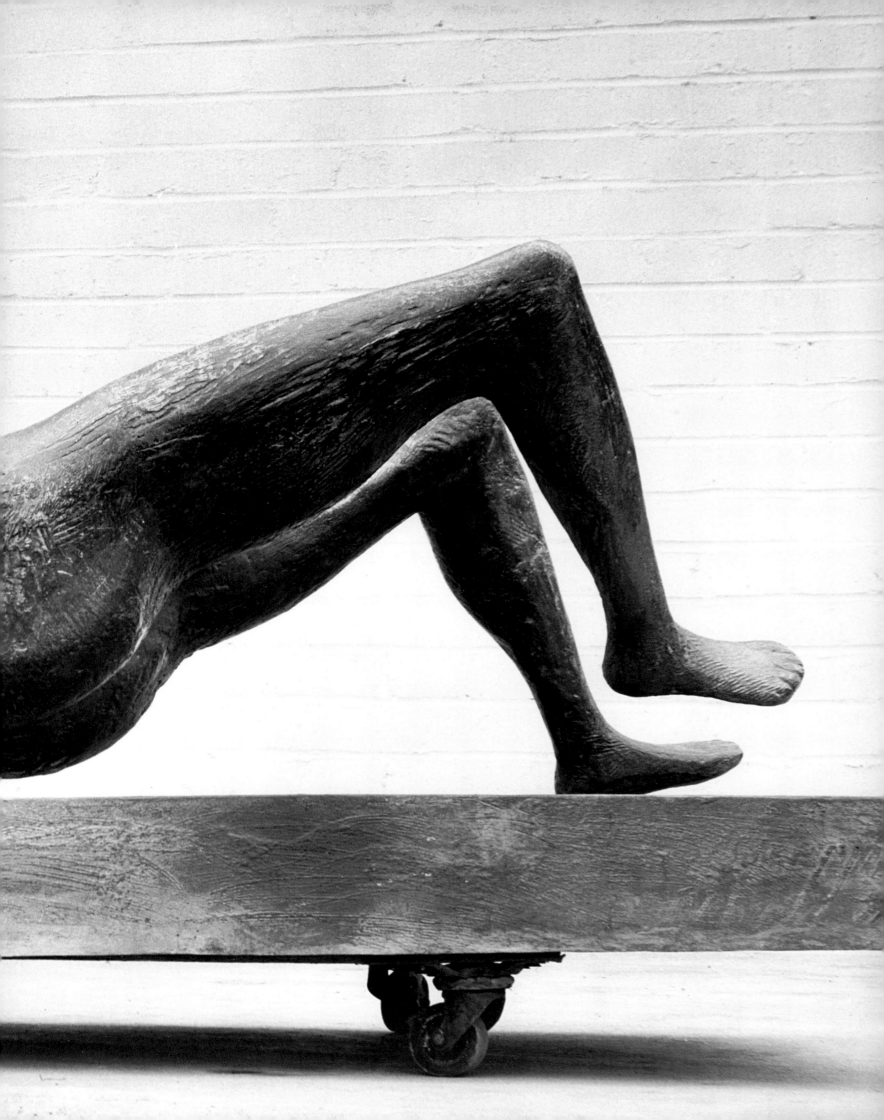

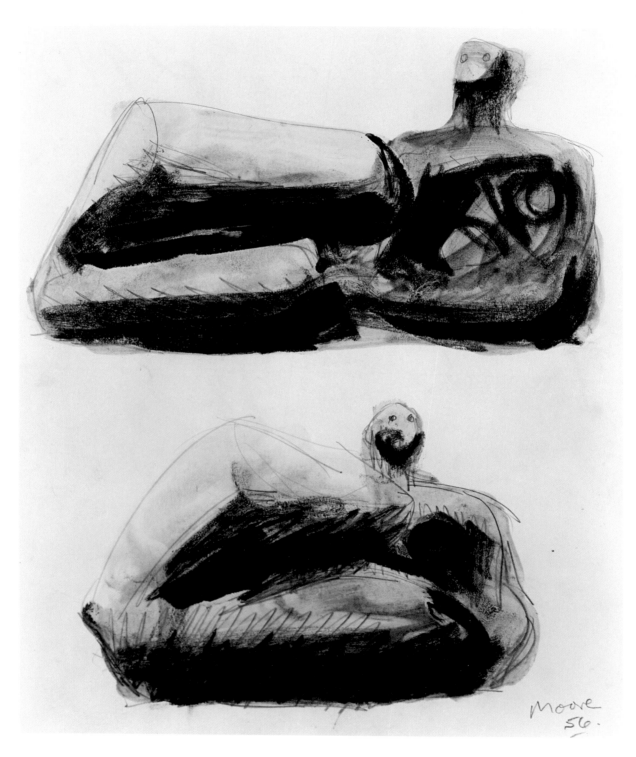

Right and Overleaf:
Cast of working Model
for UNESCO Reclining
Figure, 1957, Bronze
(239 cm long, LH 415)

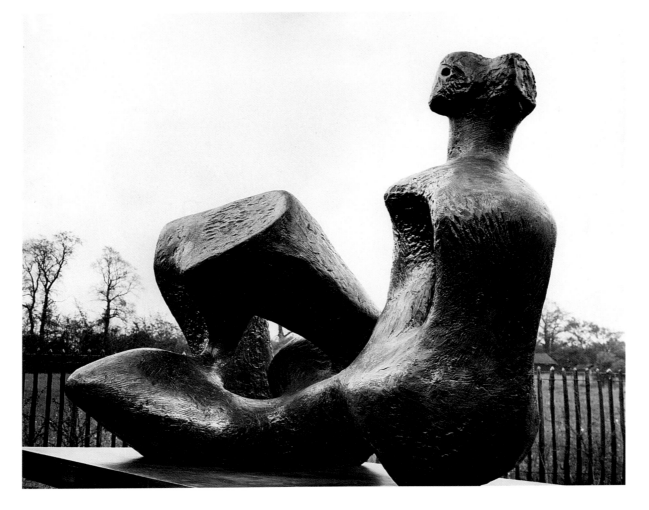

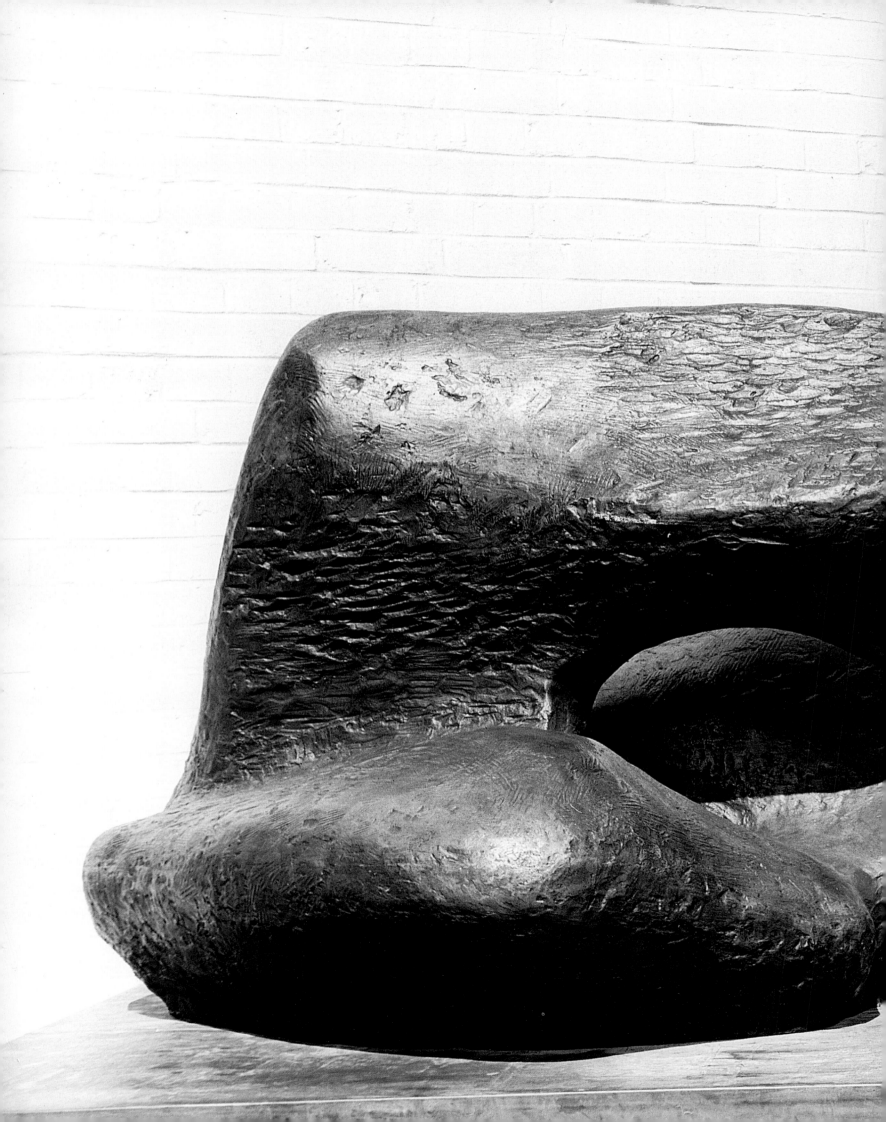

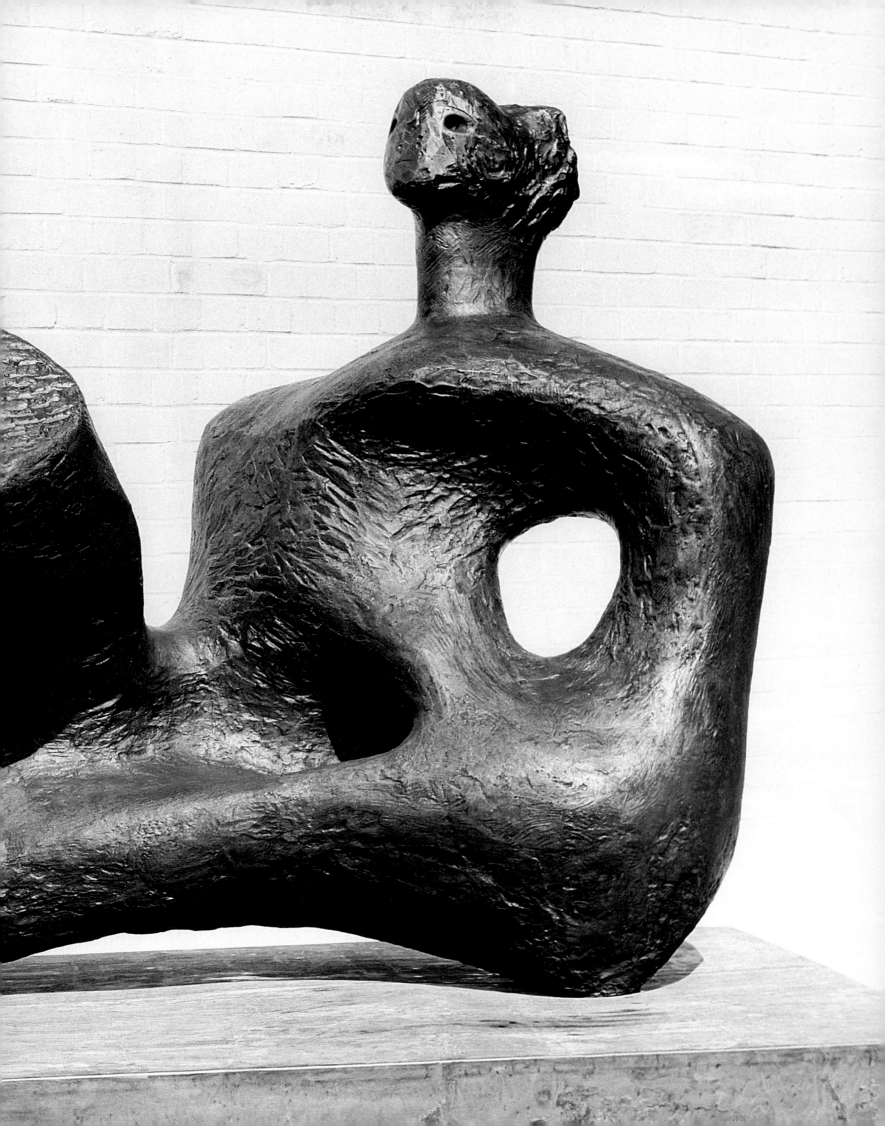

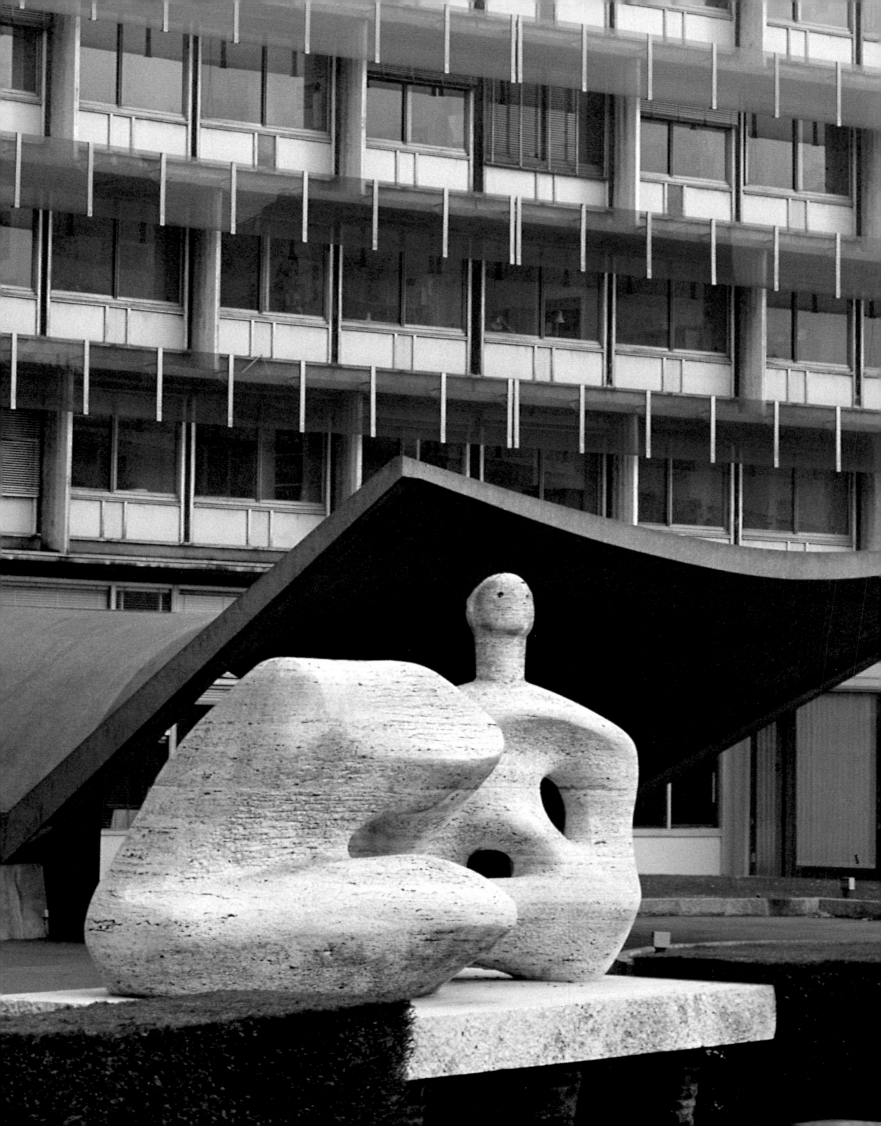

UNESCO Reclining
Figure, 1957 - 58,
Roman Travertine Marble
(508 cm long, LH 416)
'Roman travertine marble
is a stone that I have
loved ever since I first
used it in 1932. I like its
colour and its rough,
broken, pitted surface.'
'It's a beautiful stone, I'd
always wanted to do a
large piece in it. At the
unveiling it looked too
white - all newly carved
stone has a white dust on
it - but on my last trip to
Paris I went to Unesco,
and saw that it's
weathering nicely. In ten
or twenty years' time
with the washing of the
Paris rain, it will be fine.'

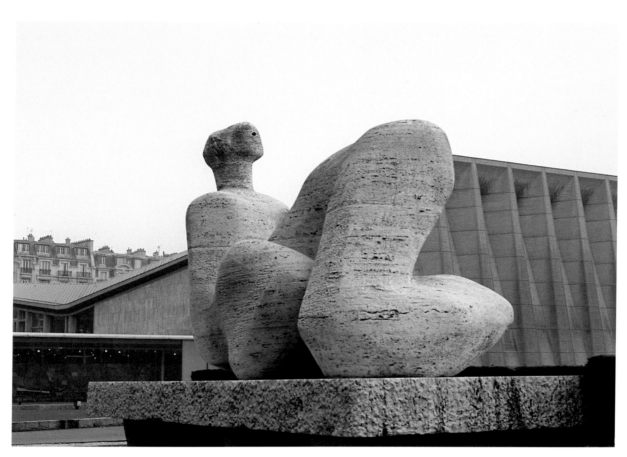

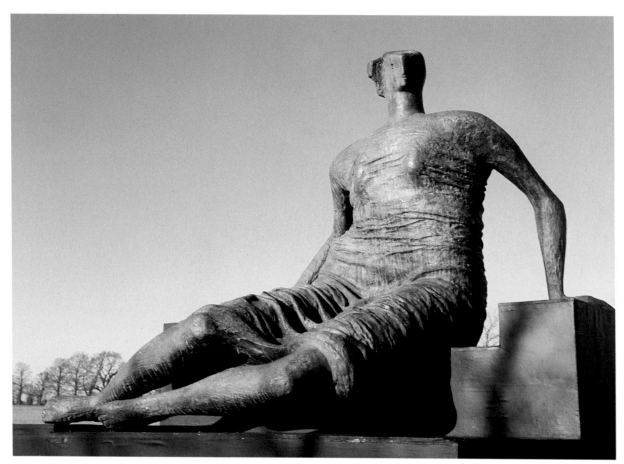

Draped Seated Woman,
1957 - 58, Bronze
(158cm high, LH 428)
'I knew that this big,
draped, seated figure was
going to be shown out of
doors and this created
the problem that the
folds in the drapery
could collect dirt and
leaves and pockets of
water. I solved it by
making a drainage tunnel
through the drapery
folds between the legs.
I found that using
drapery in sculpture was
a most enjoyable exercise
in itself.'

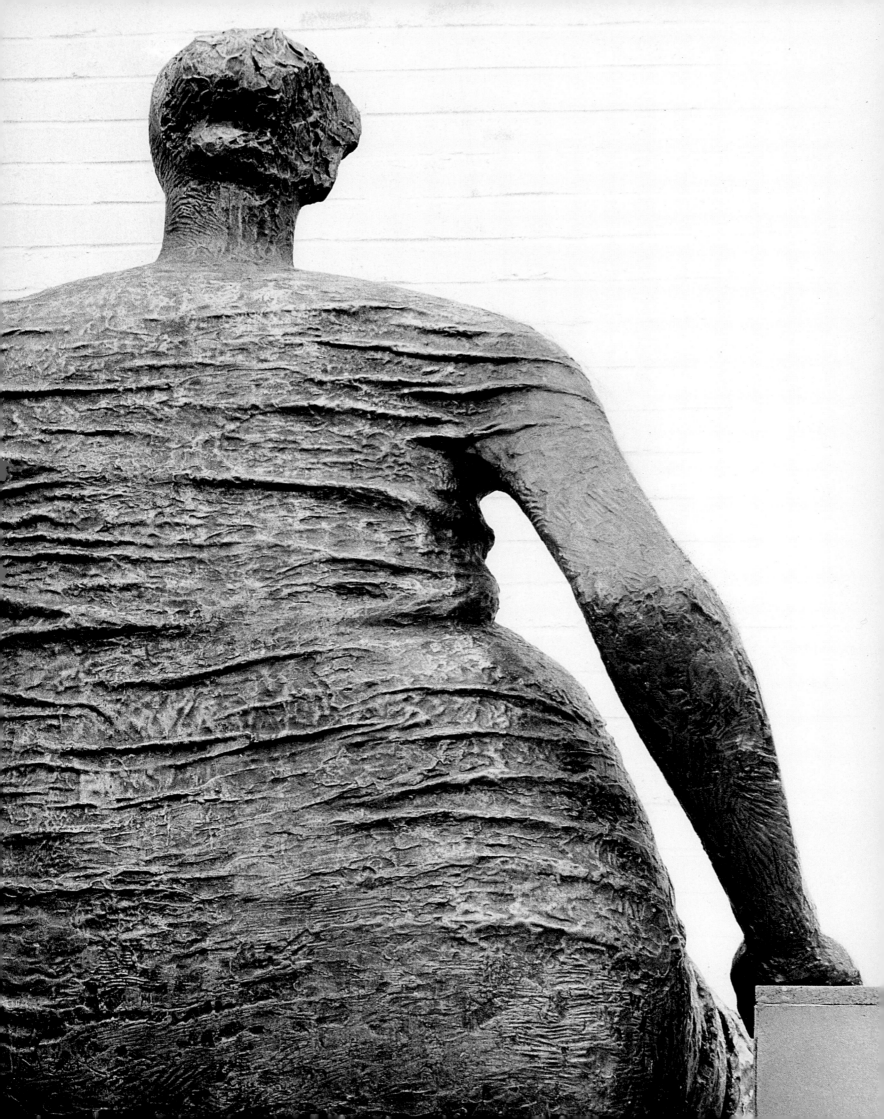

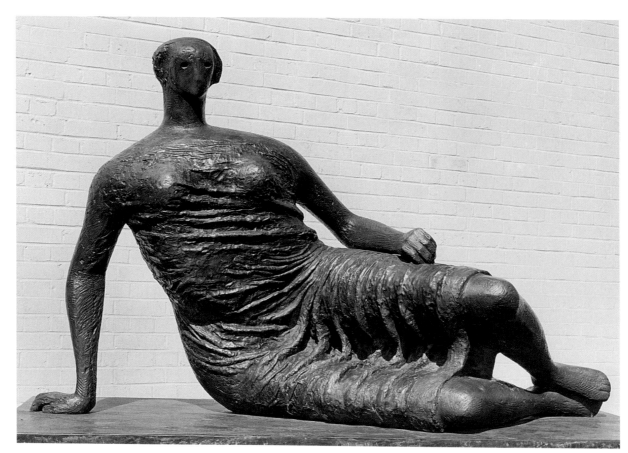

Draped Reclining
Woman, 1957 - 58,
Bronze
(208 cm long, LH 431)

Right: Seated Woman,
1957, Bronze
(145 cm high, LH 435)
'Seated Woman is
pregnant. The fullness of
her pelvis and stomach is
all to her right. I don't
remember consciously
doing it this way, but I
remember Irina [Moore]
telling me... sometimes
she could feel that the
baby was on one side
and sometimes on
the other.'

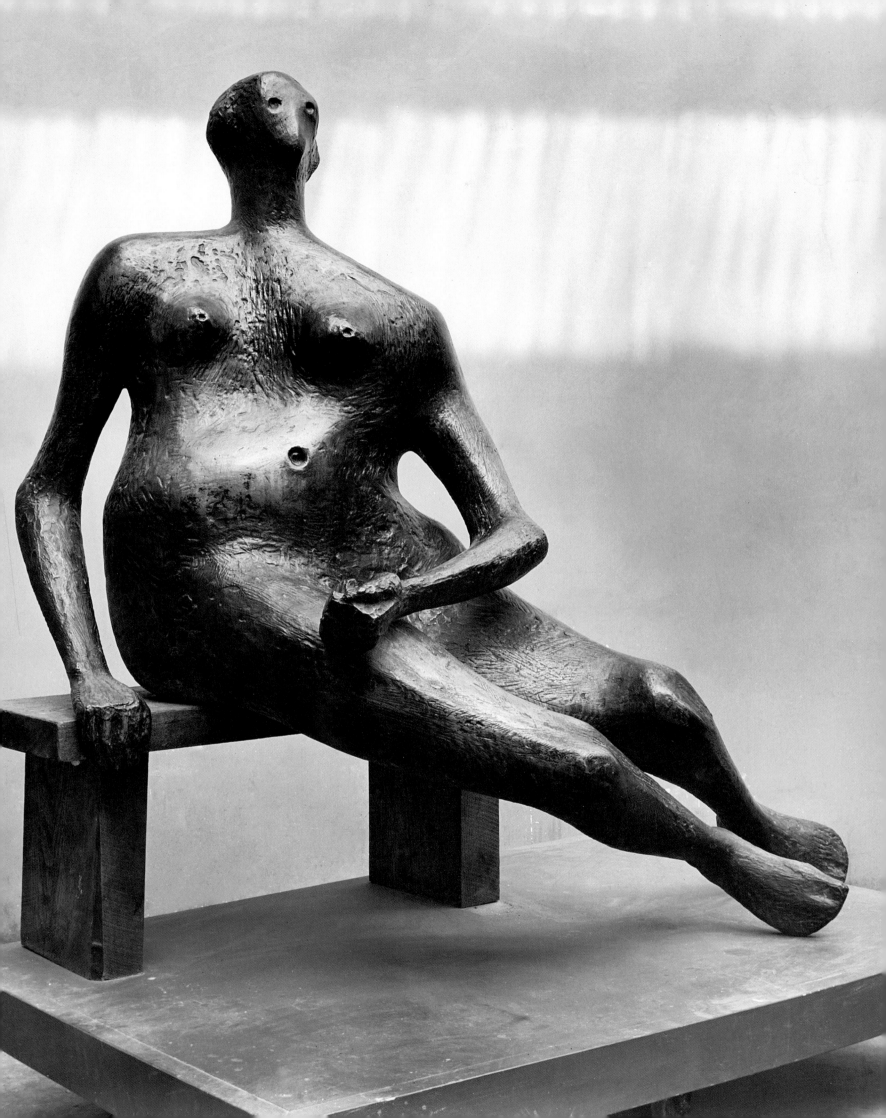

Drawing for Two Piece
Reclining Figure No 1,
c. 1960 Pencil,
(229 mm wide)

Right and overleaf:
Two Piece Reclining
Figure No. 1, 1959,
Bronze,
(130 cm long, LH 457)
'...a mixture of rock form
and mountains combined
with the human figure...
dividing the figure
into two parts made
many more three-
dimensional variations
than if it had just been
a monolithic piece.'

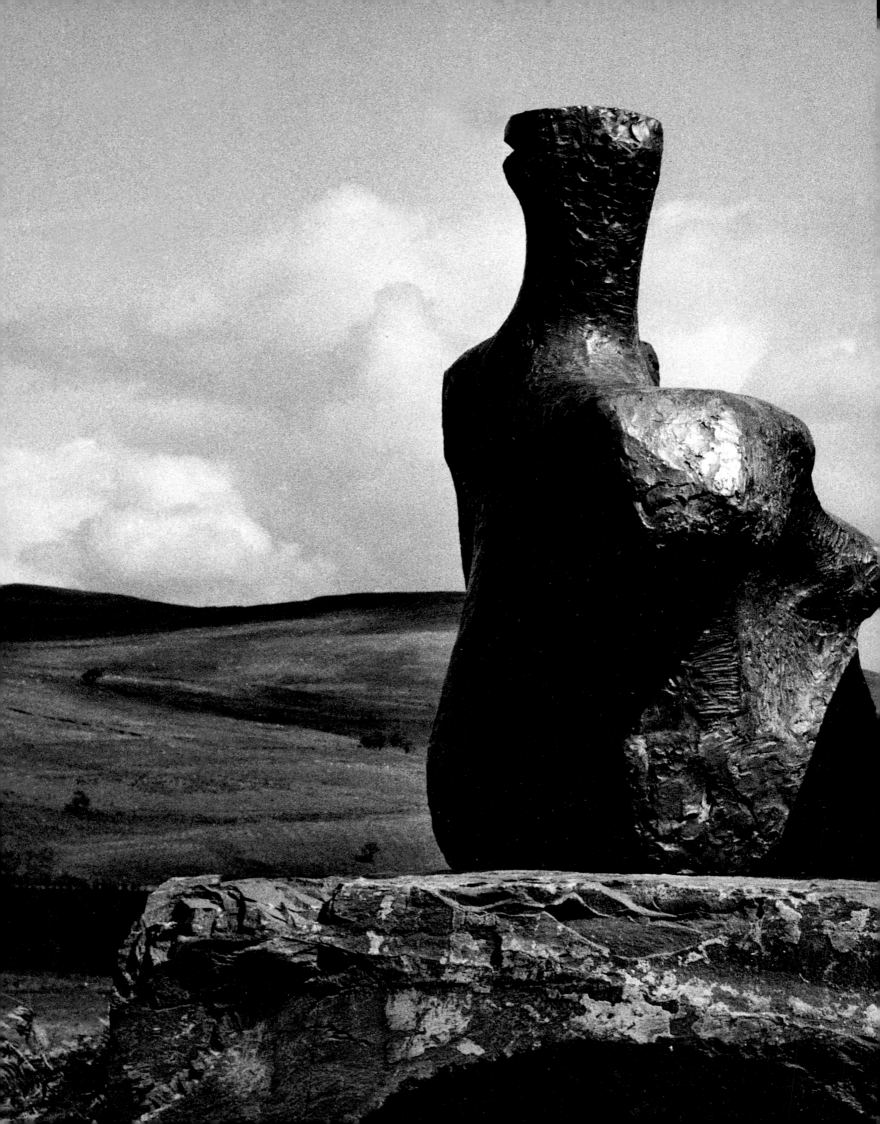

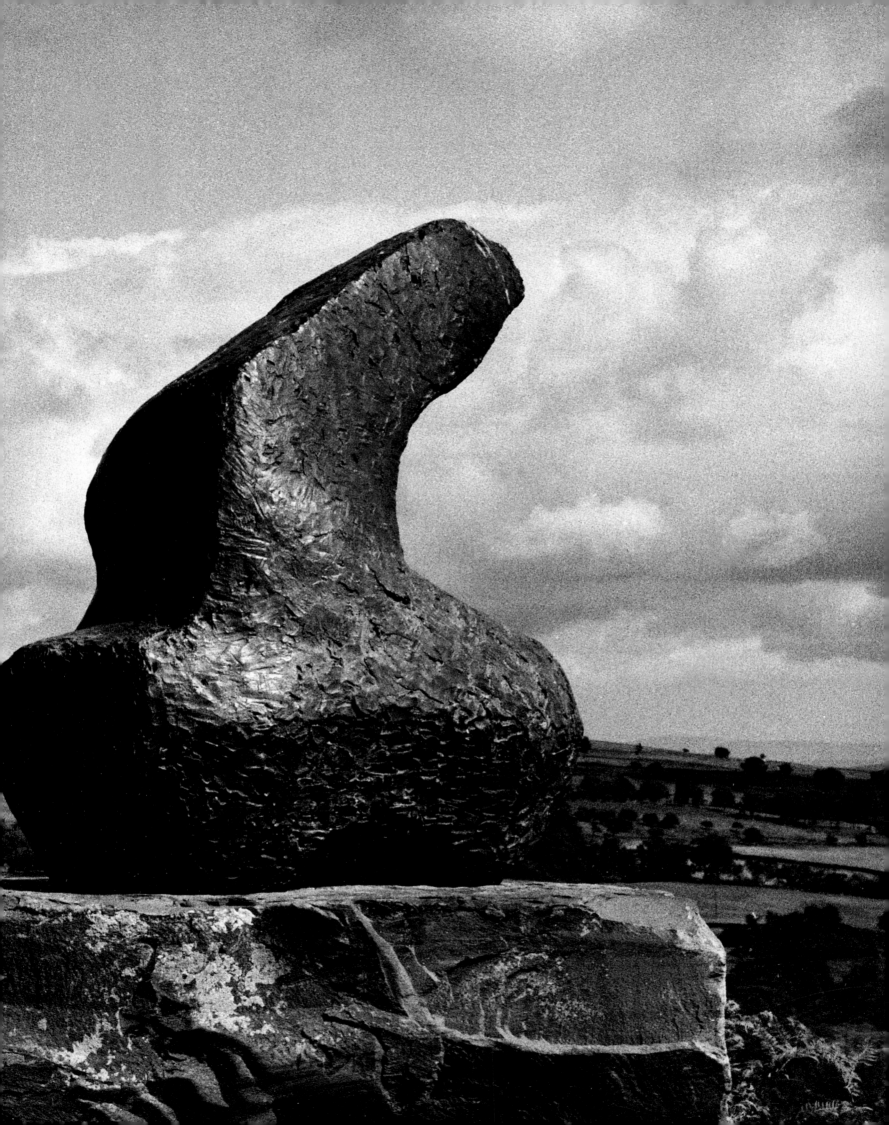

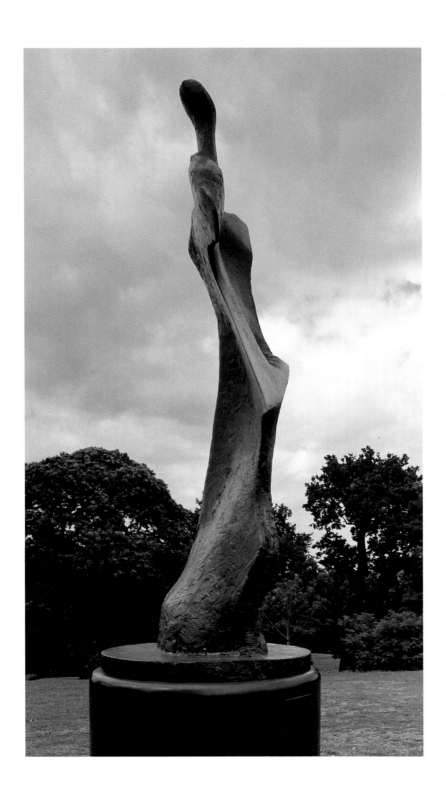

Large Standing Figure:
Knife Edge, 1961, Bronze
(358 cm high, LH 482a)
'From some views, the
thinness of the neck and
head in the torso figure
gives to the body an
expansiveness I wanted
whilst, from other views
the neck has a more
normal width. [It is] based
on the principle wherein
the thinness of one view
contrasts surprisingly with
the width of another. It
was my liking for bones
that led me to using the
sharp edge, and in fact I
included a fragment of a
real bone in producing
the maquette.'

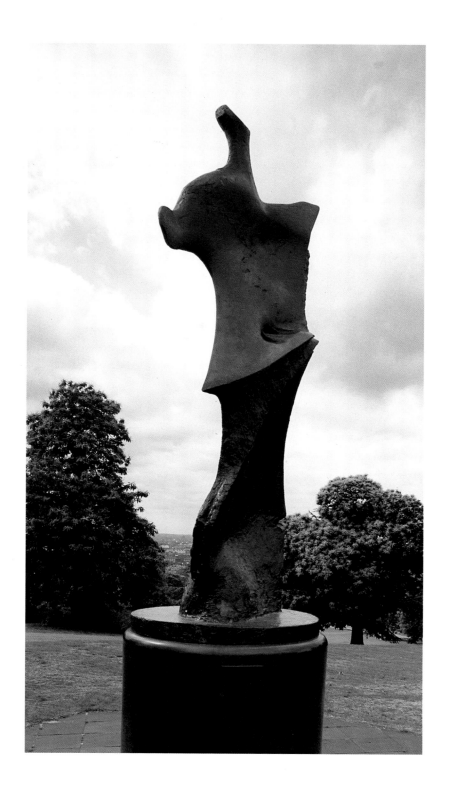

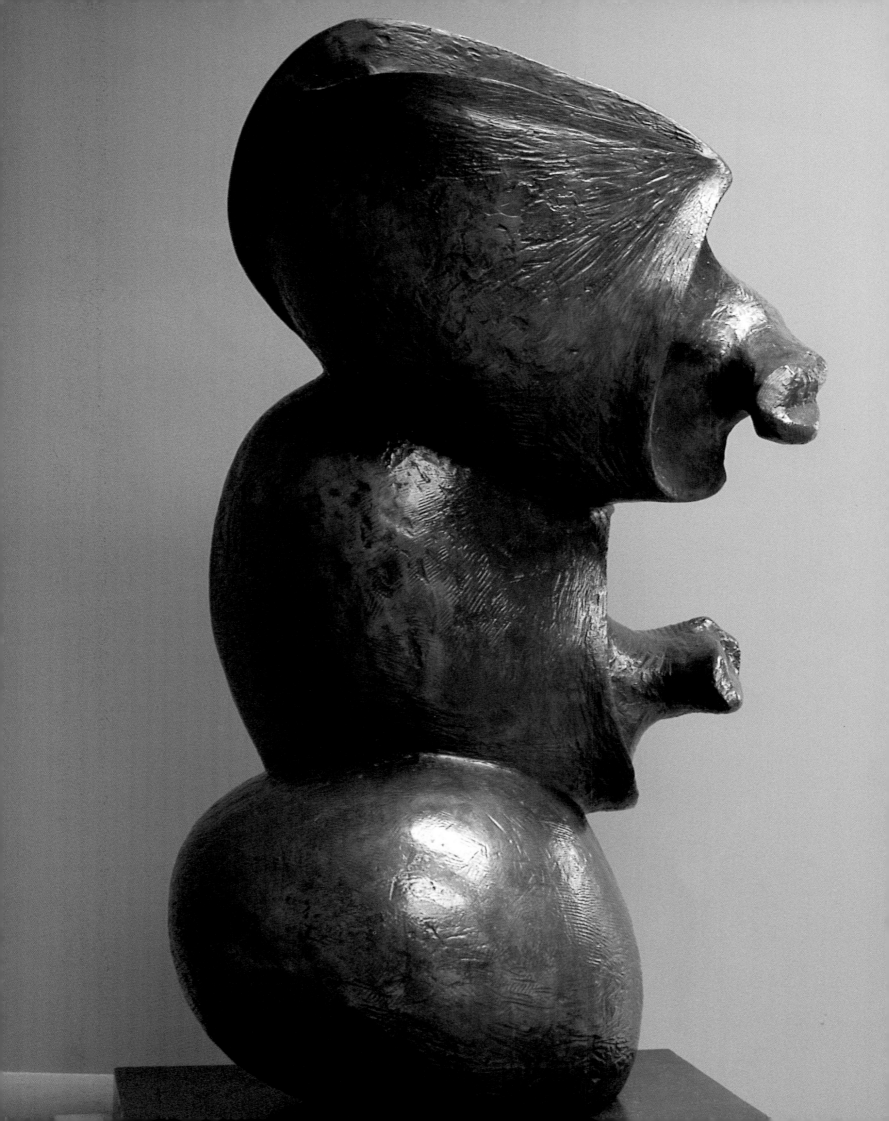

Three Part Object,
1960, Bronze
(123 cm high, LH 470)
'...a strange work, even
for me. Three similar
forms are balanced at
right angles to each
other. In my mind it has a
connection with insect
life, possibly centipedes.
Each segment has a leg,
and there is an element
in the sculpture closer to
an animal organism than
a human one.'

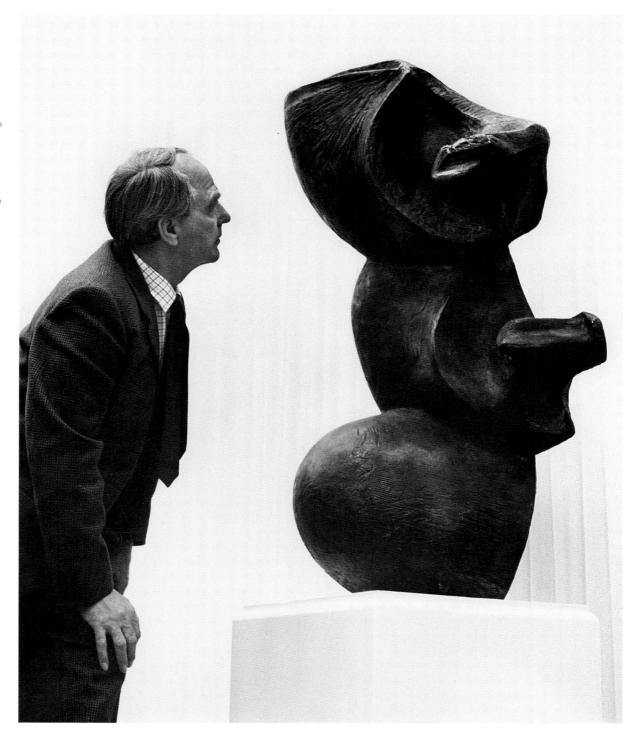

Study for Reclining
Figure, 1928
Pencil, (181 mm wide)

Right: Woman,
1957 - 58, Bronze
(152 cm high, LH 439)
'Nearly all my drawings
and virtually all my
sculptures are based on
the female form.
'Woman' has that
startling fullness of the
stomach and the breasts.
The smallness of the
head is necessary to
emphasise the
massiveness of the body...
the face and particularly
the neck are more like a
hard column than a soft
goitred female neck.'

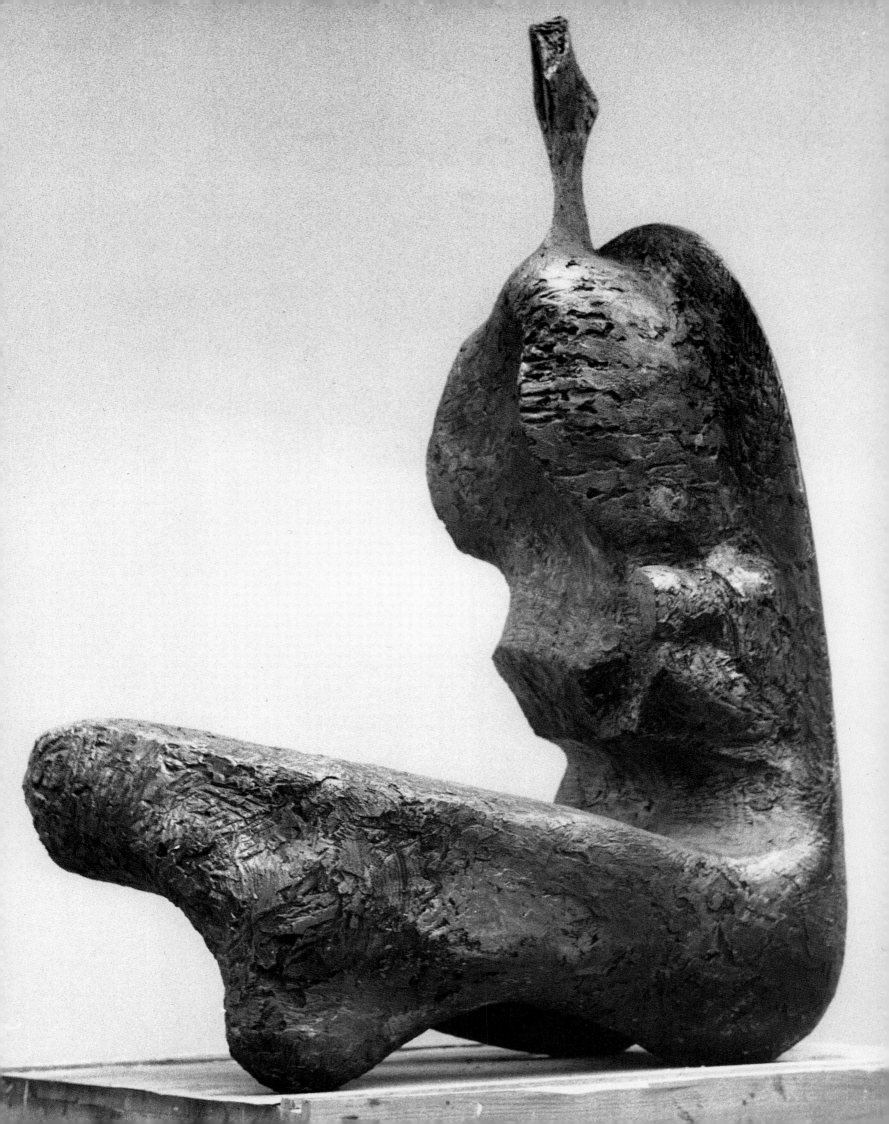

152

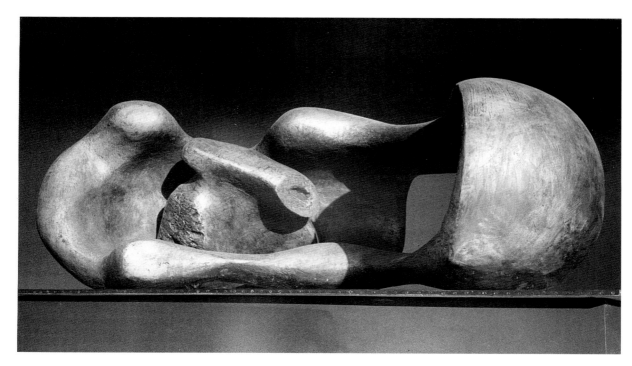

Reclining Mother and Child, 1960 - 61, Bronze (220 cm long, LH 480) 'I have a particular liking for this 'Reclining Mother and Child'. This work combines several of my different obsessions in sculpture. There's the reclining figure idea; the mother and child idea; and the interior-exterior idea. So it is the amalgamation of many ideas in one sculpture.'

Studies for Sculpture:
Ideas for Internal/
External Forms, 1949,
Pencil, crayon, chalk, pen
and ink, gouache and
watercolour,
(548 mm high)

Overleaf: Knife Edge Two
Piece, 1962 - 65, Bronze
(366 cm long, LH 516)
'When I was offered the
site near the House of
Lords... I liked the place
so much that I didn't
bother to go and see an
alternative site in Hyde
Park... one lonely
sculpture can be lost in a
large park. The House of
Lords site is quite
different. It is next to a
path where people walk
and it has a few seats
where they can sit and
contemplate it...'

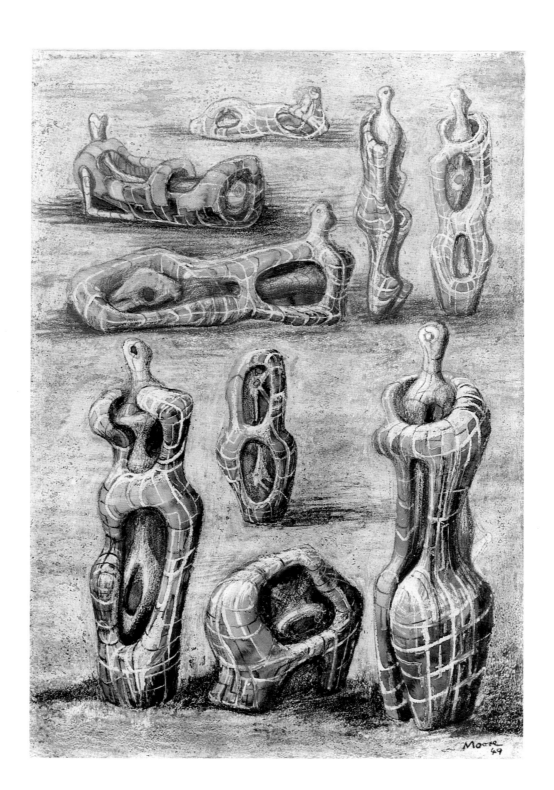

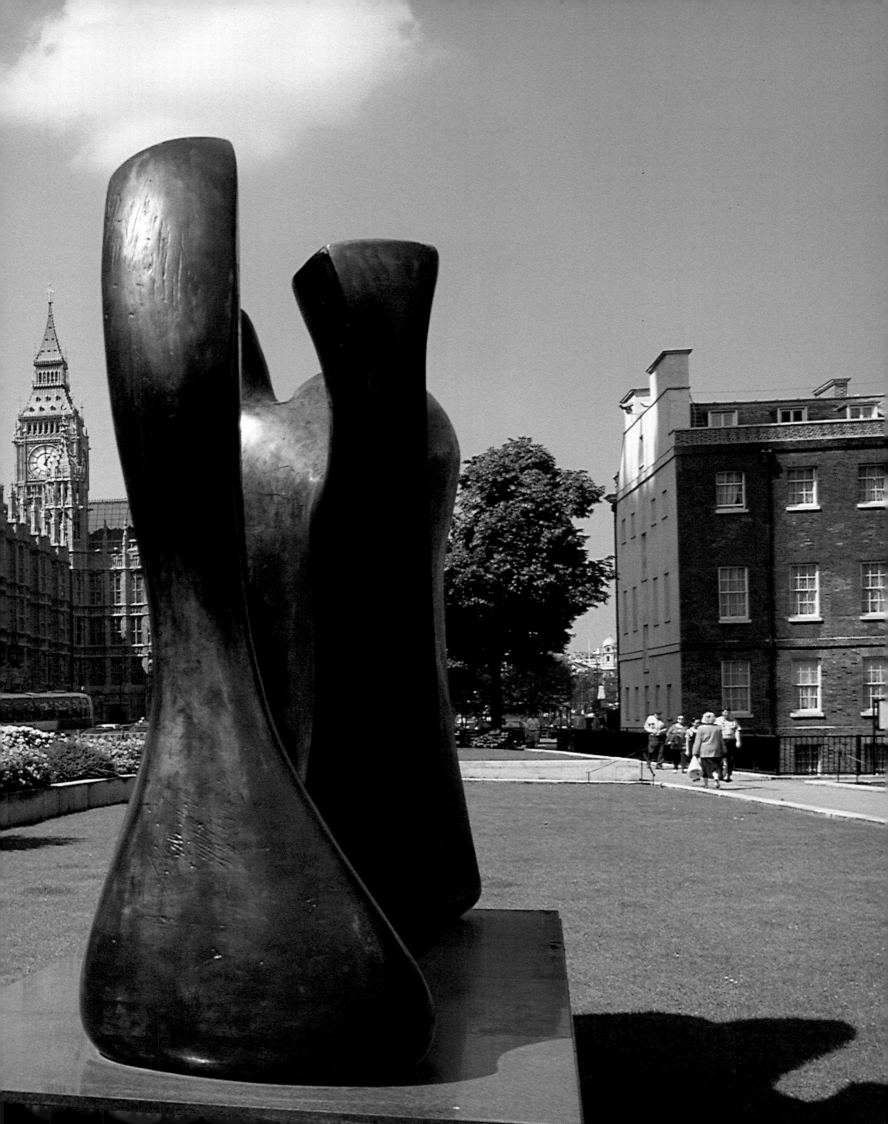

156

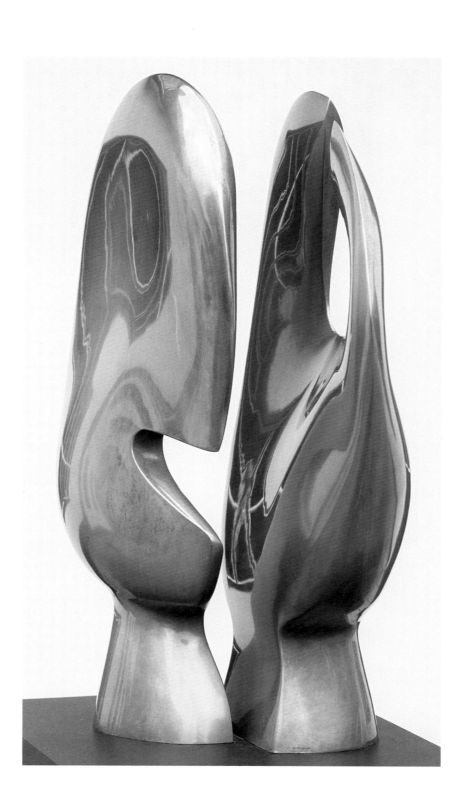

Maquette for Head
and Hand, 1962, Bronze
(18 cm high, LH 505)

Right: Moon Head,
1964, Bronze
(30 cm high, LH 521)
'The small version of this
piece was originally called
'Head in Hand', the hand
being the piece at the
back. When I came to
make it in full size... I gave
it a pale gold patina so
that each piece reflected
a strange, almost ghostly,
light at the other. This
happened quite by
accident. It was because
the whole effect
reminded me so strongly
of the light and shape
of the full moon that I
have since called it
'Moon Head'.'

Overleaf: Reclining
Figure, 1963 - 65, Bronze,
(855 cm long, LH 519)
'I knew of course that
the sculpture was to
stand in a large pool, and
I was told its depth
would be one foot two
inches. Therefore in
making the sculpture I
allowed for its base to be
covered to that depth. In
fact the water can never
be that deep without it
overflowing... So far it has
never been seen the way
I planned it.'

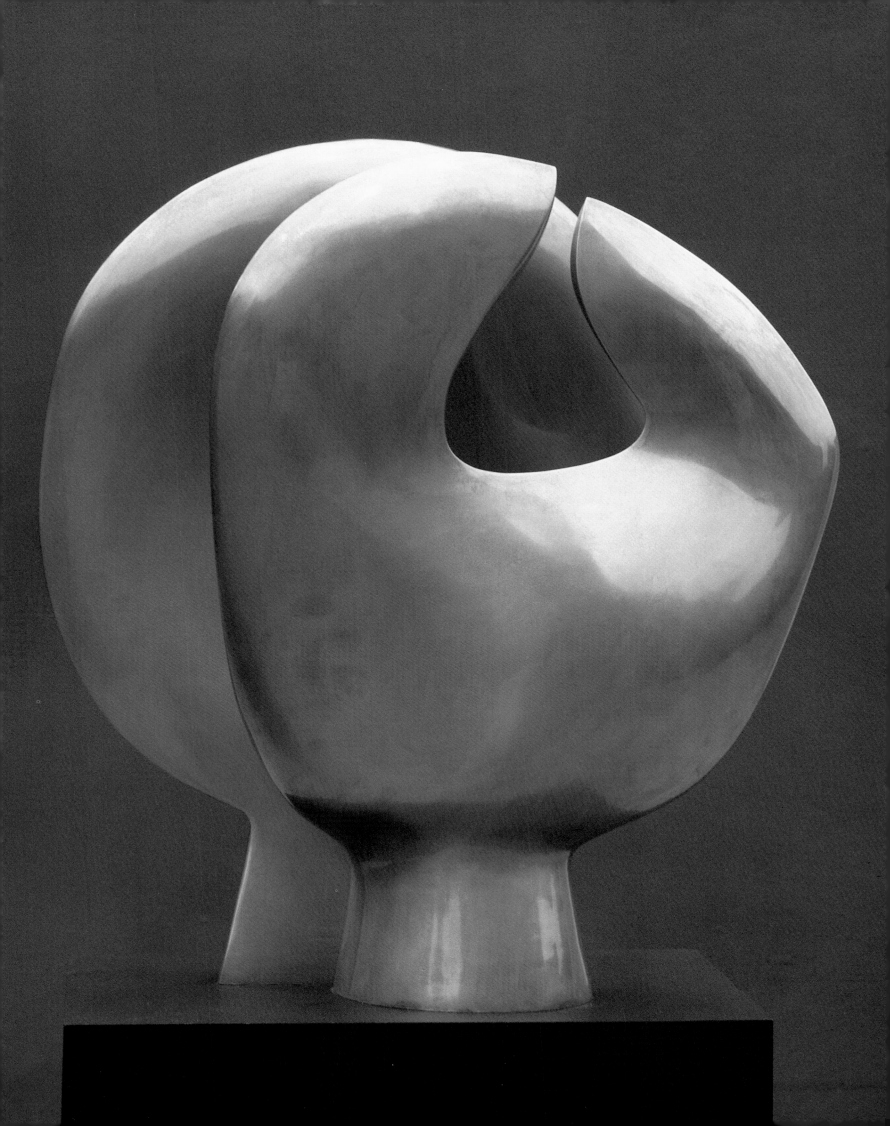

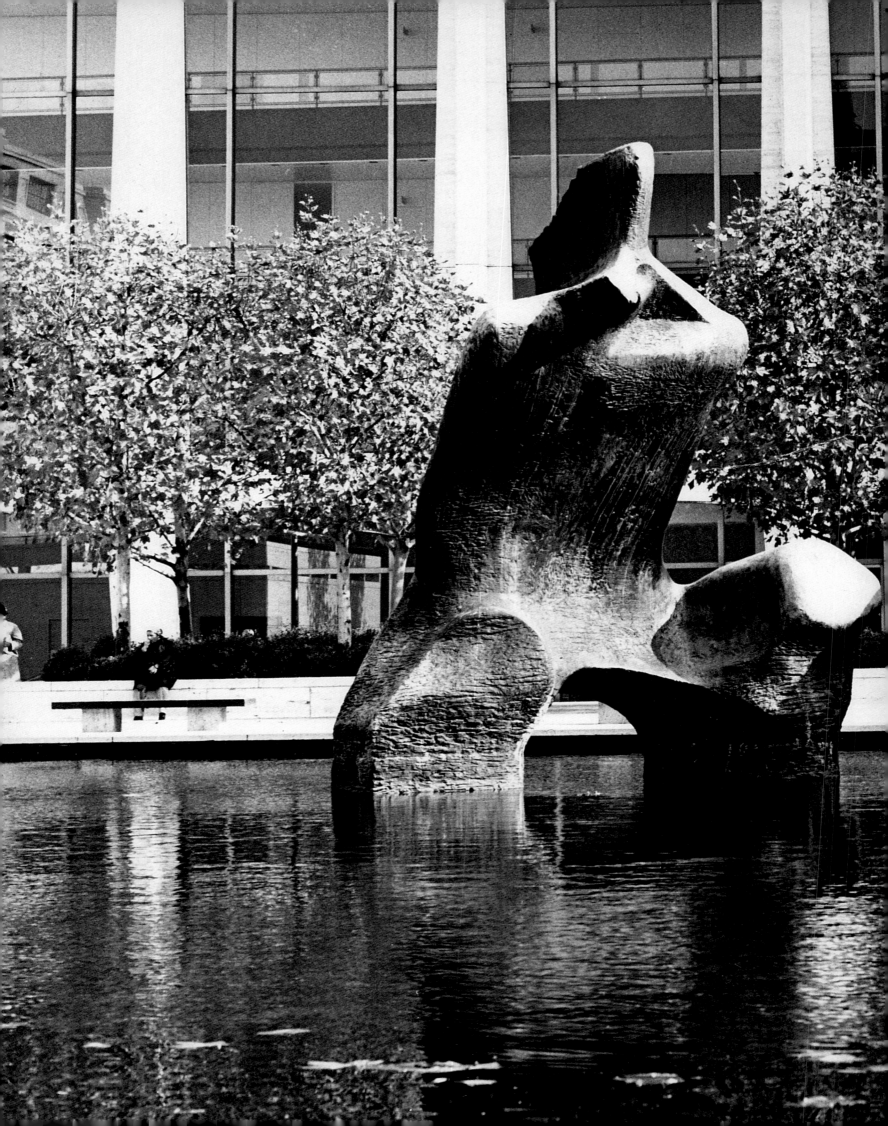

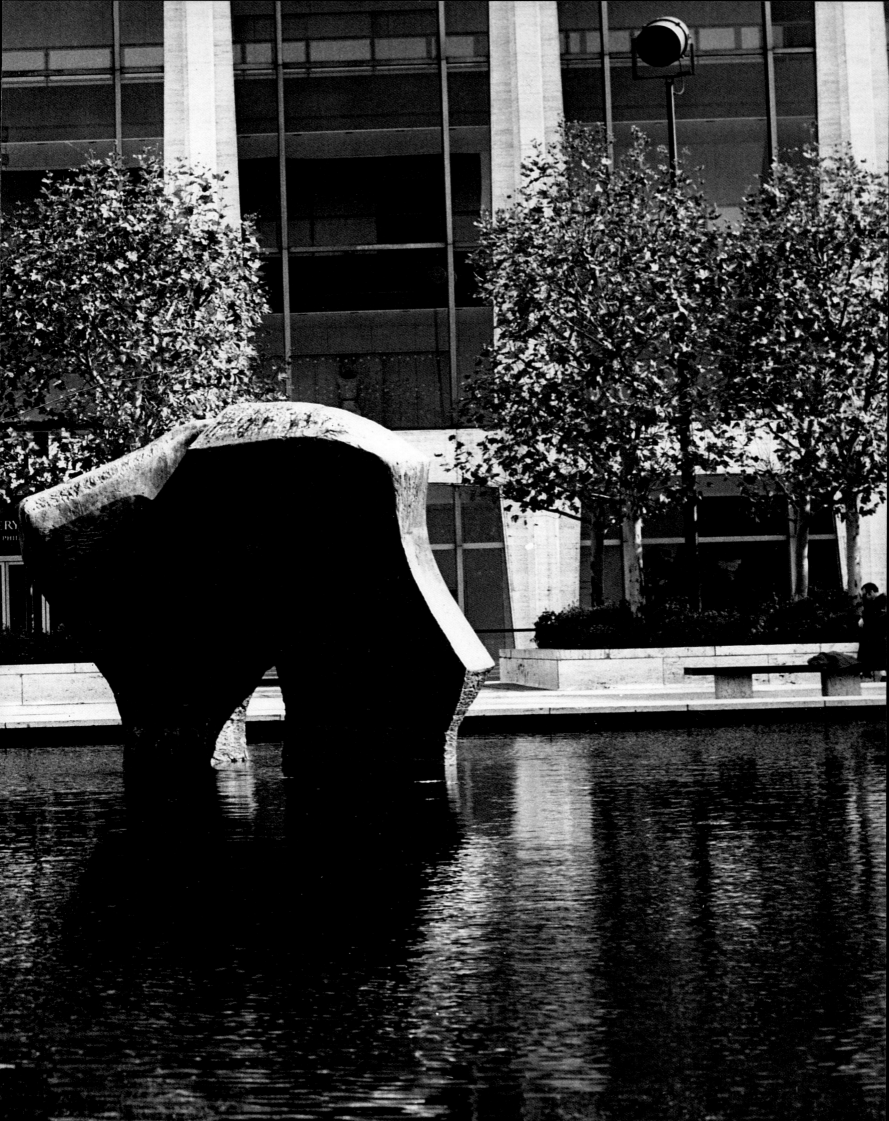

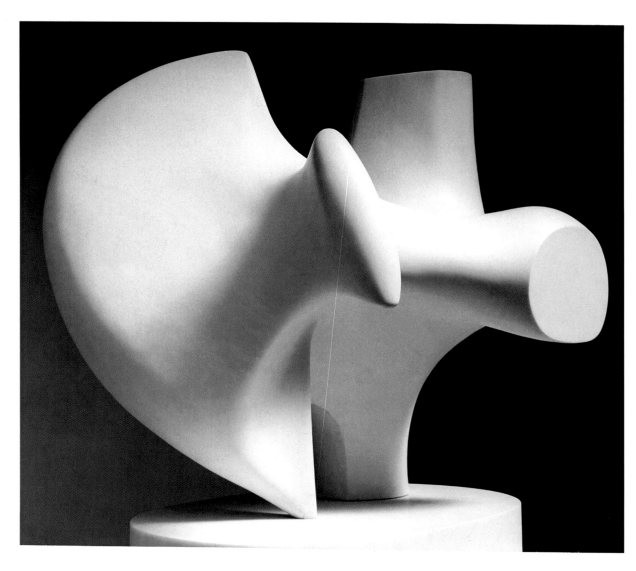

Archer, 1965,
White Marble
(80 cm high, LH 536)

Right: Large Torso: Arch,
1962 - 63, Bronze
(199 cm high, LH 503)

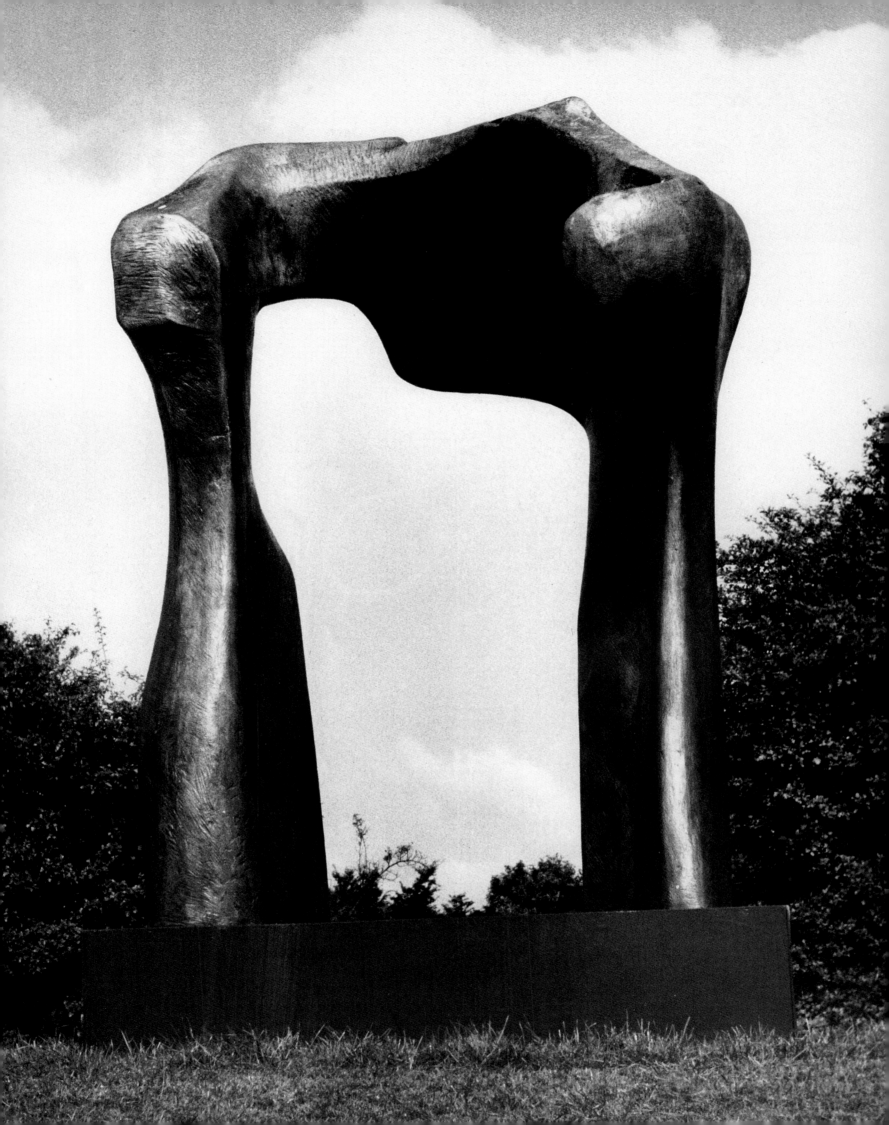

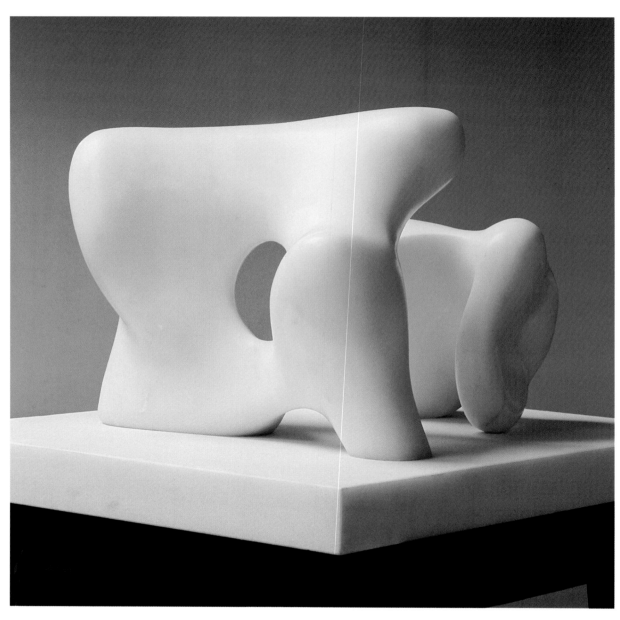

Two Forms, 1964,
White Marble
(46 cm long, LH 529)
'White Marble is a most
pure and elegant
material. In carving a
sculpture, it is very
important to match the
right material with the
particular subject in
mind. In using white
marble, I give the forms a
precision and refinement
and a surface finish that I
wouldn't try to obtain
with a rough textured
stone such as travertine.'

Large Two Forms in a
Landscape, c 1973 - 74,
Pencil, charcoal,
watercolour and pastel
wash on blotting paper,
(284 mm wide)

Overleaf: Large Two
Forms, 1966, Bronze
(610 cm long, LH 556)

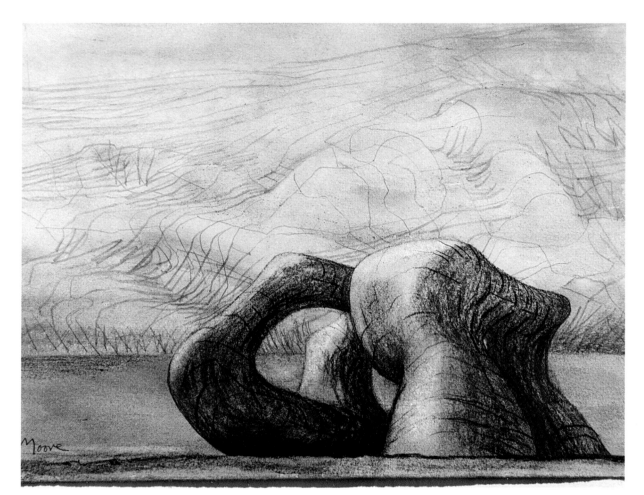

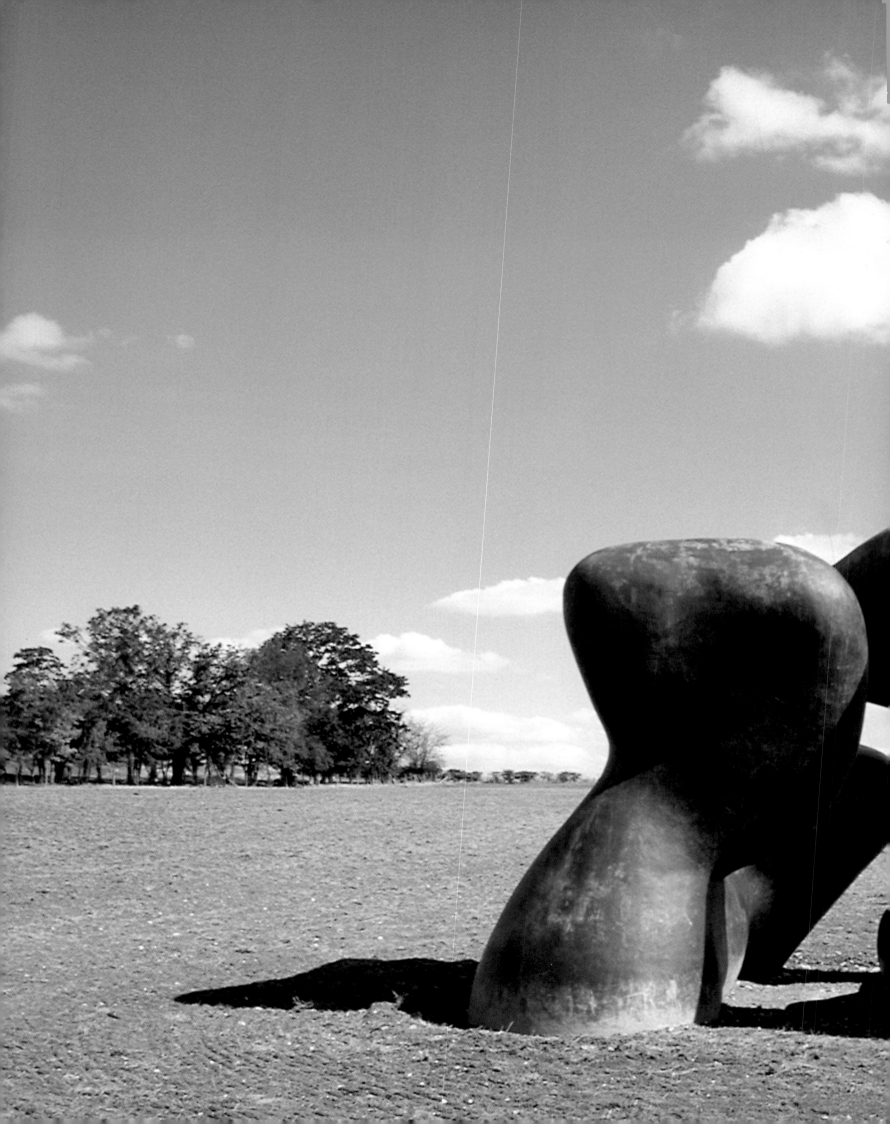

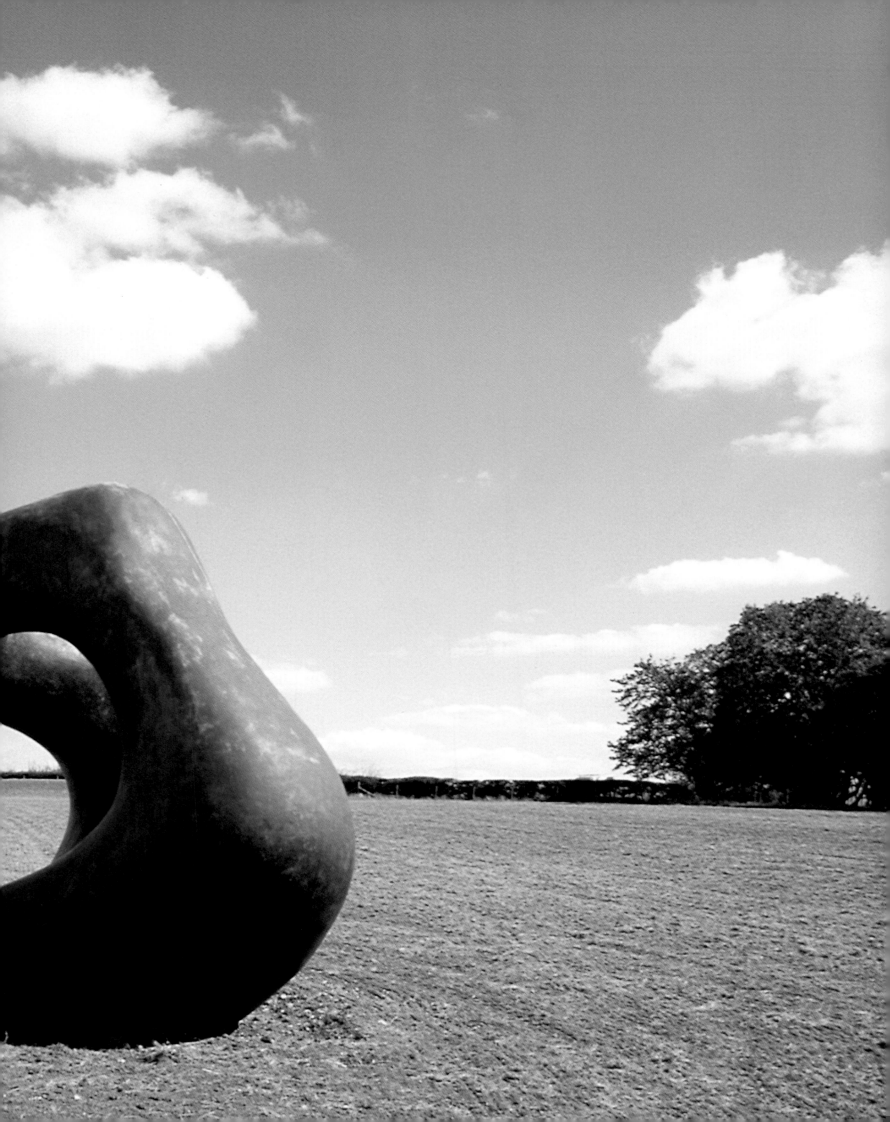

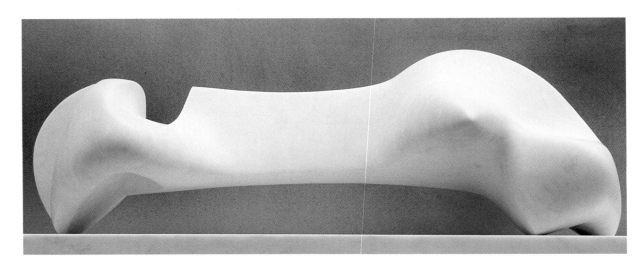

Reclining form, 1966,
White marble,
(114 cm long,)
'In stone sculpture you
have to alter the
malleable softness of
flesh and blood into
something that is harder
and less bendable.'

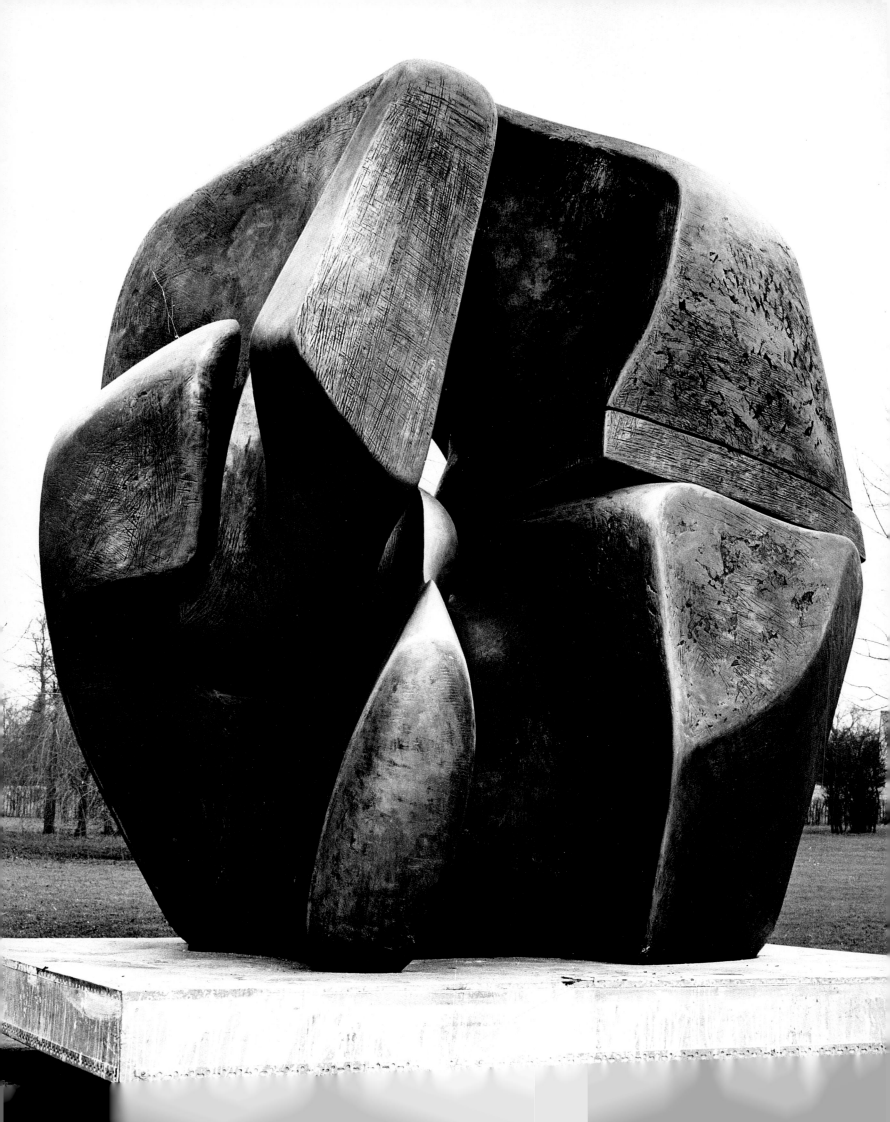

Locking Piece,
1963 - 64, Bronze
(293 cm high, LH 515)
'... certainly the largest
and perhaps the most
successful of my 'fitting-
together' sculptures. In
fact the two pieces
interlock in such a way
that they can only be
separated if the top piece
is lifted and turned at the
same time. The germ of
the idea originated from
a sawn fragment of bone
with a socket and joint
which was found in
the garden.'

170

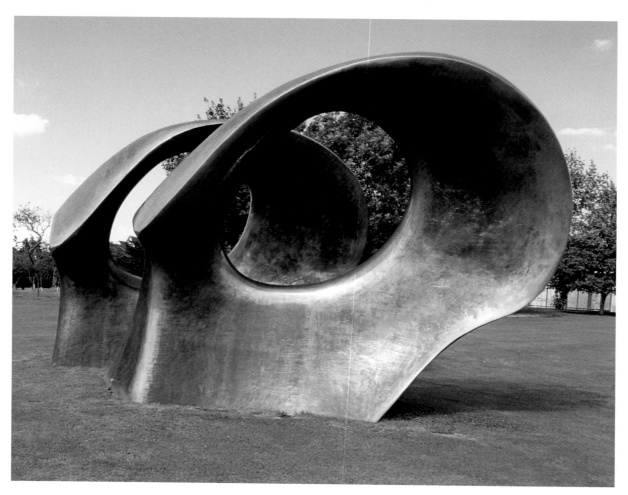

Double Oval,
1966, Bronze
(550 cm long, LH 560)
'Double Oval' is of such a
physical size that it
evokes architecture as
well as sculpture in its
construction. The two
ovals look the same but
they are not. Instead they
are echoes of each other.'

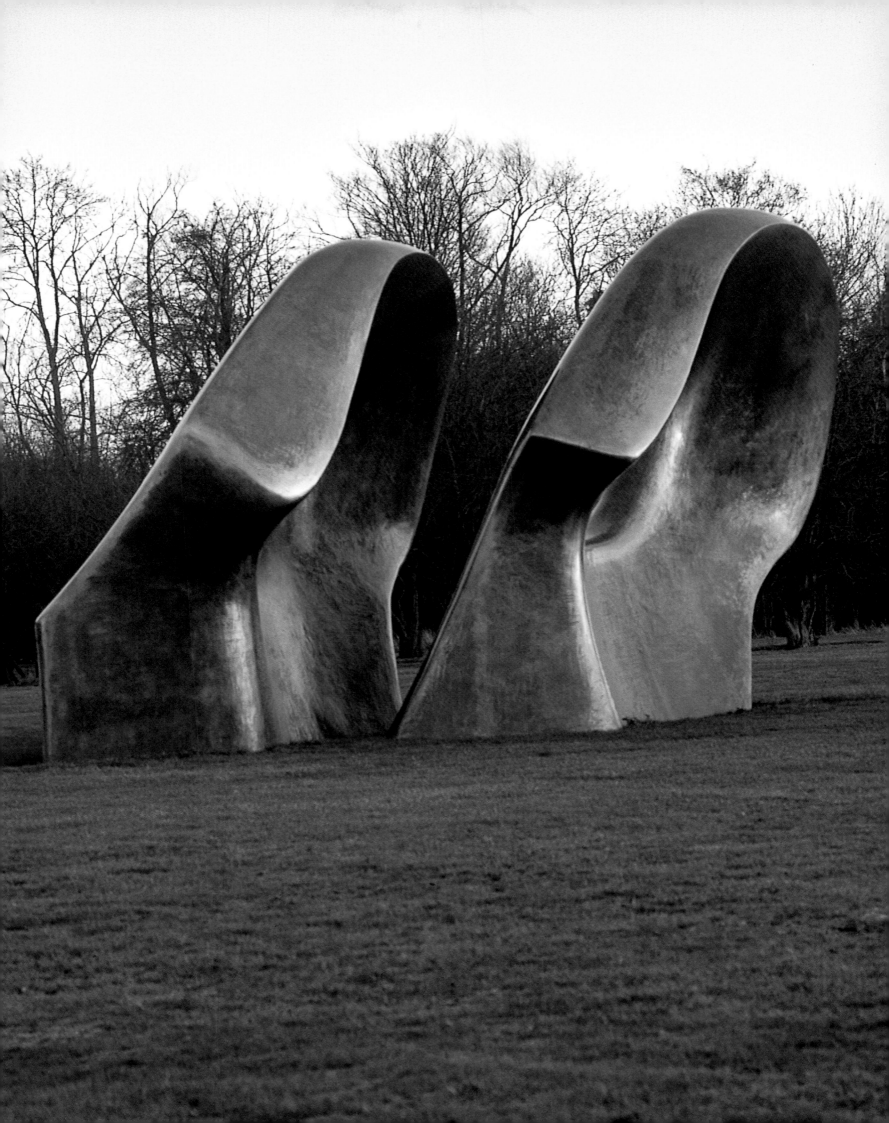

Cast of working Model
for Three Piece No. 3:
Vertebrae, 1968, Bronze
(234 cm long, LH 579)

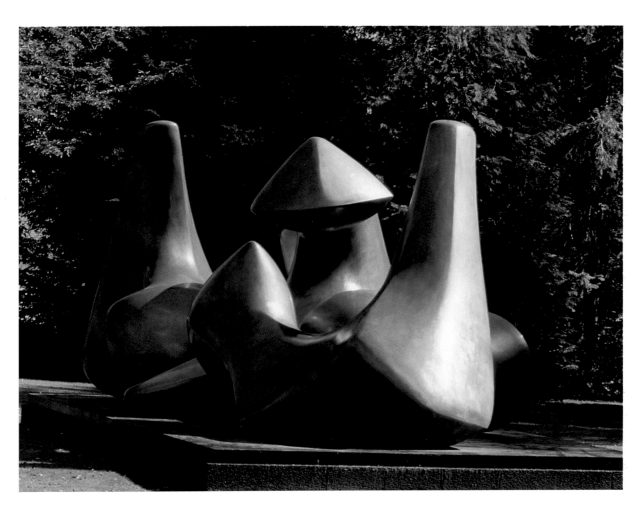

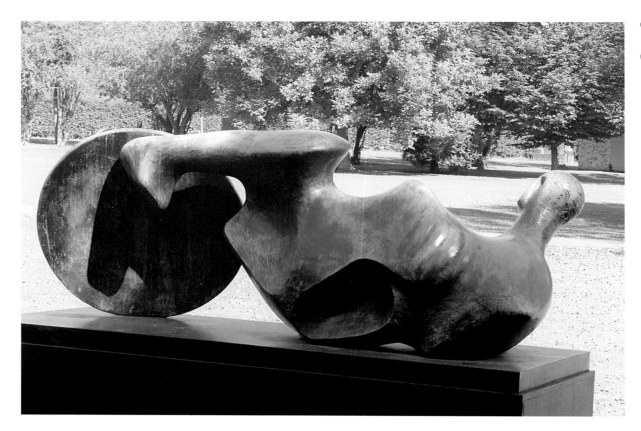

Reclining Figure: Arch
Leg, 1969 - 70, Bronze
(442 long, LH 610)

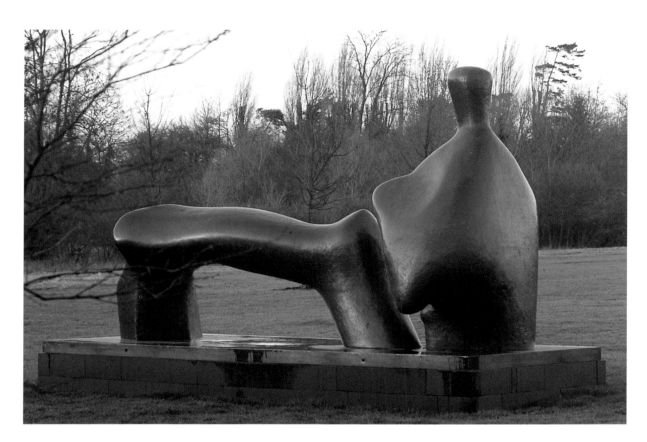

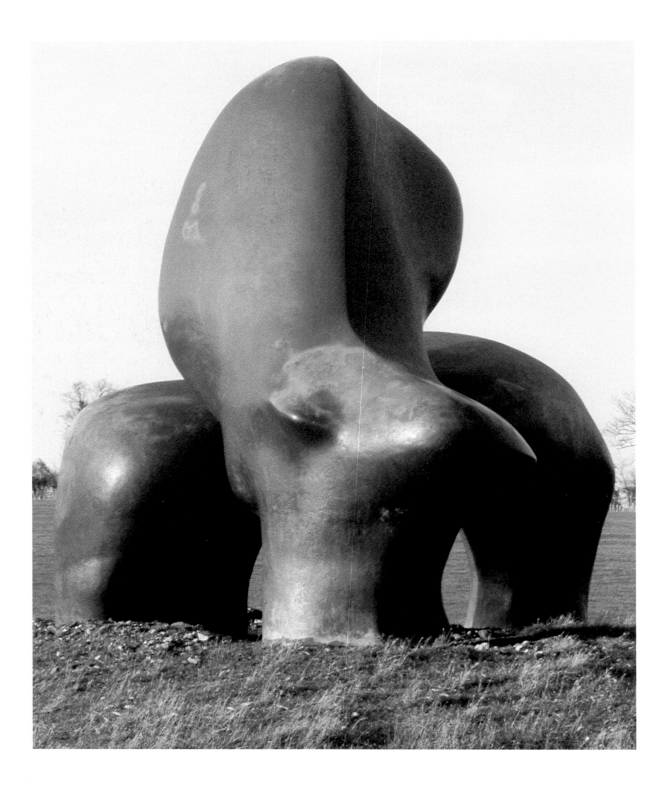

Ideas for Sheep Piece,
1969, Ballpoint pen,
from sketchbook,
(254 mm high)

Left: Sheep Piece,
1971 - 72, Bronze
(570 cm high, LH 627)

Overleaf: Large Four
Piece Reclining Figure,
1972-73, Bronze
(402 cm long, LH 629)
'There are three
fundamental poses of the
human figure. One is
standing, the other
seated, and the third is
lying down ... Of the
three poses, the reclining
figure gives the most
freedom, compositionally
and spatially. The seated
figure has to have
something to sit on. You
can't free it from its
pedestal. A reclining
figure can recline on any
surface. It is free and
stable at the same time. It
fits in with my belief that
sculpture should
be permanent, should
last for eternity. Also, it
has repose.'

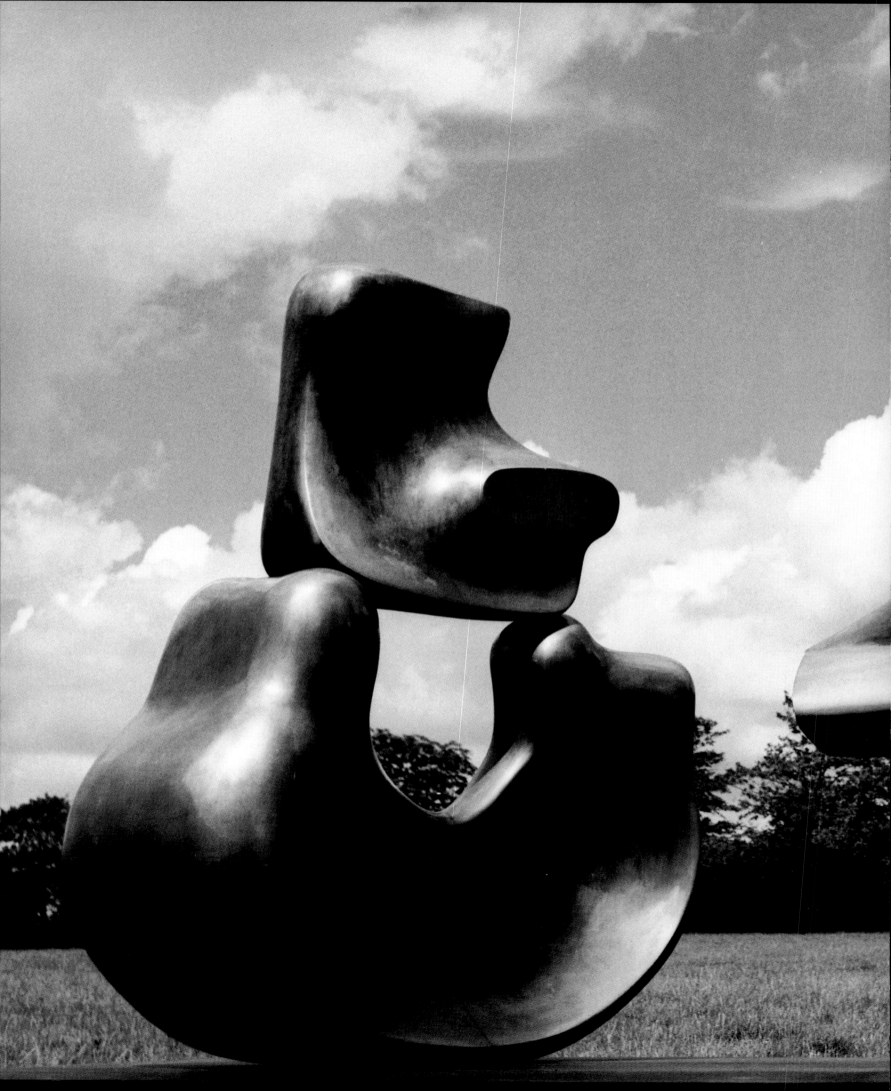

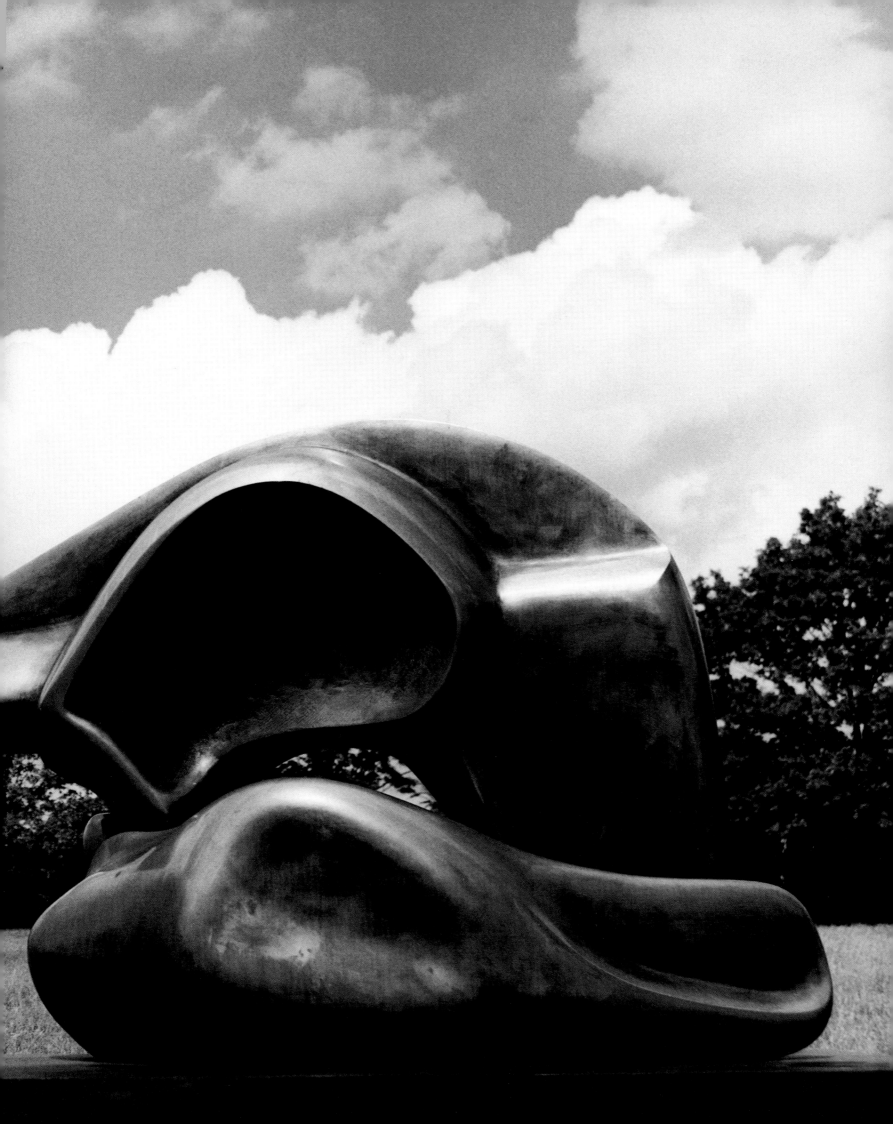

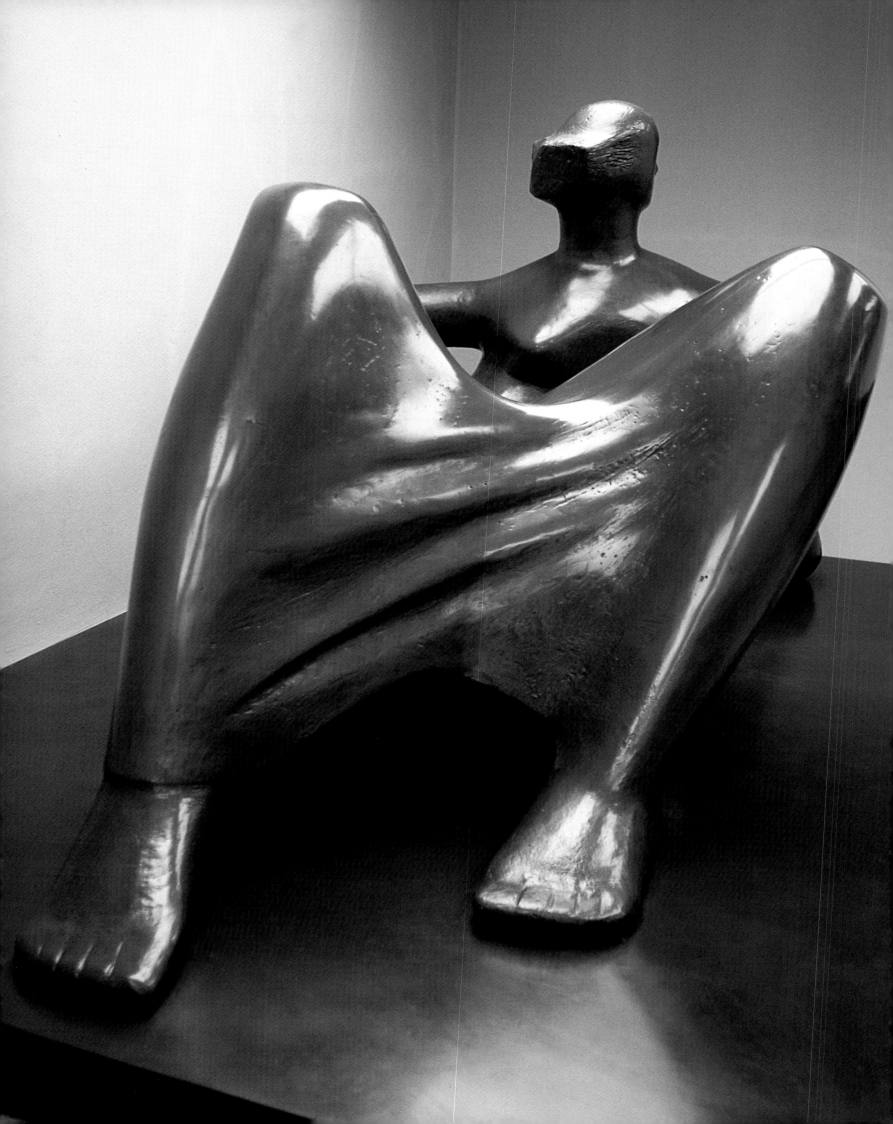

Eight Reclining Figures,
1962, Watercolour and
pen, from sketchbook,
(292 mm high)

Left: Reclining Figure:
Angles, 1979, Bronze
(218 cm long, LH 675)

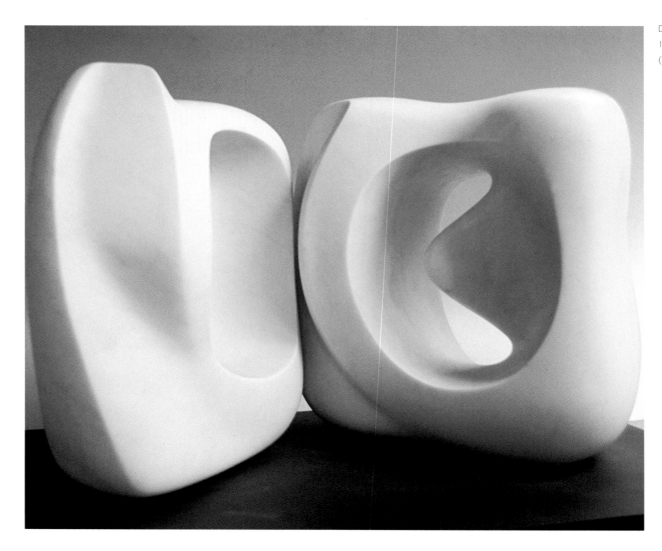

Double Tongue Form,
1972, Carrara Marble,
(76 cm long, LH 632)

Mother and Child:
Egg Form, 1977,
White Marble
(194 cm high, LH 717)

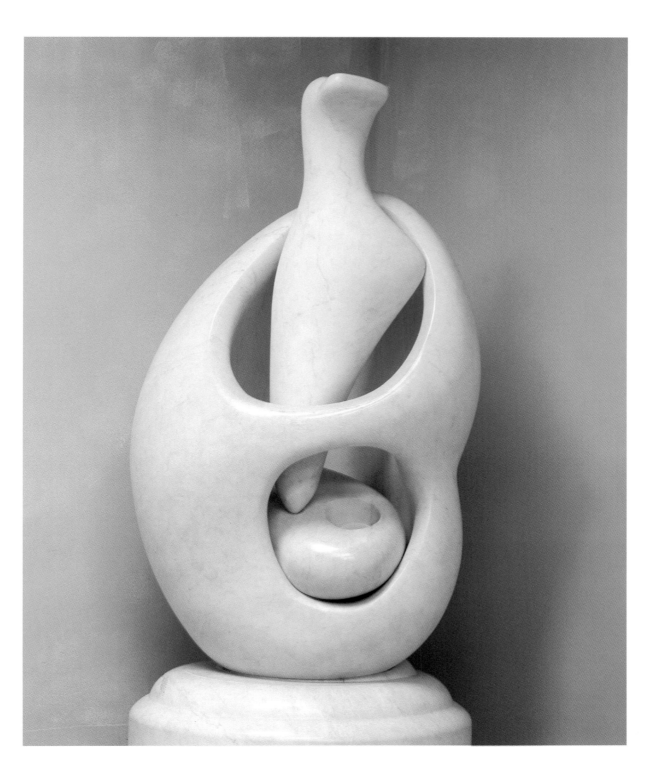

Cast of working
Model for Three Piece
Reclining Figure:
Draped, 1975, Bronze
(112 cm long, LH 654)

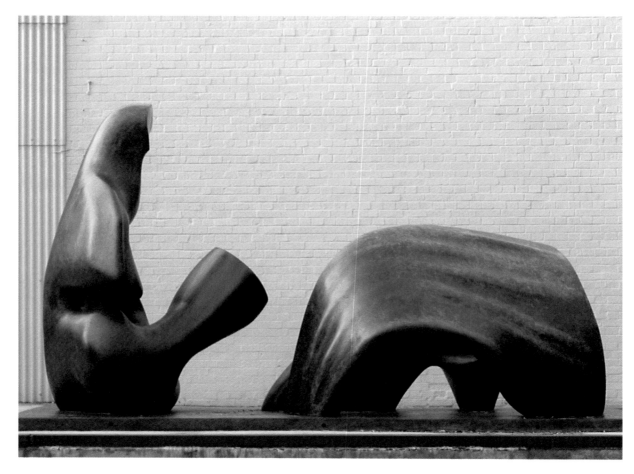

Architecture Prize
(based on Two Piece
Reclining Figure: Cut),
1979, Bronze
(32 cm long, LH 756)

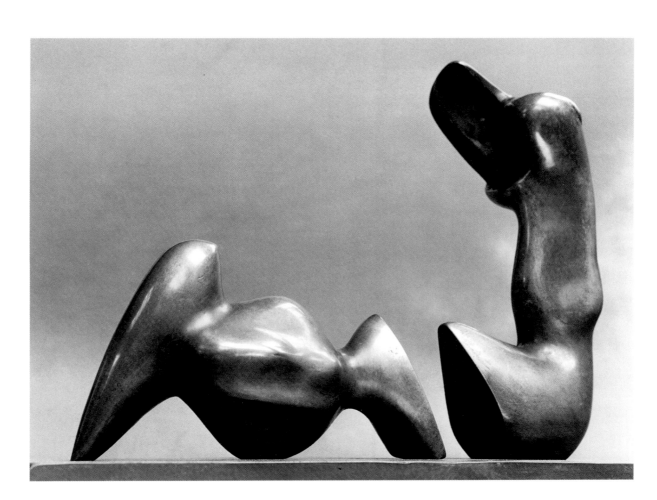

186

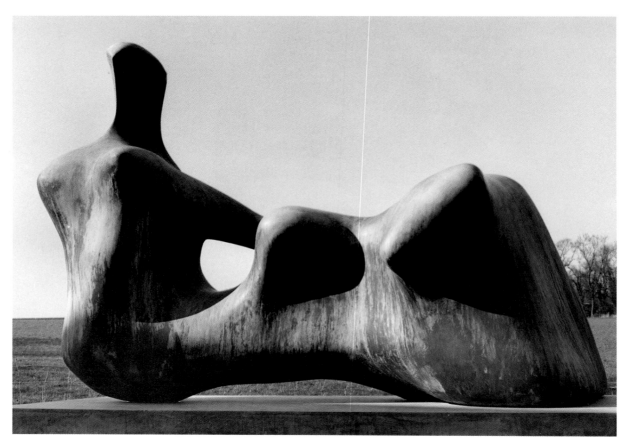

Reclining Figure: Hand,
1979, Bronze
(221 cm long, LH 709)
'The whole of my
development as a
sculptor is an attempt to
understand and realise
more completely what
form and shape are
about, and to react to
form in life, in the human
figure, and in past
sculpture. This is
something that can't be
learnt in one day, for
sculpture is a never-
ending discovery.'

Reclining Figure,
Sculpture in Landscape,
1974, Charcoal, chalk, ink
wash and watercolour,
481 mm wide

Overleaf: Draped
Reclining Mother and
Baby, 1983, Bronze (265
cm long, LH 822)

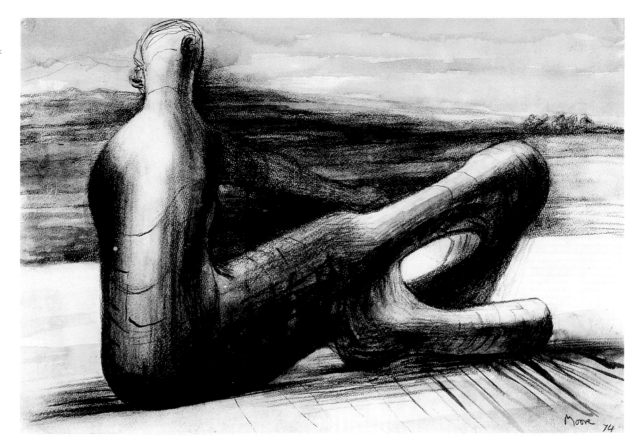

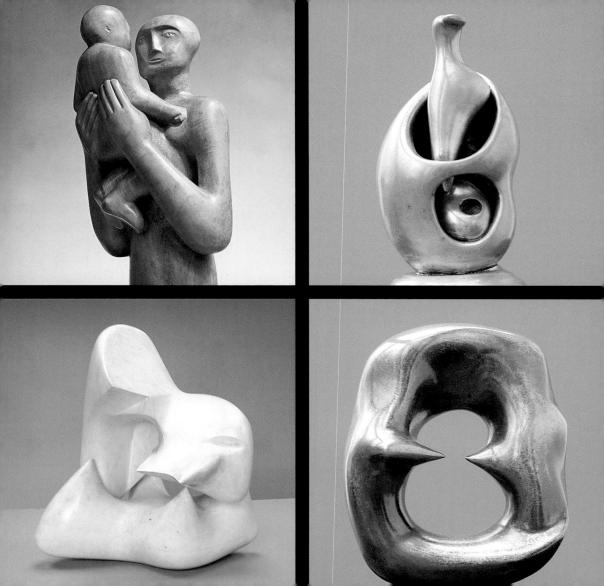

Part Three : The Works

This section is a visual compendium of as many of the various sculptural forms that Henry created through his long career as I am able to muster. It is my hope that this will constitute the best visual survey of Henry Moore's career as a sculptor in a single volume. It is not meant to be a catalogue raisonne: that already exists in the admirable six volume set published by Lund Humphries. It is, however, an attempt to show as many sculptural forms as possible.

Henry often created a sculptural form in several materials and sizes, including the maquette, and here I have shown only one representation of each form. As often as possible I have shown the form in the maquette. Both Henry and others considered his maquettes to be the most immediate form of his work; they are, for obvious reasons, the closest to his original conceptions. Where several other versions of the same form exist, I have tried to say how many there are, and what the size of the largest one is, since I feel that this information gives some indication of the extent to which he elaborated on a particular form. Some forms could not be illustrated, and are therefore not listed.

This is not meant as a work of scholarly reference; I have no pretensions in that regard, but I have attempted to render the fullest possible survey of Henry's amazing fund of ideas. While I realise that such a compilation is necessarily visually very dense, I hope that it enables an 'overview' of the career of one of the great artists of out century.

Henry at work, 1967

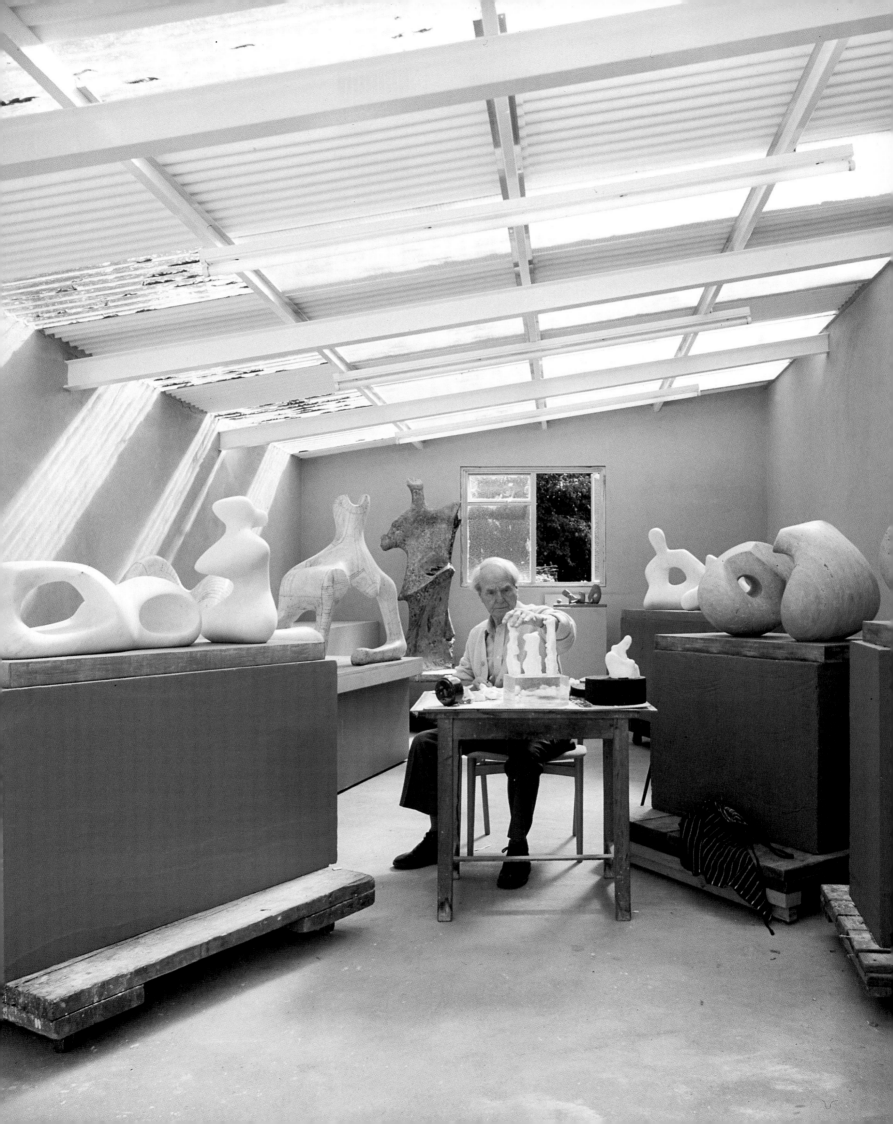

194

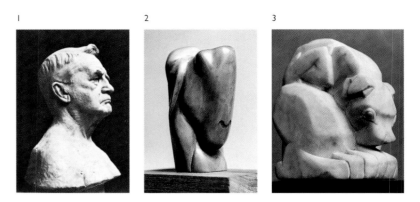

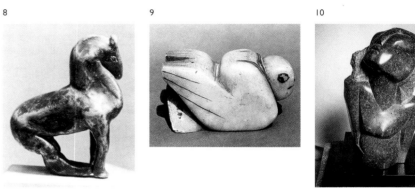

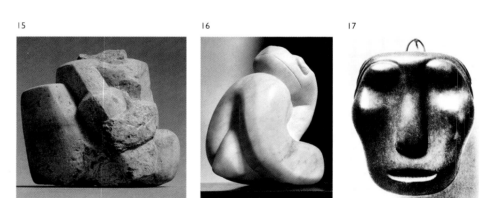

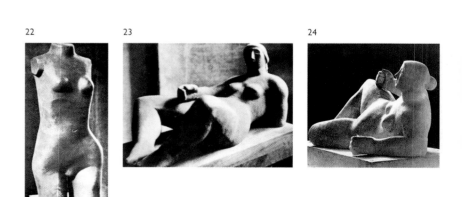

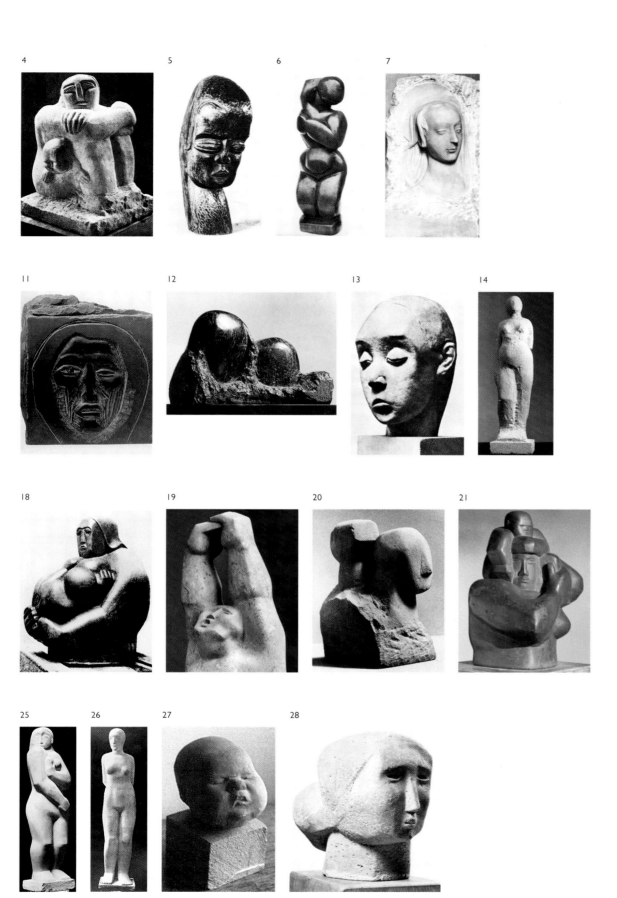

196

29

30
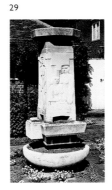
31
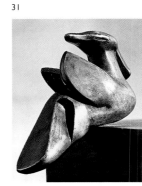

36

37
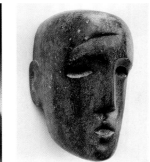
38

44
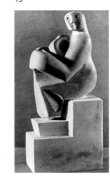
45
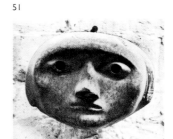
46
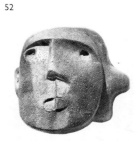

50
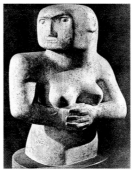
51
52

32 33 34 35

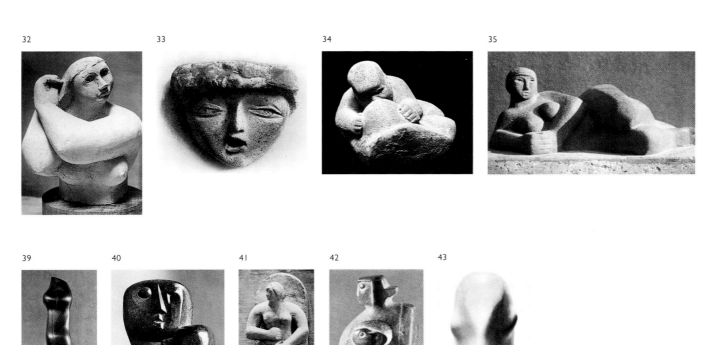

39 40 41 42 43

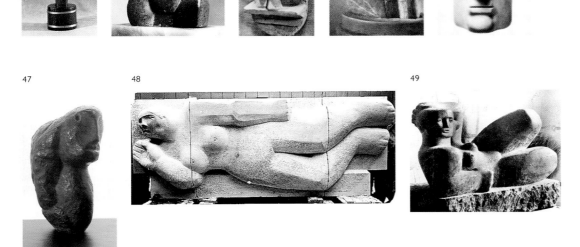

47 48 49

53 54 55 56

198

57　　　58　　　59

64　　　65　　　66

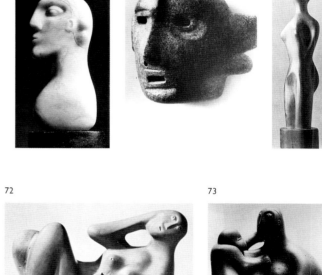

72　　　73

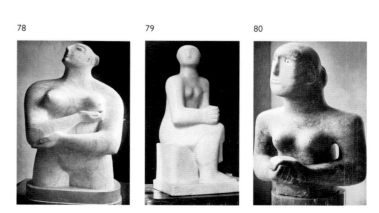

78　　　79　　　80

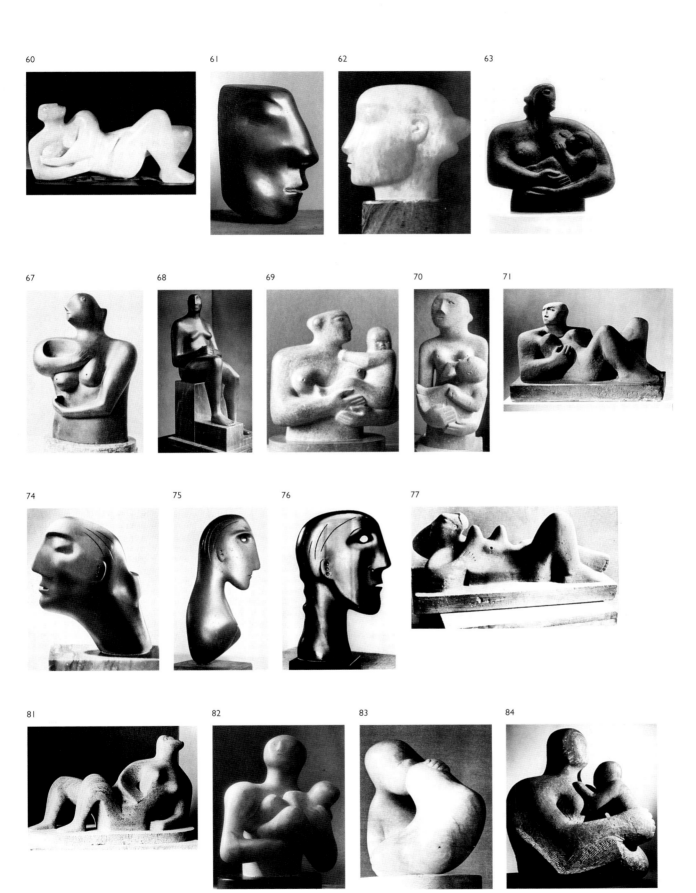

60

61

62

63

67

68

69

70

71

74

75

76

77

81

82

83

84

85 Half-figure, 1931,
Cumberland alabaster
24.1cm high, LH 98

86 Composition, 1931, Blue
Hornton stone 48.3cm high,
LH 99

87 Mother and Child, 1931,
Burgundy stone 35.6cm high,
LH 100

88 Reclining Figure, 1931,
Lead 43.2cm long, LH 101

89 Composition, 1931,
Cumberland alabaster
41.9cm long, LH 102

90 Relief, 1931, Bronze
46.4cm high, LH 103

91 Relief, 1931, Bronze
46.7cm high, LH 104

92 Mother and Child,
1931, Cumberland alabaster
45.7cm high, LH 105

93 Mother and Child, 1931,
Sycamore wood 76.2cm high,
LH 106

94 Mother and Child, 1931,
Verde di prato 20.3cm high,
LH 107

95 Mother and Child, 1931,
Cumberland alabaster
51.1 cm high, LH 107a

96 Girl, 1931, Ancaster stone
73.7cm high, LH 109

97 Seated Girl, 1931,
Anhydrite stone 44.5cm high,
LH 110

98 Figure, 1931, Beechwood
24.1cm high, LH 111

99 Girl, 1932, Boxwood
31.8cm high, LH 112

100 Figure, 1932, Boxwood
43.2cm high, LH 113

101 Figure, 1932, Beechwood
33cm high, LH 114

102 Composition, 1932,
Beechwood 33cm high,
LH 115

103 Half-figure, c.1932,
Bronze 14cm high, LH 116

104 Half-figure, 1932,
Armenian marble
83.8cm high, LH 117

105 Relief, 1932, Wood and
gesso 25.4cm high, LH 118

106 Composition, 1932,
African wonderstone
44.5cm high, LH 119

107 Mother and Child,
1932, Carved concrete
17.8cm high, LH 120

108 Reclining Figure, 1932,
Bronze 15.2cm long, LH 120a

109 Reclining Figure, 1932,
Stone and carved concrete
21cm long, LH 120b

110 Mother and Child, 1932,
Alabaster 24.1cm high,
LH 120c

111 Mother and Child,
1932, Green Hornton stone
88.9cm high, LH 121

112 Reclining Figure, 1932,
Carved reinforced concrete
109.2cm long, LH 122

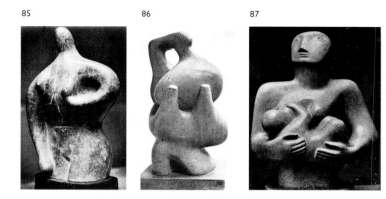

85 86 87

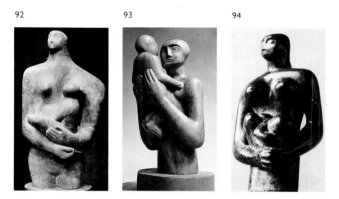

92 93 94

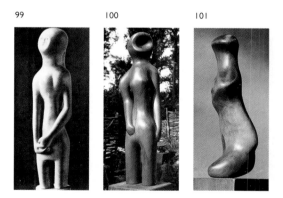

99 100 101

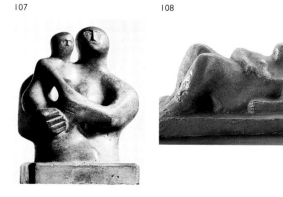

107 108

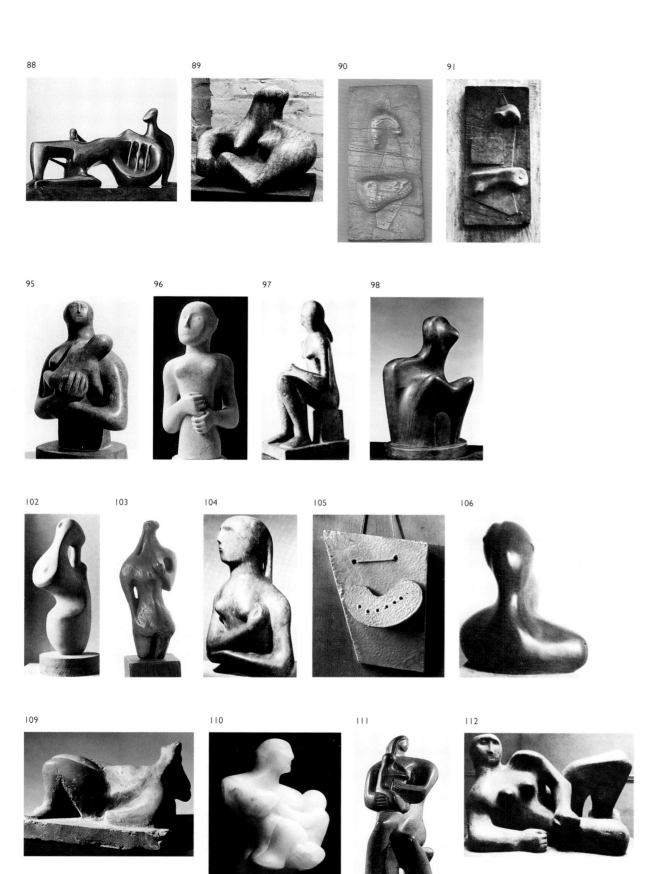

202

113
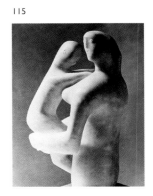

114
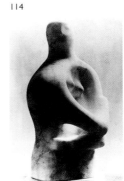

115
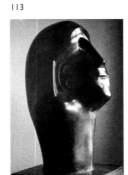

120
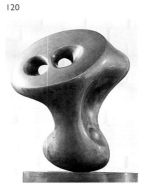

121
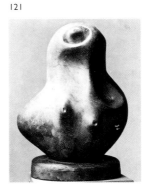

122
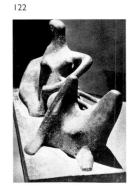

127
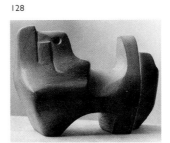

128
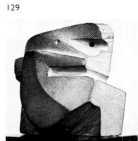

129
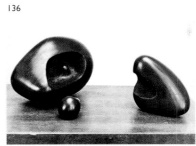

134
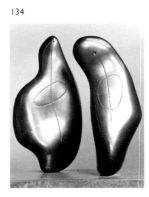

135
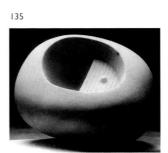

136

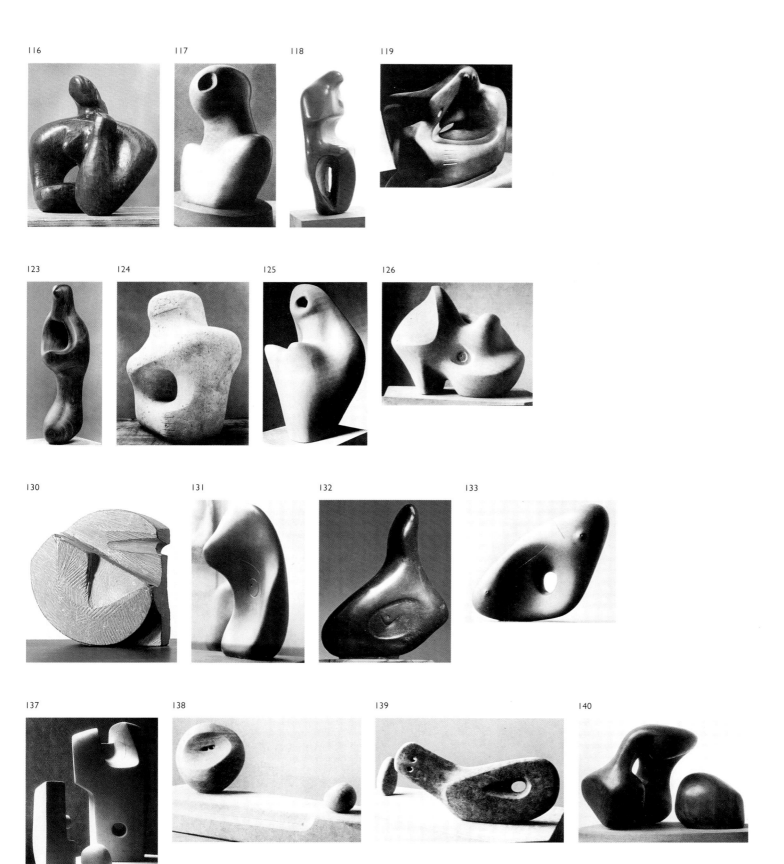

116

117

118

119

123

124

125

126

130

131

132

133

137

138

139

140

204

141 Four-piece Composition:
Reclining Figure, 1934,
Cumberland alabaster
50.8cm long, LH 154

142 Hole and Lump,
1934, Elmwood 68.6cm high,
LH 154a

143 Square Form, 1934,
Burgundy stone 32.2cm high,
LH 154b

144 Mother and Child, 1934,
African Wonderstone
10.8cm high, LH 154c

145 Seated Figure, 1934,
Bronze 13.7cm high, LH 154d

146 Seated Figure, c.1934,
Bronze 12.7cm high, LH 154e

147 Reclining Figure,
c.1934-5, Corsehill stone
62.2cm long, LH 155

148 Carving, 1935,
Cumberland alabaster
34.3cm high, LH 156

149 Figure, c.1935, Bronze
15.2cm high, LH 157

150 Carving, 1935, Walnut
wood 96.5cm high, LH 158

151 Mother and Child, 1935,
Bronze 12.7cm high, LH 158a

152 Carving, 1935, African
wood 40.6cm long, LH 159

153 Head and Shoulders,
1935, Bronze 7.7cm high,
LH 159a

154 Carving, 1935, African
wood 40.6cm long, LH 160

155 Sculpture, 1935, White
marble 55.9cm long, LH 161

156 Small Reclining Figure,
1935, Bronze 7.7cm high,
LH 161a

157 Reclining Figure,
1935, African Wonderstone
14cm long, LH 161b

158 Reclining Figure, 1935-6,
Elmwood 88.9cm long,
LH 162

159 Head, c.1936, Hopton-
wood stone 26.7cm high,
LH 163

160 Carving, c.1936,
Travertine marble
45.7cm high, LH 164

161 Mother and Child, 1936,
Ancaster stone 50.8cm high,
LH 165

162 Two Forms, 1936, Brown
Hornton stone 40.6cm high,
LH 166

163 Square Form, 1936,
Green Hornton stone
40.6cm long, LH 167

164 Square Form, 1936,
Brown Hornton stone
53.3cm long, LH 168

165 Carving, 1936, Brown
Hornton stone 50.8cm long,
LH 169

166 Two Forms, 1936,
Hornton stone 106.7cm high,
LH 170

167 Head, 1936, Corsham
stone 9.8cm high, LH 170a

141
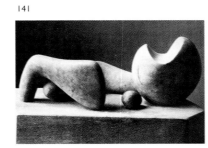

142
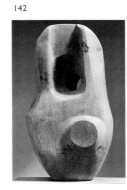

143
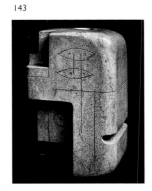

148
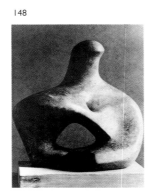

149
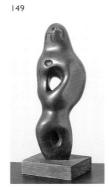

150
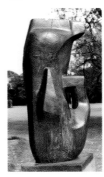

151
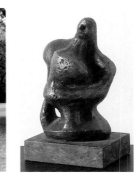

155
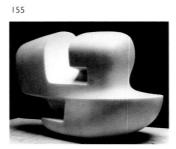

156

157

161

162

163

144 145 146 147

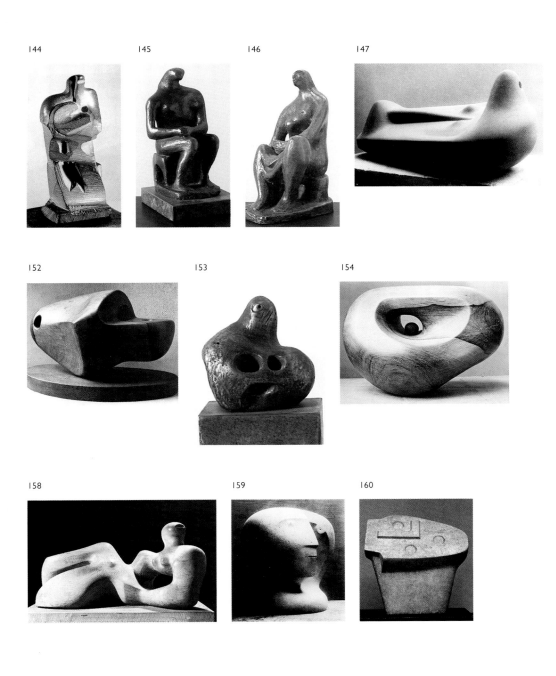

152 153 154

158 159 160

164 165 166 167

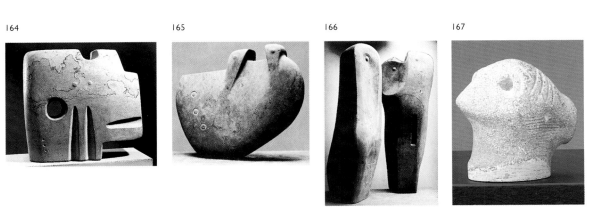

206

168

169

170

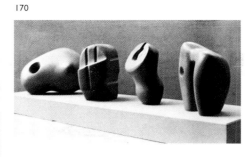

175

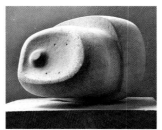

176

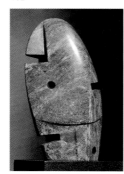

177

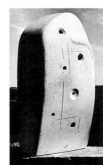

182

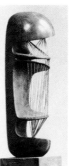

183

184

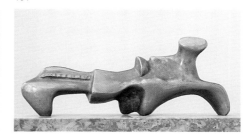

188

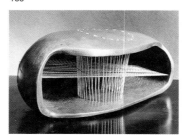

189

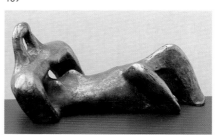

190

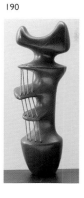

171

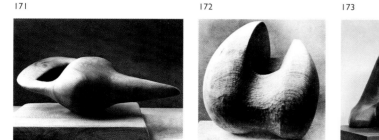

172

173

174

178

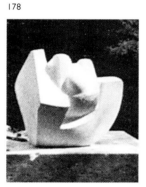

179

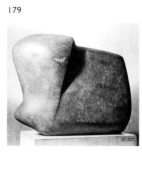

180

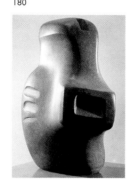

181

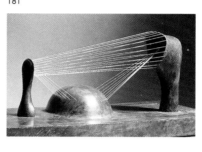

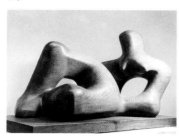

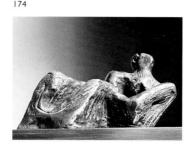

185

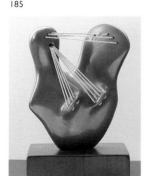

186

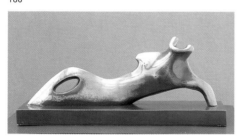

187

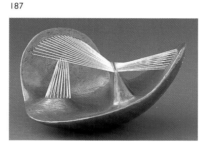

191

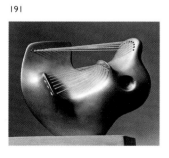

192

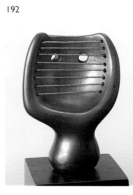

193

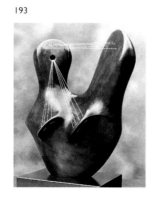

194

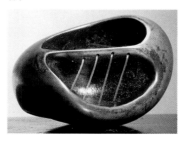

208

195 Head, 1938, Elmwood and string 20.3cm high, LH 188

196 Stringed Figure, 1938, Lignum vitae and string 15.2cm long, LH 189

197 Stringed Figure, 1938, Lignum vitae and string 35.6cm high, LH 190

198 Recumbent Figure, 1938, Green Hornton stone 139.7cm long, LH 191
One other form exists: Recumbent Figure, 13cm high bronze 1938 (LH 184)

199 Reclining Figure, 1938, Bronze 36.8cm long, LH 192a
One other form exists: Large Reclining Figure, 1036cm long bronze cast 1983 (LH192b)

200 Reclining Figure, 1938, Bronze 14cm long, LH 193

201 Mother and Child, 1938, Elmwood 91.4cm high, LH 194

202 Head, 1939, Bronze and String 13.7cm high, LH 195

203 Stringed Reclining Figure, 1939, Bronze and String 25.4cm long, LH 197

204 Stringed Ball, 1939, Bronze and String 8.9cm long, LH 198

205 Stringed Figure, 1939, Lead and String 25.7cm high, LH 199

206 Reclining Stringed Figure, 1939, Bronze and brass wire 26cm long, LH 199a

207 Mother and Child, 1939, Lead and wire 17.8cm high, LH 200

208 Mother and Child, 1939, Bronze and String 19cm long, LH 201

209 Reclining Figure, 1939, Bronze 27.9cm long, LH 202

210 Reclining Figure, 1939, Bronze 22.9cm long, LH 203

211 Reclining Figure, 1939, Bronze 25.4cm long, LH 204

212 Bird Basket, 1939, Lignum vitae and string 41.9cm long, LH 205

213 Stringed Figure, 1939, Bronze and String 25.4cm long, LH 206

214 Stringed Figure, 1939, Bronze and String 21cm long, LH 207

215 Reclining Figure, 1939, Bronze 33cm long, LH 208

216 Reclining Figure: Snake, 1939, Bronze 28.9cm long, LH 208a

217 Figure, 1939, Bronze 40.7cm high, LH 209

218 Reclining Figure, 1939, Elmwood 205.7cm long, LH 210
One other form exists: Reclining Figure, 21.6cm long bronze 1938 (LH 185)

219 Three Points, 1939-40, Bronze 20cm long, LH 211

220 Interior Figure, 1939-40, Bronze 27.3cm high, LH 212a
One other form exists: The Helmet, 29.2cm high bronze 1939-40 (LH 212)

195
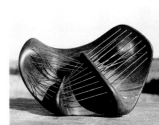

196
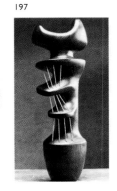

197
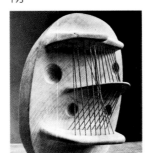

201
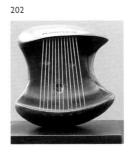

202
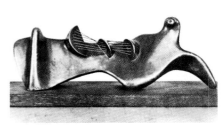

203
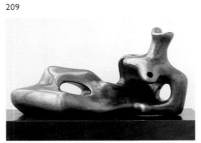

208
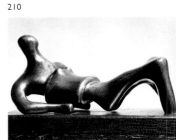

209

210

214
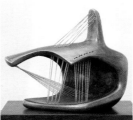

215
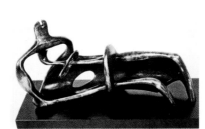

216

198
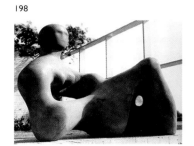

199
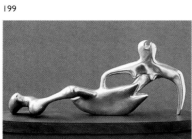

200
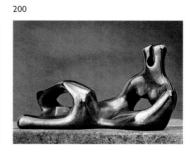

204
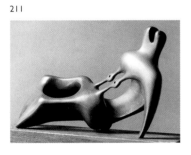

205
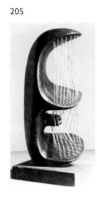

206
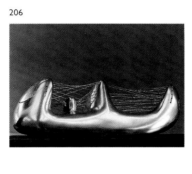

207
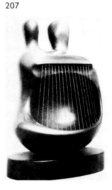

211
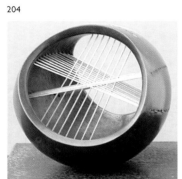

212
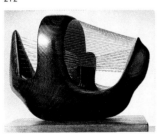

213
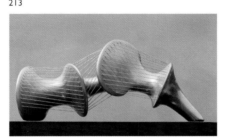

217
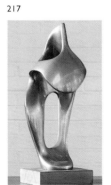

218
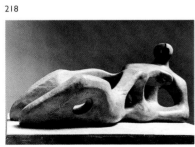

219
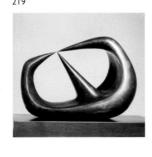

220
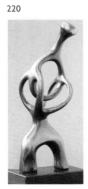

221 The Bride, 1939-40, Lead and wire 24.1cm high, LH 213

222 Madonna and Child, 1943, Terracotta 14.6cm high, LH 215

223 Madonna and Child, 1943, Bronze 14cm high, LH 216

224 Madonna and Child, 1943, Terracotta 15.2cm high, LH 218

225 Madonna and Child, 1943, Bronze 15.9cm high, LH 219

226 Madonna and Child, 1943, Terracotta 11.4cm high, LH 220

227 Madonna and Child, 1943, Bronze 15.6cm high, LH 221

228 Madonna and Child, 1943, Bronze 18.2cm high, LH 222
Two other forms exist: Largest is Claydon Madonna and Child, 122cm high Hornton stone 1948-9 (LH 270)

229 Madonna and Child, 1943, Bronze 15.9cm high, LH 225

230 Madonna and Child, 1943-4, Hornton stone 149.9cm high, LH 226
One other form exists: Madonna and Child, 15.9cm high bronze 1943 (LH 224)

231 Family Group, 1944, Bronze 18.7cm high, LH 228

232 Family Group, 1944, Bronze 20cm high, LH 229

233 Family Group, 1944, Bronze 15.6cm high, LH 230

234 Family Group, 1944, Terracotta 15.6cm high, LH 231

235 Family Group, 1944, Terracotta 16.2cm high, LH 232

236 Family Group, 1944, Bronze 14.9cm high, LH 233

237 Family Group, 1945, Bronze 17.2cm high, LH 235
One other form exists: Family Group, 44.1cm high bronze 1946 (LH 265)

238 Family Group, 1945, Bronze 14cm high, LH 237

239 Family Group, 1945, Bronze 18.1cm high, LH 238

240 Family Group, 1945, Bronze 12.7cm high, LH 239
Four other forms exist: Largest is Seated Man, 155cm high bronze 1949 (LH 269a)

241 Family Group, 1945, Bronze 12.7cm high, LH 240a

242 Two Seated Women and a Child, 1945, Bronze 17.2cm high, LH 241

243 Reclining Figure, 1945, Bronze 16.5cm long, LH 245

244 Reclining Figure, 1945, Terracotta 15.2cm long, LH 247
Two other forms exist: Largest is Reclining Figure, 190.5cm long elmwood 1945-6 (LH 263)

245 Reclining Figure, 1945, Terracotta 16.5cm long, LH 249

246 Reclining Figure, 1945, Bronze 17.8cm long, LH 250
One other form exists: Reclining Figure, 44.5cm long bronze 1945 (LH 257)

221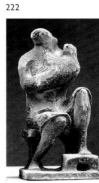

222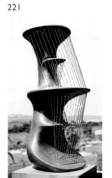

223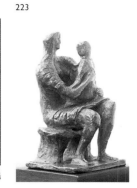

228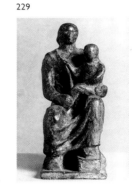

229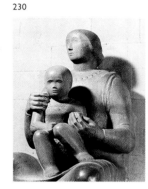

230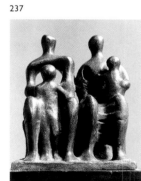

235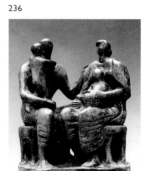

236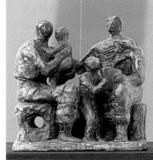

237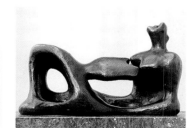

242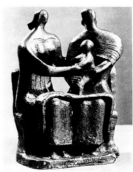

243

224

225

226

227

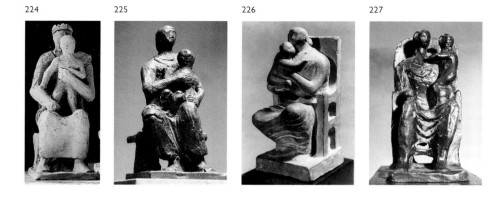

231

232

233

234

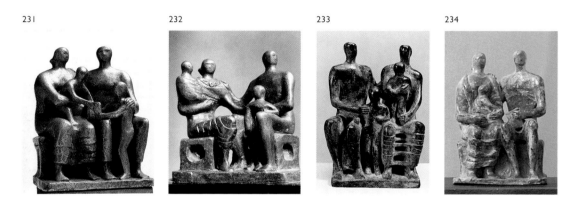

238

239

240

241

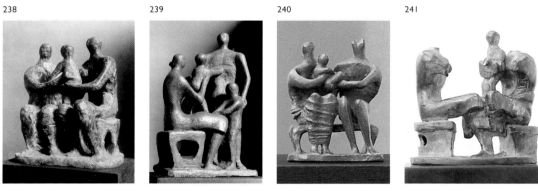

244

245

246

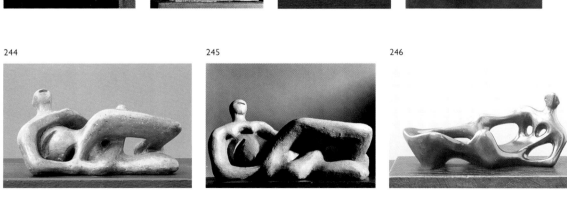

247 Reclining Figure, 1945, Bronze 17.8cm long, LH 251 *One other form exists: Reclining Figure, 40.6cm high bronze 1945 (LH 256)*

248 Reclining Figure, 1945, Bronze 18.4cm long, LH 252

249 Reclining Figure, 1945, Terracotta 18.4cm long, LH 254

250 Reclining Figure, 1945, Terracotta 13.3cm long, LH 255

251 Reclining Figure, 1946, Terracotta 43.2cm long, LH 261 *One other form exists: Reclining Figure, 19.1cm long terracotta 1945 (LH 253)*

252 Memorial Figure, 1945-6, Hornton stone 142.2cm long, LH 262 *Two other forms exist: Largest is Reclining Figure, 17.8cm high terracotta 1945 (LH 242)*

253 Woman Reading, 1946, Terracotta 14cm high, LH 264

254 Reclining Figure, 1946-7, Brown Hornton stone 68.6cm long, LH 266

255 Family Group, 1947, Bronze 40.6cm high, LH 267 *One other form exists: Family Group, 20cm high terracotta 1945 (LH 240)*

256 Three Standing Figures, 1947-8, Darley Dale stone 213.4cm high, LH 268 *One other form exists: Three Standing Figures, 21cm high terracotta 1945 (LH 258)*

257 Pointed Reclining Figure, 1948, Bronze 19cm long, LH 268a

258 Seated Figure, 1949, Bronze 43cm high, LH 271

259 Seated Figure: Armless, 1949, Bronze 25.5cm high, LH 272a *One other form exists: Seated Figure, 23cm high bronze 1949 (LH 272)*

260 Reclining Figure, 1949, Hornton stone 76cm long, LH 273 *One other form exists: Reclining Figure, 20.3cm long bronze 1945 (LH 246)*

261 Rocking Chair No.1, 1950, Bronze 32cm high, LH 274

262 Rocking Chair No.2, 1950, Bronze 28cm high, LH 275

263 Rocking Chair No.4: Miniature, 1950, Bronze 14.5cm high, LH 277 *One other form exists: Rocking Chair No.3, 32cm high bronze 1950 (LH 276)*

264 Helmet Head No.1, 1950, Bronze 34cm high, LH 279 *One other form exists: Maquette for Helmet Head No.1, 14cm high lead 1950 (LH 278)*

265 Helmet Head No.2, 1950, Bronze 34cm high, LH 281 *One other form exists: Maquette for Helmet Head No.2, 16cm high lead 1950 (LH 280)*

266 Three Interiors for Helmets, 1950, Lead 12.5cm high, LH 282

267 Small Helmet Head, 1950, Bronze 11.5cm high, LH 283

268 Maquette for Openwork Head No.1, 1950, Bronze 18cm high, LH 284 *One other form exists: Openwork Head No.1, 38cm high bronze 1950 (LH 285)*

269 Maquette for Openwork Head and Shoulders, 1950, Bronze 15cm high, LH 286 *One other form exists: Openwork Head and Shoulders, 44.5cm high bronze 1950 (LH 287)*

270 Openwork Head No.2, 1950, Bronze 40cm high, LH 289 *One other form exists: Maquette for Openwork Head No.2, 14.5cm high bronze 1950 (LH 288)*

271 Maquette for Strapwork Head, 1950, Bronze 10cm high, LH 289a

272 Standing Figure, 1950, Bronze 221cm high, LH 290 *Three other forms exist: Largest is Double Standing Figure, 221cm high bronze 1950 (LH 291)*

273 Working Model for Reclining Figure: Festival, 1950, Bronze 43cm long, LH 292 *One other form exists: Reclining Figure: Festival, 228.5cm long bronze 1951 (LH 293)*

247
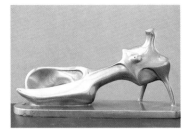

248
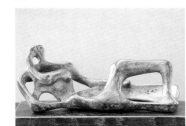

249
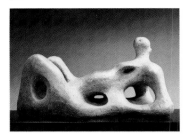

253
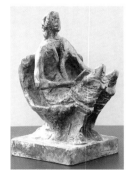

254
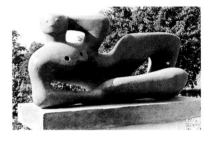

255
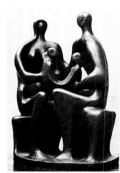

260
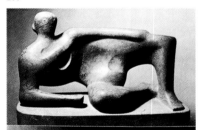

261
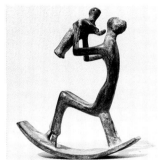

262
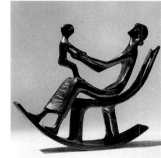

267
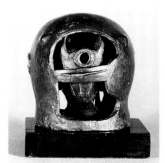

268
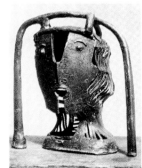

269
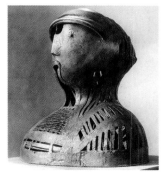

250
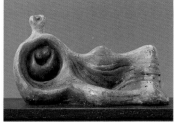

251
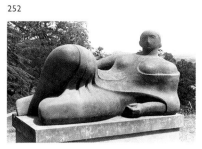

252
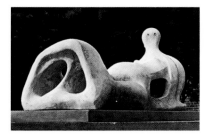

256
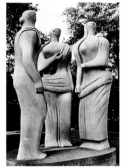

257
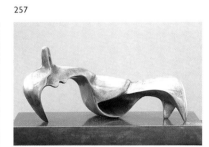

258
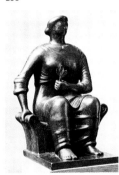

259
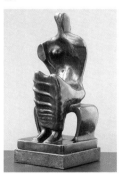

263
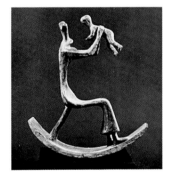

264
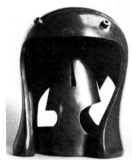

265
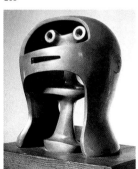

266
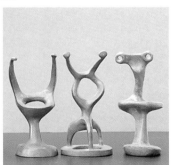

270
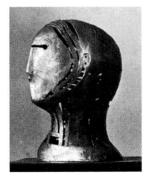

271
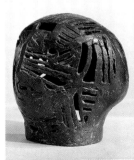

272
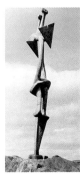

273
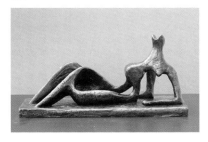

274 Small Maquette No.1 for Reclining Figure, 1950, Bronze 24cm long, LH 292a

275 Small Maquette No.2 for Reclining Figure, 1950, Bronze 21cm long, LH 292b

214 **276** Maquette for Upright Internal/External Form: Flower, 1951, Bronze 21.5cm high, LH 293a *One other form exists: Upright Internal/External Form: Flower, 76.5cm high bronze 1951 (LH 293b)*

277 Interior Form, 1951, Bronze 47cm high, LH 295a *Seven other forms exist: Largest is Large Upright Internal/External Form, 673cm high bronze 1953-4 (LH 297a)*

278 Reclining Figure: External Form, 1953-4, Bronze 213.5cm long, LH 299 *One other form exists: Working Model for Reclining Figure: Internal/External Form, 53.5cm long bronze 1951 (LH 298)*

279 Interior Piece for Reclining Figure, 1953, Plaster, unfinished 213.5cm high, LH 300

280 Animal Head, 1951, Bronze 30.5cm long, LH 301

281 Goat's Head, 1952, Bronze 20.5cm high, LH 302

282 Bar Helmet Head, 1952, Bronze 11.5cm high, LH 303

283 Helmet Head and Shoulders, 1952, Bronze 16.5cm high, LH 304

284 Relief No.1, 1952, Bronze 12.5cm long, LH 305

285 Relief No.2, 1952, Bronze 11.5cm high, LH 306

286 Mother and Child: Corner Sculpture No.1, 1952, Bronze 18cm high, LH 307

287 Mother and Child: Corner Sculpture No.3, 1952, Plaster 21cm high, LH 309

288 Mother and Child: Corner Sculpture No.4, 1952, Plaster 23cm high, LH 310

289 Family: Maquette for Corner Sculpture, 1952, Bronze 14cm high, LH 311

290 Mother and Child on Ladderback Rocking Chair, 1952, Bronze 21cm high, LH 312

291 Mother and Child on Ladderback Chair, 1952, Bronze 40.5cm high, LH 313

292 Maquette for Mother and Child, 1952, Bronze 21.5cm high, LH 314 *One other form exists: Mother and Child, 51cm high bronze 1953 (LH 315)*

293 Half Figure, 1952, Bronze 17cm high, LH 316

294 Standing Figure No.1, 1952, Bronze 24cm high, LH 317

295 Standing Figure No.2, 1952, Bronze 28cm high, LH 318

296 Standing Figure No.3, 1952, Bronze 21cm high, LH 319 *One other form exists: Standing Girl, 152.5cm high elmwood 1952 (LH 319a)*

297 Standing Figure No.4, 1952, Bronze 24.5cm high, LH 320

298 Standing Figure No.5, 1952, Bronze 32cm high, LH 320a

299 Maquette for Three Standing Figures, 1952, Bronze 25.5cm high, LH 321 *One other form exists: Three Standing Figures, 71cm high bronze 1953 (LH 322)*

274
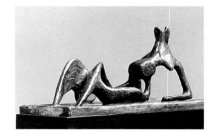

275
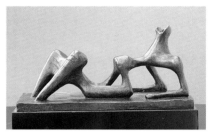

276
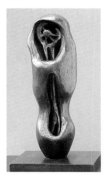

280
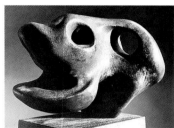

281
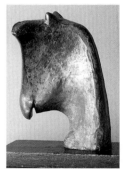

282
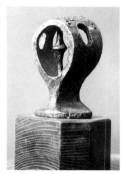

286
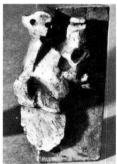

287
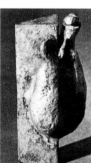

288

289
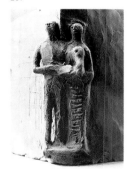

293
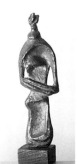

294
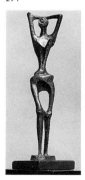

295
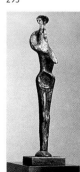

296
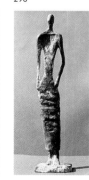

277
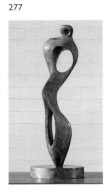

278
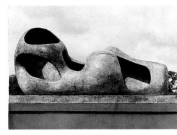

279
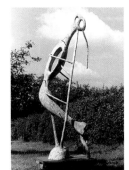

283
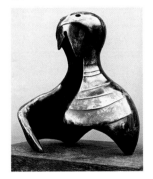

284
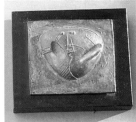

285

290
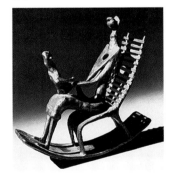

291
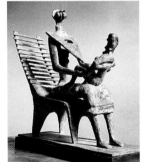

292

297
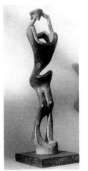

298
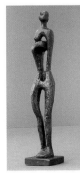

299
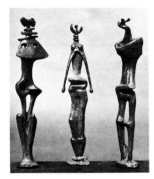

300 Leaf Figure No.2, 1952, Bronze 25.5cm high, LH 324 *One other form exists: Leaf Figure No.4, 49.5cm high bronze 1952 (LH 326)*

301 Leaf Figure No.3, 1952, Bronze 49.5cm high, LH 325 *One other form exists: Leaf Figure No.1, 25.5cm high bronze 1952 (LH 323)*

302 Reclining Figure No.1, 1952, Bronze 20.5cm long, LH 327

303 Reclining Figure No.3, 1952, Bronze 21cm long, LH 330

304 Reclining Figure: Fragment, 1952, Bronze 14cm long, LH 331a *Two other forms exist: Largest is Reclining Figure No.4, 58.5cm long bronze 1954 (LH 332)*

305 Draped Reclining Figure: Fragment, 1953, Bronze 16.5cm long, LH 332a

306 Thin Reclining Figure, 1953, Bronze 15cm long, LH 334

307 Draped Reclining Figure, 1952-3, Bronze 157.5cm long, LH 336 *Two other forms exist: Largest is Head of Draped Reclining Figure, 28cm high bronze 1952-3 (LH 336a)*

308 Reclining Figure No.6, 1954, Bronze 22cm long, LH 337

309 Draped Torso, 1953, Bronze 89cm long, LH 338

310 Miniature Head No.1, 1952, Bronze 4.5cm high, LH 338a

311 Miniature Head No.2, 1952, Bronze 5.5cm high, LH 338b

312 Miniature Head No.3, 1952, Bronze 7cm high, LH 338c

313 Miniature Head No.4, 1952, Bronze 5.5cm high, LH 338d

314 Time/Life Screen: Maquette No.1, 1952, Bronze 18cm high, LH 339

315 Time/Life Screen: Maquette No.2, 1952, Bronze 18cm high, LH 340

316 Time/Life Screen: Maquette No.3, 1952, Bronze 18cm high, LH 341

317 Time/Life Screen: Maquette No.4, 1952, Bronze 18cm high, LH 342 *Two other forms exist: Largest is Time/Life Screen, 305cm high Portland stone 1952-3 (LH 344)*

318 Square Form: Head, 1952, Bronze 15.2cm high, LH 344a

319 Seated Figure, 1952, Bronze 20.5cm high, LH 345

320 Seated Woman on Bench, 1952, Bronze 22cm high, LH 346

321 Maquette for King and Queen, 1952, Bronze 23cm high, LH 348 *Eight other forms exist: Largest is King and Queen, 164cm high bronze 1952-3 (LH 350)*

322 Study for Hands of Queen, 1952, Bronze 12.5cm high, LH 349

323 Study for Head of Queen, 1952, Bronze 22cm high, LH 349a

324 Study for Head of Queen No.2, 1952, Bronze 23.5cm high, LH 349b

325 Hand Relief No.1, 1952, Bronze 34.5cm long, LH 354

300
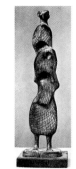

301

302
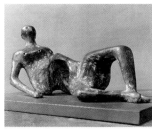

303
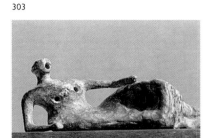

307

308

309

314
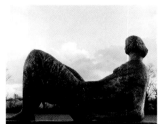

315

319
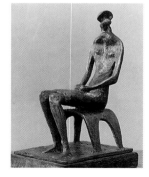

320

321
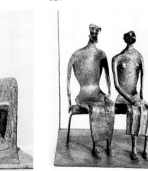

304

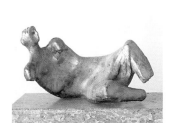

305

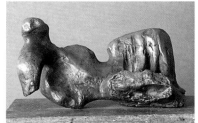

306

310

311

312

313

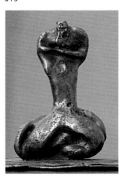

316

317

318

322

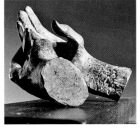

323

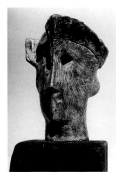

324

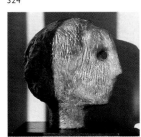

325

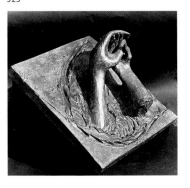

326 Hand Relief No.2, 1952, Bronze 33cm long, LH 355

327 Small Head, 1953, Bronze 7.5cm high, LH 356

328 Head, 1953, Corsham Stone 35.5cm high, LH 356a

329 Head, 1953, Hornton Stone 33cm high, LH 356c

330 Head of Queen, 1953, Green soapstone 27.5cm high, LH 356e

331 Study for Head of Warrior, 1953, Bronze 25.5cm high, LH 358a

332 Reclining Warrior, 1953, Bronze 19.5cm long, LH 358b

333 Warrior with Shield, 1953-4, Bronze 152.5cm high, LH 360
Three other forms exist: Largest is Warrior's Head, 25.5cm high bronze 1953 (LH 359)

334 Maquette for Seated Torso, 1954, Bronze 14cm high, LH 361
One other form exists: Seated Torso, 49.5cm long bronze 1954 (LH 362)

335 Stringed Figure, 1953, Elmwood and string 365.5cm high, LH 362a

336 Harlow Family Group, 1954-5, Hadene stone 164cm high, LH 364
One other form exists: Family Group, 15.6cm high bronze 1944 (LH 227)

337 Wall Relief: Maquette No.1, 1955, Bronze 57cm long, LH 365
One other form exists: Wall Relief, 689cm high brick 1955 (LH 375)

338 Wall Relief: Maquette No.2, 1955, Bronze 44.5cm long, LH 366

339 Wall Relief: Maquette No.3, 1955, Bronze 48cm long, LH 367

340 Wall Relief: Maquette No.4, 1955, Bronze 46cm long, LH 368

341 Wall Relief: Maquette No.5, 1955, Bronze 46cm long, LH 369

342 Wall Relief: Maquette No.6, 1955, Bronze 47cm long, LH 370

343 Wall Relief: Maquette No.7, 1955, Bronze 47cm long, LH 371

344 Wall Relief: Maquette No.9, 1955, Bronze 47cm long, LH 373

345 Wall Relief: Maquette No.10, 1955, Porcelain 35.5cm long, LH 373a

346 Three Forms Relief, 1955, Bronze 32.5cm long, LH 374

347 Upright Motive: Maquette No.1, 1955, Bronze 30.5cm high, LH 376
One other form exists: Upright Motive No.1: Glenkiln Cross, 335.5cm high bronze 1955-6 (LH 377)

348 Upright Motive No.2, 1955-6, Bronze 320cm high, LH 379

349 Upright Motive: Maquette No.3, 1955, Bronze 25.5cm high, LH 380

350 Upright Motive: Maquette No.4, 1955, Bronze 29cm high, LH 381

351 Upright Motive: Maquette No.5, 1955, Bronze 29cm high, LH 382
One other form exists: Upright Motive No.5, 213.5cm high bronze 1955-6 (LH 383)

218

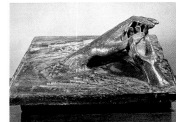
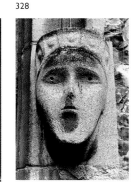

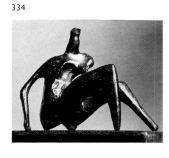

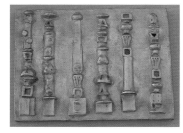

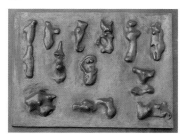

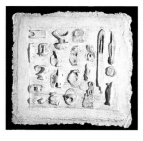

329
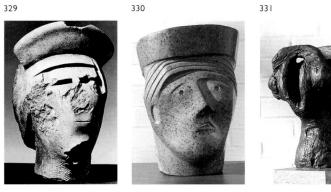
330

331

335

336

337

341

342

343

347
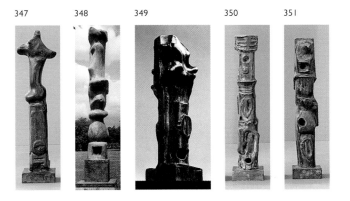
348

349

350

351

352 Upright Motive:
Maquette No.6, 1955, Bronze
30.5cm high, LH 384

353 Upright Motive:
Maquette No.7, 1955, Bronze
32cm high, LH 385
One other form exists: Upright
Motive No.7, 320cm high
bronze 1955-6 (LH 386)

354 Upright Motive:
Maquette No.8, 1955, Bronze
30.5cm high, LH 387
One other form exists: Upright
Motive No.8, 198cm high
bronze 1955-6 (LH 388)

355 Upright Motive:
Maquette No.9, 1955, Bronze
25.5cm high, LH 389

356 Upright Motive:
Maquette No.10, 1955,
Bronze 30.5cm high, LH 390

357 Upright Motive:
Maquette No.11, 1955,
Bronze 31cm high, LH 391

358 Upright Motive:
Maquette No.12, 1955,
Bronze 30.5cm high, LH 392

359 Upright Motive:
Maquette No.13, 1955,
Bronze 30cm high, LH 392a

360 Bird, 1955, Bronze
14cm long, LH 393

361 Object: Bird Form, 1955,
Bronze 10cm long, LH 394

362 Animal Head, 1956,
Bronze 56cm long, LH 396
One other form exists:
Maquette for Animal Head,
11.5cm long bronze 1956
(LH 395)

363 Head: Lines, 1955,
Bronze 30cm high, LH 397

364 Seated Figure: Armless,
1955, Bronze 44.5cm high,
LH 398

365 Standing Figure No.1,
1955, Bronze 24cm high,
LH 399

366 Standing Figure No.2,
1955, Bronze 24cm high,
LH 400

367 Standing Mother and
Child: Holes, 1955, Bronze
22cm high, LH 400a

368 Mother and Child:
Petal Skirt, 1955, Bronze
16.5 cm high, LH 400b

369 Head, 1955, Bronze
14cm high, LH 400c

370 Upright Figure, 1956-60,
Elmwood 274.5cm high,
LH 403
Two other forms exist: Largest
is Reclining Figure, 244cm long
bronze 1956 (LH 402)

371 Maquette for Fallen
Warrior, 1956, Bronze
23cm long, LH 404

372 Falling Warrior,
1956-7, Bronze 147.5cm long,
LH 405

373 Maquette for Mother
and Child with Apple, 1956,
Bronze 17cm high, LH 406a
One other form exists: Mother
and Child with Apple, 74.5cm
high bronze 1956 (LH 406)

374 Mother and Child:
Crossed Feet, 1956, Bronze
23cm high, LH 407

375 Mother and Child:
Uncrossed Feet, 1956, Bronze
20.5cm high, LH 408

376 Mother with Child
on Knee, 1956, Bronze
17cm high, LH 409
One other form exists: Mother
and Child: Fragment, 17cm
long bronze 1956 (LH 409b)

377 Mother and Child, 1956,
Bronze 17cm high, LH 409a

378 Seated Woman:
One Arm, 1956, Bronze
20.5cm high, LH 410

220

352

353

354

360

361

366

367

368
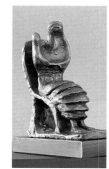

373
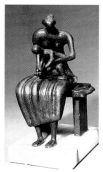
374
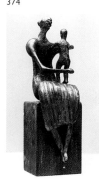
375
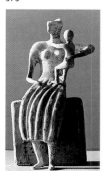

355 356 357 358 359

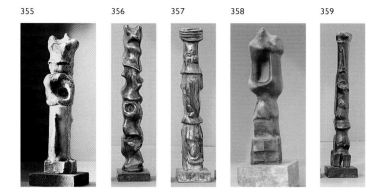

362 363 364 365

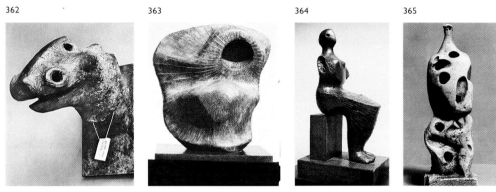

369 370 371 372

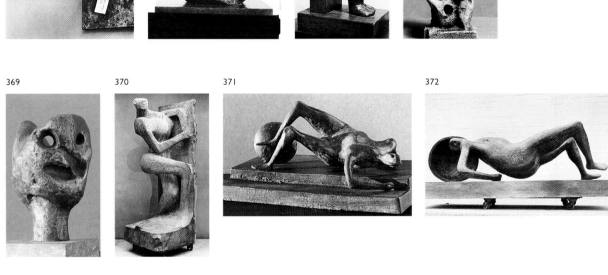

376 377 378

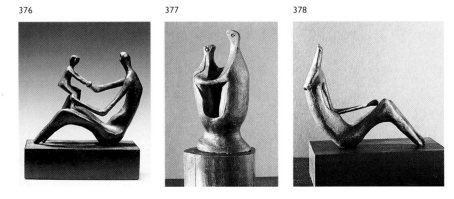

379 Reclining Figure: Goujon, 1956, Bronze 24cm long, LH 411a

380 Draped Reclining Figure, 1957, Bronze 73.5cm long, LH 412 *One other form exists: Draped Reclining Figure, 16.5cm long bronze 1956 (LH 411)*

381 Maquette for Reclining Figure, 1957, Bronze 21.5cm long, LH 413a *One other form exists: Reclining Figure, 70cm long bronze 1957 (LH 413)*

382 Maquette for UNESCO Reclining Figure, 1956, Bronze 22cm long, LH 414 *Three other forms exist: Largest is UNESCO Reclining Figure, 508cm long Roman travertine marble 1957-8 (LH 416)*

383 Mother and Child against Open Wall, 1956, Bronze 20.5cm high, LH 418

384 Seated Woman in Chair, 1956, Bronze 26.5cm high, LH 418a

385 Seated Woman with Book, 1956, Bronze 20cm high, LH 418b

386 Woman with Cat, 1957, Bronze 22cm high, LH 419

387 Seated Girl, 1956, Bronze 21cm high, LH 420

388 Maquette for Seated Figure against Curved Wall, 1955, Bronze 28cm long, (Wall omitted) LH 421 *One other form exists: Seated Figure against Curved Wall, 81.5cm long bronze 1956-7 (LH 422)*

389 Draped Seated Figure against Curved Wall, 1956-7, Bronze 23cm high, LH 423

390 Girl Seated against Square Wall, 1957-8, Bronze102cm high, LH 425 *(Wall omitted)One other form exists: Maquette for Girl Seated against Square Wall, 24cm high bronze 1957 (LH 424)*

391 Draped Seated Woman, 1957-8, Bronze 185.5cm high, LH 428 *Two other forms exist: Largest is Working Model for Draped Seated Woman: Figure on Steps, 65cm high bronze 1956 (LH 427)*

392 Maquette for a Draped Reclining Woman, 1956, Bronze 18cm long, LH 429

393 Draped Reclining Woman, 1957-8, Bronze 208.5cm long, LH 431 *One other form exists: Fragment Figure, 19cm long bronze 1957 (LH 430)*

394 Seated Woman with Crossed Feet, 1957, Bronze 19cm high, LH 432

395 Seated Figure on Ledge, 1957, Bronze 26cm high LH 432a

396 Seated Woman on Curved Block, 1957, Bronze 20.5cm high, LH 433

397 Maquette for Seated Woman, 1956, Bronze 18.5cm high, LH 433a *Two other forms exist: Largest is Working Model for Seated Woman, 76cm high bronze 1980 (LH 433b)*

398 Maquette for Seated Woman, 1956, Bronze 17cm high, LH 434 *One other form exists: Seated Woman, 145cm high bronze 1957 (LH 435)*

399 Seated Figure on Square Steps, 1957, Bronze 23.5cm long, LH 436

400 Seated Figure on Circular Steps, 1957, Bronze 26cm long, LH 437

401 Armless Seated Figure against Round Wall, 1957, Bronze 28cm high, LH 438

402 Woman, 1957-8, Bronze 152.5 high, LH 439

403 Mother and Child, 1958, Bronze 11cm high, LH 439a

404 Maquette for Seated Woman, 1957, Bronze 19cm high, LH 439b *One other form exists: Seated Woman, 190.5cm high bronze 1958-9 (LH 440)*

405 Three Motives against Wall No.1, 1958, Bronze 106.5cm long, LH 441 *One other form exists: Animal Form, 34.5cm high bronze 1959 (LH 443)*

222

379
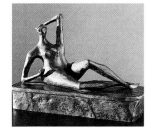

380
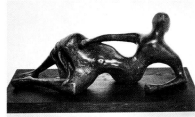

381
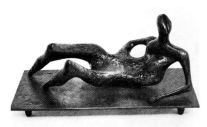

386 387 388
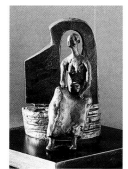 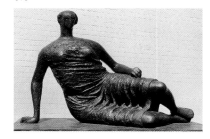 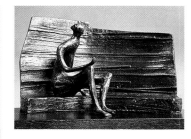

393 394 395
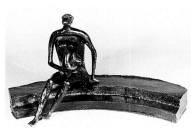 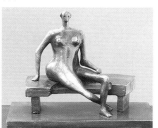 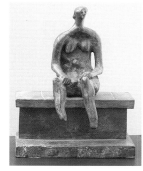

400 401 402
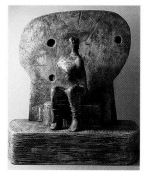 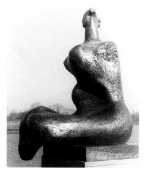

382

383

384

385

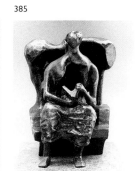

389

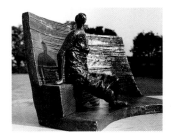

390

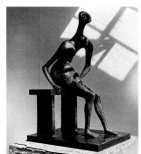

391

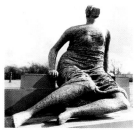

392

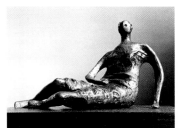

396

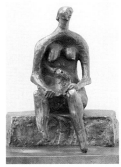

397

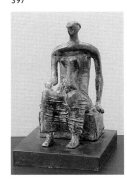

398

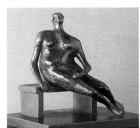

399

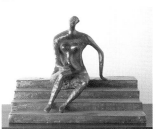

403

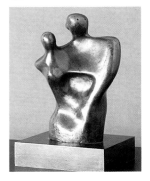

404

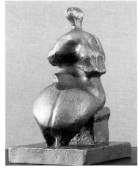

405

406 Three Motives against Wall No.2, 1959, Bronze 107.5cm long, LH 442

407 Round Sculptural Object, 1959, Bronze 11.5cm high, LH 444

408 Bird, 1959, Bronze 38cm long, LH 445

409 Fledgling, 1960, Bronze 18cm long, LH 446

410 Horse, 1959, Bronze 19cm high, LH 447

411 Rearing Horse, 1959, Bronze 20cm high, LH 447a

412 Animal: Horse, 1960, Bronze 18cm high, LH 448

413 Headless Animal, 1960, Bronze 24cm long, LH 449

414 Sheep, 1960, Bronze 24cm long, LH 449a

415 Maquette for Relief No.1, 1959, Bronze 13.5cm high, LH 450a
One other form exists: Relief No.1, 223.5cm high bronze 1959 (LH 450)

416 Reclining Figure, 1959-64, Elmwood 261.5cm long, LH 452

417 Mother and Child: Hollow, 1959, Bronze 32cm high, LH 453

418 Mother and Child: Arch, 1959, Bronze 49.5cm long, LH 453a

419 Two Seated Figures against Wall, 1960, Bronze 48.5cm high, LH 454

420 Reclining Figure: Bowl, 1960, Bronze 28cm long, LH 455

421 Maquette for Two Piece Reclining Figure No.1, 1959, Bronze 16cm long, LH 457a
One other form exists: Two Piece Reclining Figure No.1, 193cm long bronze 1959 (LH 457)

422 Two Piece Reclining Figure No.2, 1960, Bronze 259cm long, LH 458

423 Seated Woman: Shell Skirt, 1960, Bronze 22cm high, LH 459

424 Standing Figure Relief No.1, 1960, Bronze 25.5cm high, LH 460

425 Standing Figure Relief No.2, 1960, Bronze 25.5cm high, LH 461

426 Two Torsos, 1960, Bronze 20.5cm long, LH 462

427 Maquette for Seated Figure: Arms Outstretched, 1960, Bronze 16.5cm high, LH 463
One other form exists: Working Model for Seated Figure: Arms Outstretched, 63.5cm high bronze (LH 463a)

428 Maquette for Reclining Figure, 1960, Bronze 21cm long, LH 464

429 Square Head, 1960, Bronze 28cm high, LH 466

430 Helmet Head No.3, 1960, Bronze 29.5cm high, LH 467

406
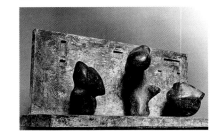

407
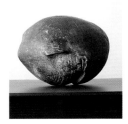

408
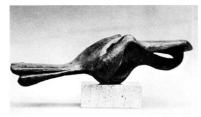

412
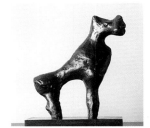

413
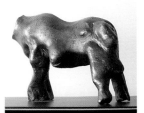

414
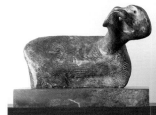

419
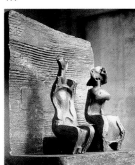

420
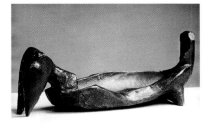

425

426

427

409

410

411

415

416

417

418

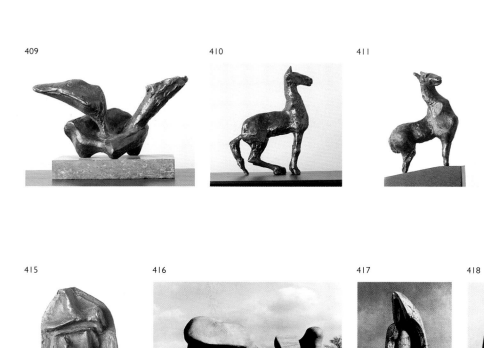

421

422

423

424

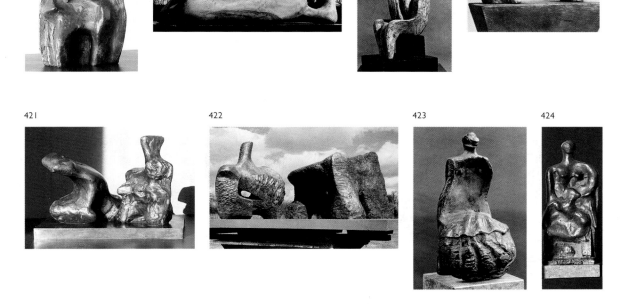

428

429

430

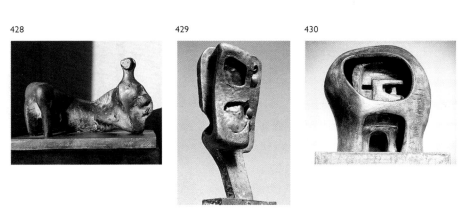

431 Small Head: Strata, 1960, Bronze 12cm high, LH 468

432 Head of a Girl, 1960, Bronze 25.5cm high, LH 468a

433 Sculptural Object, 1960, Bronze 46.5cm high, LH 469

434 Three Part Object, 1960, Bronze 123cm high, LH 470

435 Seated Woman: Thin Neck, 1961, Bronze 162.5cm high, LH 472
One other form exists: Maquette for Seated Woman: Thin Neck, 25.5cm high bronze 1960 (LH 471)

436 Two Piece Reclining Figure: Maquette No.1, 1960, Bronze 24cm long, LH 473

437 Two Piece Reclining Figure: Maquette No.2, 1961, Bronze 25.5cm long, LH 474

438 Two Piece Reclining Figure: Maquette No.3, 1961, Bronze 20.5cm long, LH 475
One other form exists: Two Piece Reclining Figure No.5, 373cm long bronze 1963-4 (LH 517)

439 Two Piece Reclining Figure: Maquette No.4, 1961, Bronze 21cm long, LH 476

440 Two Piece Reclining Figure: Maquette No.5, 1962, Bronze 15cm long, LH 477

441 Two Piece Reclining Figure No.3, 1961, Bronze 239cm long, LH 478

442 Two Piece Reclining Figure No.4, 1961, Bronze 109cm long, LH 479

443 Reclining Mother and Child, 1960-61, Bronze 220cm long, LH 480

444 Standing Figure: Knife Edge, 1961, Bronze 284.5cm high, LH 482
Two other forms exist: Largest is Large Standing Figure: Knife Edge, 358cm high bronze 1961 (LH 482a)

445 The Wall: Background for Sculpture, 1962, Bronze 254cm long, LH 483

446 Seated Figure: Cross Hatch, 1961, Bronze 13.5cm high, LH 484

447 Draped Seated Figure: Headless, 1961, Bronze 20.5cm high, LH 485

448 Seated Figure: Armless, 1961, Bronze 12.5cm high, LH 486

449 Seated Figure: Armless Draped, 1961, Bronze 17cm high, LH 486a

450 Three-Quarter Figure, 1961, Bronze 38cm high, LH 487

451 Woman, 1961, Bronze 18cm high, LH 488

452 Reclining Figure: Bunched, 1961, Bronze 14.5cm long, LH 489
One other form exists: Reclining Figure: Bunched, 190cm long travertine marble 1961/69 (LH 489a)

453 Reclining Figure: Bunched No.2, 1961, Bronze 13.5cm long, LH 489b

454 Maquette for Stone Memorial No.1, 1961, Bronze 13.5cm high, LH 490

455 Maquette for Stone Memorial No.2, 1961, Bronze 10cm high, LH 491
Two other forms exist: Largest is Stone Memorial, 180.5cm long travertine marble 1961/69 (LH 491b)

456 Head: Cross Hatch, 1961, Bronze 13.5cm high, LH 492

457 Emperors' Heads, 1961, Bronze 21cm long, LH 493a

431
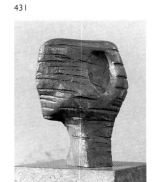

432
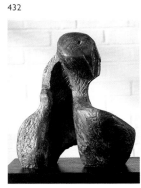

433
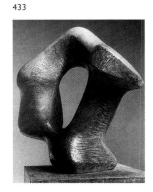

438
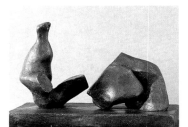

439
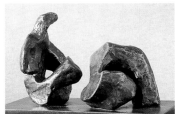

440
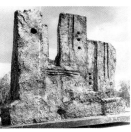

444
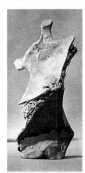

445
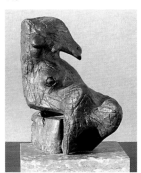

446
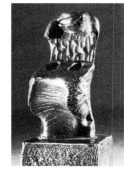

447
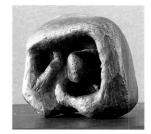

452
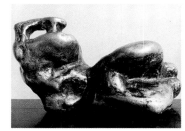

453
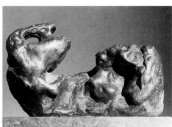

454
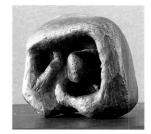

434

435

436

437

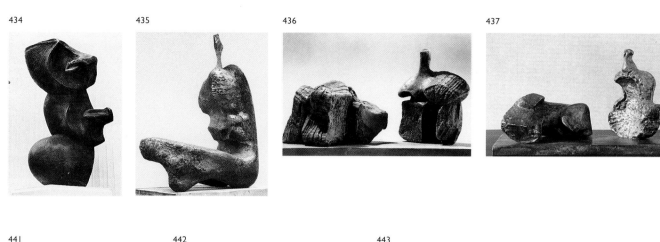

441

442

443

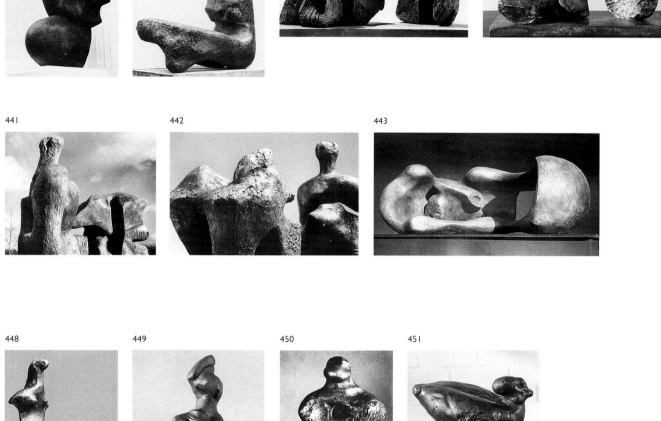

448

449

450

451

455

456

457

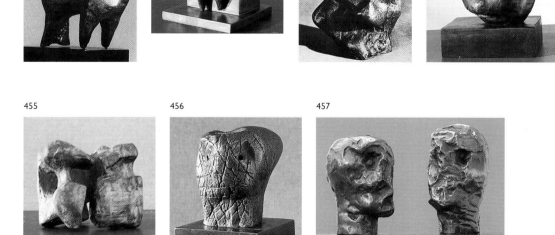

458 Split Head, 1961, Bronze 10cm high, LH 494

459 Frontal Sculpture, 1961, Bronze 6.5cm high, LH 494a

460 Snake Head, 1961, Bronze 10cm high, LH 495

461 Sculpture: Hollow and Bump, 1961, Bronze 10cm high, LH 496

462 Mother and Child, 1961, Bronze 8.5cm high, LH 497

463 Upright Motive: Saw Edge, 1961, Bronze 14.5, LH 498

464 Three Piece Reclining Figure: Maquette No.1, 1961, Bronze 19.5cm long, LH 499

465 Three Piece Reclining Figure No.1, 1961-2, Bronze 287cm long, LH 500

466 Three Piece Reclining Figure: Maquette No.2: Polished, 1962, Bronze 21.5cm long, LH 501

467 Slow Form: Tortoise, 1962, Bronze 21.5cm long, LH 502
One other form exists: Large Slow Form, 77cm long bronze 1962/68 (LH 502a)

468 Maquette for Large Torso: Arch, 1962, Bronze 11cm high, LH 503a
Three other forms exist: Largest is The Arch, 610cm high bronze 1963/69 (LH 503b)

469 Working Model for Knife Edge Two Piece, 1962, Bronze 71cm long, LH 504
Three other forms exist: Largest is Mirror Knife Edge, 762cm long bronze 1977 (LH 714)

470 Maquette for Head and Hand, 1962, Bronze 18cm high, LH 505
Two other forms exist: Largest is Moon Head, 57cm high bronze 1964 (LH 521)

471 Ear Piece, 1962, Bronze 18cm high, LH 505a

472 Sculptural Form, 1962, Bronze 25cm high, LH 505b

473 Divided Head, 1963, Bronze 35cm high, LH 506

474 Head: Cyclops, 1963, Bronze 30cm high, LH 507

475 Helmet Head No.4: Interior-Exterior, 1963, Bronze 47.5cm high, LH 508

476 Head: Boat Form, 1963, Bronze 15cm long, LH 509
One other form exists: Large Totem Head, 244cm high bronze 1968 (LH 577)

477 Mother and Child: Wheels, 1962, Bronze 28cm high with base, LH 510

478 Torso, 1962, Bronze 11.5cm high, LH 510a

479 Mother and Child: Bone, 1963, Bronze 19cm high, LH 511

480 Mother and Child: Round Head, 1963, Bronze 28.5cm high, LH 512

481 Three Piece Reclining Figure No.2: Bridge Prop, 1963, Bronze 251.5cm long, LH 513

482 Three Piece Reclining Figure, 1963, Bronze 22cm long, LH 513a

483 Locking Piece, 1963-4, Bronze 293.5cm high, LH 515
One other form exists: Working Model for Locking Piece, 106.5cm high bronze 1962 (LH 514)

484 Reclining Figure, 1963-5, Bronze 855cm long, LH 519
One other form exists: Working Model for Reclining Figure (Lincoln Centre), 427cm long bronze 1963-5 (LH 518)

228

458
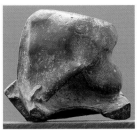

459
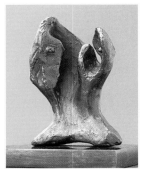

460
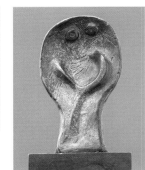

465
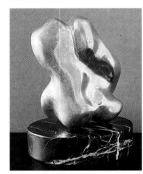

466
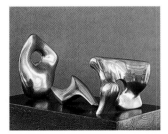

471
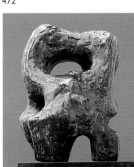

472
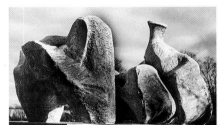

473
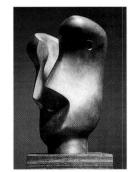

478
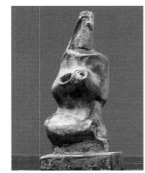

479
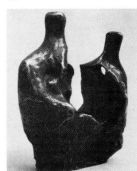

480
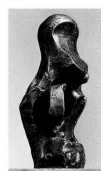

461 462 463 464

467 468 469 470

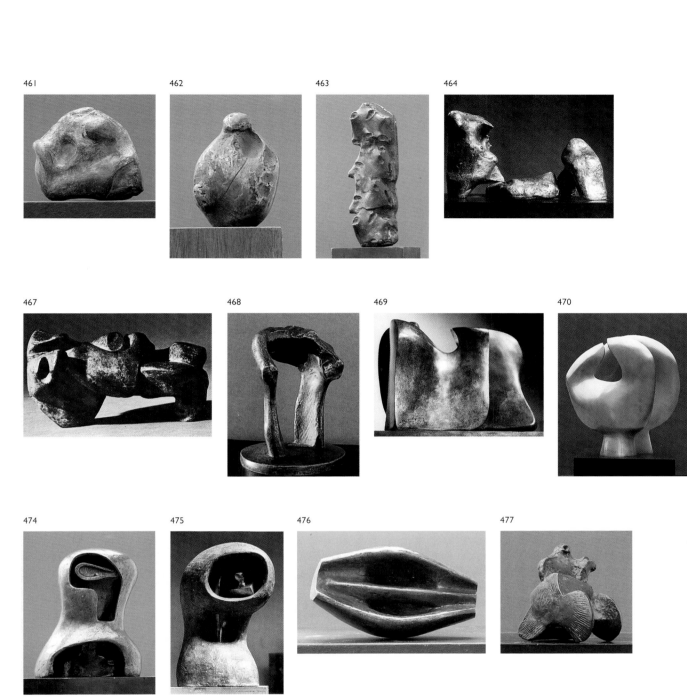

474 475 476 477

481

482

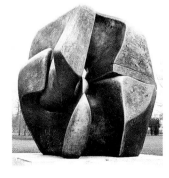

483

484

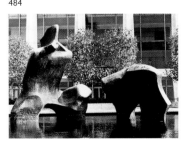

230

485 Two Piece Reclining Figure: Maquette No.6, 1964, Bronze 24cm long, LH 520

486 Profile Head, c. 1964, Bronze 7.5cm high, LH 522a

487 Small Head, c. 1965, Bronze 7.5cm high, LH 522b

488 Head: Profile, c.1964, Bronze 22cm high, LH 522c

489 Head, c.1964, Bronze 31cm high, LH 522d

490 Thin Head, 1964, Bronze 12cm high, LH 523

491 Nuclear energy, 1964-6, Bronze 366cm high, LH 526
Two other forms exist: Largest is Atom Piece (Working Model for Nuclear Energy), 120cm high bronze 1964-5 (LH 525)

492 Working Model for Sundial, 1965, Bronze 56cm high, LH 527
One other form exists: Sundial, 366cm high bronze 1965-6 (LH 528)

493 Two Forms, 1964, White marble 46cm long, LH 529

494 Oval Sculpture, 1964, Bronze 44cm high, LH 530

495 Maquette for Three Way Piece No.1, 1964, Bronze 9cm long, LH 531
Two other forms exist: Largest is Three Way Piece No.1: Points, 193cm high bronze 1964-5 (LH 533)

496 Archer, 1965, White marble 80cm high, LH 536
Two other forms exist: Largest is Three Way Piece No.2: (The) Archer, 340cm long bronze 1964-5 (LH 535)

497 Maquette for Reclining Interior Oval, 1965, Bronze 18cm long, LH 537
One other form exists: Reclining Interior Oval, 213cm long red travertine marble 1965 (LH 538)

498 Thin Standing Figure, 1965, Bronze 19cm high, LH 539 *Two other forms exist: Largest is Two Three-Quarter Figures on Base, 101.5cm high bronze cast 1984 (LH 539b)*

499 Mother with Child on Back, 1965, Bronze 17cm high, LH 540

500 Globe and Anvil, 1966, Bronze 20cm high, LH 541
One other form exists: Anvil, 57cm long bronze 1966 (LH 542)

501 Two Piece Sculpture No.7: Pipe, 1966, Bronze 94cm long, LH 543

502 Helmet Head No.5, 1966, Bronze 42cm high, LH 544
One other form exists: Interior Form, 32cm high bronze 1966 (LH 545)

503 Owl, 1966, Bronze 20cm high, LH 546

504 Two Piece Reclining Figure: Maquette No.8, 1966, Bronze 24cm long, LH 547

505 Three Rings, 1966, Rosa aurora 100cm long, LH 548
Two other forms exist: Largest is Three Rings, 269cm long red travertine marble 1966 (LH 549)

506 Maquette for Upright Form, 1966, Bronze 7cm high, LH 550a
Two other forms exist including Upright Form, 60cm high rosa aurora 1966 (LH 551)

507 Girl Torso, 1966, Bronze 22cm high, LH 553

508 Torso, 1966, White marble 79cm high, LH 554

509 Two Forms, 1966, Red travertine marble 152cm long, LH 555
Two other forms exist: Largest is Large Two Forms, 610cm long bronze 1966 (LH 556)

510 Reclining Form, 1966, White marble 114 long, LH 557

511 Maquette for Double Oval, 1966, Bronze 24cm long, LH 558
Two other forms exist: Largest is Double Oval, 550cm long bronze 1966 (LH 560)

485
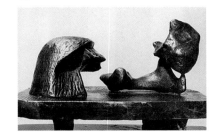

486

487

492
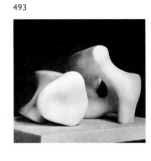

493
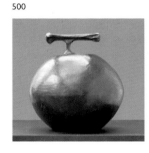

494
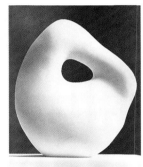

499

500
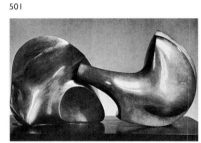

501

506

507

508

488 489 490 491

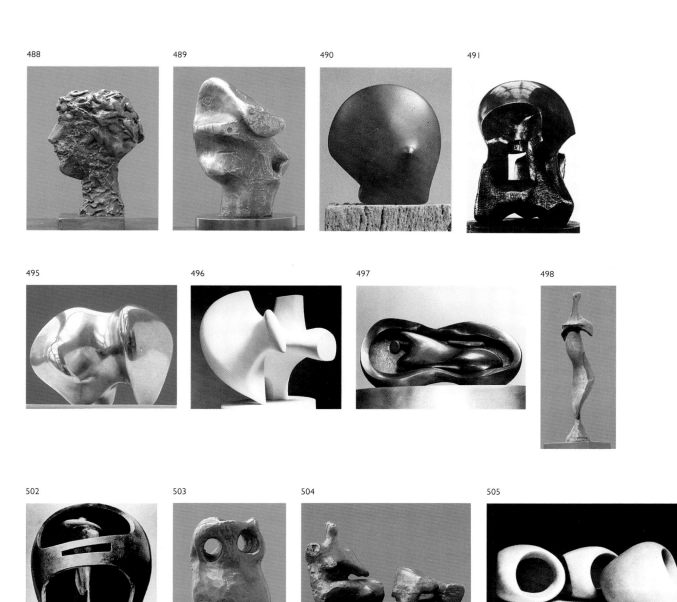

495 496 497 498

502 503 504 505

509 510 511

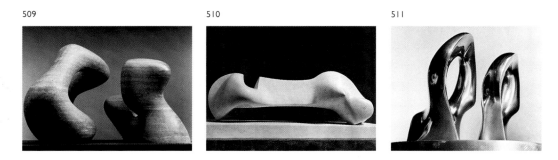

512 Maquette for Two Nuns, 1966, Bronze 10cm high, LH 561
One other form exists: Two Nuns, 151cm high white marble 1966-8 (LH 562)

513 Standing Girl: Bonnet and Muff, 1966, Bronze 23cm high, LH 563

514 Maquette for Reclining Figure: Cloak, 1966, Bronze 12cm long, LH 564
One other form exists: Reclining Figure: Cloak, 37cm long bronze 1967 (LH 565)

515 Standing Figure: Shell Skirt, 1967, Bronze 18cm high, LH 566

516 Doll Head, 1967, Bronze 10cm high, LH 567

517 Maquette for Torso, 1967, Bronze 9cm high, LH 568
Two other forms exist: Largest is Torso with Point, 137cm long bronze 1967 (LH 570)

518 Working Model for Divided Oval: Butterfly, 1967, Bronze 91.5cm long, LH 571a
Two other forms exist: Largest is Large Divided Oval: Butterfly, 800cm long bronze cast 1985/6 (LH 571b)

519 Girl: Half Figure, 1967, Rosa aurora 85cm high, LH 572

520 Mother and Child, 1967, Rosa aurora 130cm long, LH 573

521 Maquette for Sculpture with Hole and Light, 1967, Bronze 10cm long, LH 574
One other form exists: Sculpture with Hole and Light, 127cm long red travertine marble 1967 (LH 575)

522 Maquette for Two Piece Reclining Figure No.9, 1967, Bronze 23cm long, LH 575a
One other form exists: Two Piece Reclining Figure No.9, 249cm long bronze 1968 (LH 576)

523 Maquette for Three Piece No.3: Vertebrae, 1968, Bronze 19cm long, LH 578
Three other forms exist: Largest is Three Forms Vertebrae, 1219cm long bronze 1978/9 (LH 580a)

524 Maquette for Two Piece Sculpture No.10, 1968, Bronze 12.5cm long, LH 580b
One other form exists: Two Piece Sculpture No.10: Interlocking, 91cm long bronze 1968 (LH 581)

525 Maquette for Two Piece Sculpture No.11, 1968, Bronze 10cm long, LH 582

526 Two Piece Carving: Interlocking, 1968, White Marble 71cm long, LH 583

527 Interlocking Two Piece Sculpture, 1968-70, White Marble 315cm long, LH 584

528 Bust of a Girl: Two Piece, 1968, Rosa aurora 78cm high, LH 585

529 Upright Motive A, 1968, Bronze 29cm high, LH 586
One other form exists: Upright Motive No.9, 335.5cm high bronze 1979 (LH 586a)

530 Upright Motive B, 1968, Bronze 29cm high, LH 587

531 Upright Motive C, 1968, Bronze 30cm high, LH 588

532 Upright Motive D, 1968, Bronze 30cm high, LH 589

533 Upright Motive E, 1968, Bronze 30cm high, LH 590

534 Maquette for Spindle Piece, 1968, Bronze 16cm high, LH 591 *Three other forms exist: Largest is Large Spindle Piece, 450cm high travertine marble 1981 (LH 593a)*

535 Maquette for Oval with Points, 1968, Bronze 14cm high, LH 594
Two other forms exist: Largest is Oval with Points, 332cm high bronze 1968-70 (LH 596)

536 Maquette for Square Form with Cut, 1969, Bronze 16.5cm high, LH 597 *Two other forms exist: Largest is Large Square Form with Cut, 545cm high Rio Serra marble 1969-71 (LH 599)*

537 Two Piece Points: Skull, 1969, Bronze 76cm high, LH 600

538 Pointed Torso, 1969, Bronze 66cm high, LH 601

512

513

514

519
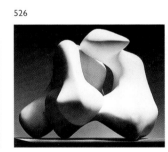

520

521

525
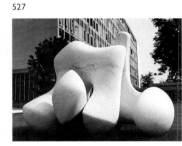

526

527

533
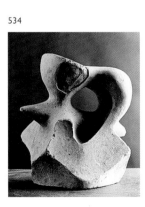

534

535
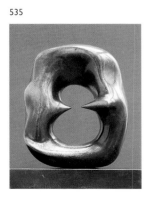

515
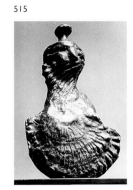

516
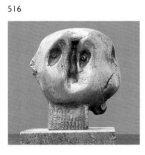

517
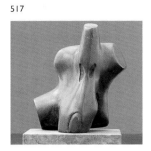

518
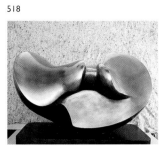

522
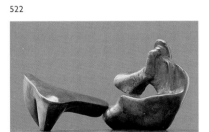

523
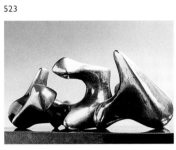

524
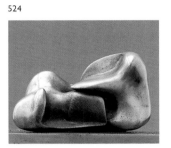

528
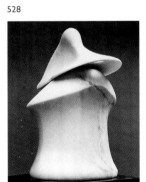

529
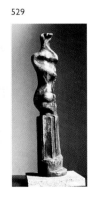

530
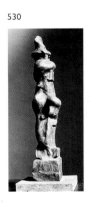

531
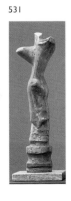

532
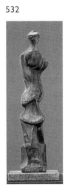

536
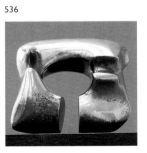

537
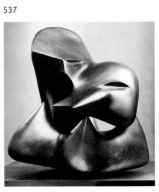

538
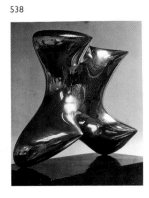

539 Architectural Project, 1969, Bronze 64cm long, LH 602

540 Reclining Figure: Points, 1969, Bronze16cm long, LH 603

234

541 Maquette for Two Piece Reclining Figure: Points, 1969, Bronze 14cm long, LH 604 *Two other forms exist: Largest is Two Piece Reclining Figure: Points, 365cm long bronze 1969-70 (LH 606)*

542 Maquette for Reclining Figure, 1969, Bronze 15cm long, LH 607 *One other form exists: Reclining Figure, 343cm long bronze 1969-70 (LH 608)*

543 Maquette for Reclining Figure: Arch Leg, 1969, Bronze 18cm long, LH 609 *One other form exists: Reclining Figure: Arch Leg, 442cm long 1969-70 (LH 610)*

544 Maquette for Reclining Connected Forms, 1969, Bronze 18cm long, LH 611 *Three other forms exist: Largest is Large Reclining Connected Forms, 802cm long Roman travertine marble 1969 (LH 613)*

545 Two Forms, 1969, White marble 89cm long, LH 614

546 Working Model for Animal Form, 1969-71, Bronze 66cm long, LH 615 *Two other forms exist: Largest is Large Animal Form, 274cm long travertine marble 1969-70 (LH 617)*

547 Arch Form, 1970, Serpentine 210cm long, LH 618

548 Maquette for Oblong Composition, 1970, Bronze 14cm long, LH 619 *One other form exists: Oblong Composition, 120cm long red travertine marble 1970 (LH 620)*

549 Bridge Form, 1971, Bronze 71cm long, LH 621

550 Fledglings, 1971, Bronze 16cm long, LH 622

551 Bird Form I, 1973, Black marble 37cm long, LH 623

552 Bird Form II, 1973, Black marble 40cm long, LH 624

553 Maquette for Sheep Piece, 1969, Bronze 14cm long, LH 625 *Two other forms exist: Largest is Sheep Piece, 570cm high bronze 1971-2 (LH 627)*

554 Large Four Piece Reclining Figure, 1972-3, Bronze 402cm long, LH 629 *One other form exists: Four Piece Reclining Figure, 74cm long bronze 1972 (LH 628)*

555 Three Way Piece Carving, 1972, Carrara marble 48cm long, LH 631

556 Double Tongue Form, 1972, Carrara marble 76cm long, LH 632

557 Head, 1972, Travertine marble 46cm high, LH 633

558 Maquette for Hill Arches, 1972, Bronze 11cm long, LH 634 *Two other forms exist: Largest is Hill Arches, 550cm long bronze 1973 (LH 636)*

559 Serpent, 1973, Bronze 24cm long, LH 637

560 Bust of a Girl, 1973, Bronze 12cm high, LH 638

561 Column, 1973, Bronze 17cm high, LH 639

562 Maquette for Goslar Warrior, 1973, Bronze 24.5cm long, LH 640 *One other form exists: Goslar Warrior, 300cm long bronze 1973-4 (LH 641)*

563 Reclining Figure: Bone, 1974, Bronze 27cm long, LH 642 *One other form exists: Reclining Figure: Bone, 157.5cm long travertine marble 1975 (LH 643)*

564 Maquette for Carving: Points, 1974, Bronze 12.5cm long, LH 643a *One other form exists: Carving: Points, 86cm long rosa aurora 1974 (LH 644)*

565 Maquette for Animal Carving, c. 1969, Bronze 11cm long, LH 645 *One other form exists: Animal Carving, 63.5cm long rosa aurora 1974 (LH 646)*

539
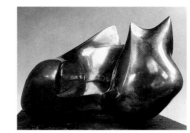

540
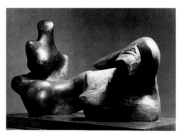

541
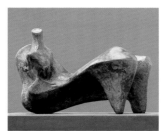

545
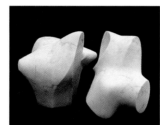

546
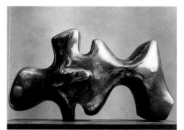

547
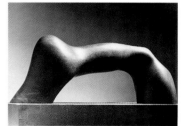

552
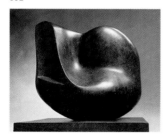

553
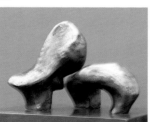

554
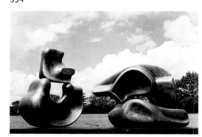

559
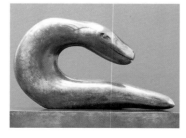

560
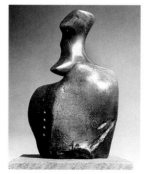

561
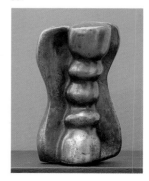

542
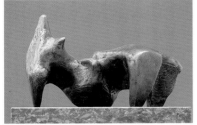

543
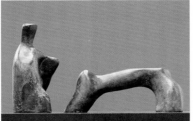

544
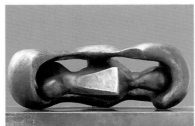

548
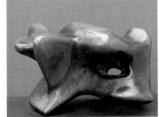

549
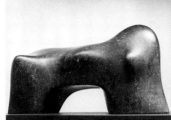

550
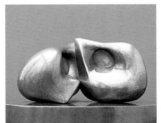

551
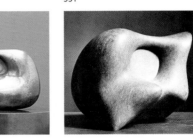

555

556

557

558

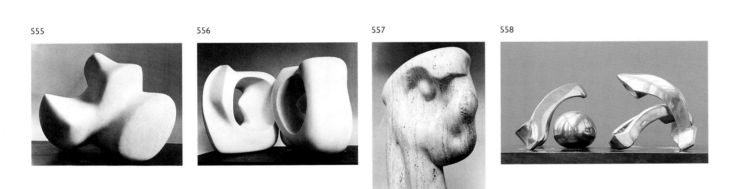

562

563

564

565

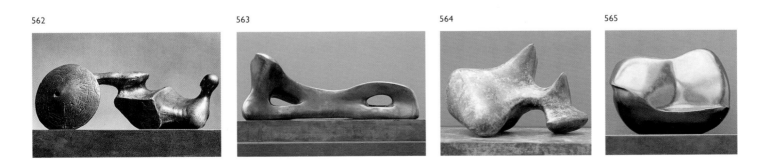

566 Maquette for Reclining Mother and Child, 1974, Bronze 18cm long, LH 647
Two other forms exist: Largest is Reclining Mother and Child, 213cm long bronze 1975-6 (LH 649)

567 Maquette for Helmet Head No.6, 1975, Bronze 11cm high, LH 650
Five other forms exist: Largest is Large Figure in a Shelter, 762 cm high bronze cast 1985-6 (LH 652c)

568 Helmet Head No.7, 1975, Bronze 11cm high, LH 652

569 Maquette for Three Piece Reclining Figure: Draped, 1975, Bronze 25cm long, LH 653
Two other forms exist: Largest is Three Piece Reclining Figure: Draped, 447cm long bronze 1975 (LH 655)

570 Maquette for Reclining Figure: Holes, 1975, Bronze 23.5cm long, LH 656
One other form exists: Reclining Figure: Holes, 222cm long elmwood 1976-8 (LH 657)

571 Standing Woman: Bonnet, 1975, Bronze 19cm high, LH 658

572 Standing Girl: Shell Skirt, 1975, Bronze 17.5cm, LH 659

573 Standing Woman: Shell Skirt, 1975, Bronze 17cm high, LH 660

574 The Matron, 1975, Bronze 22cm high, LH 661

575 Broken Figure, 1975, Bronze19cm long, LH 662
One other form exists: Broken Figure, 109cm long black marble 1975 (LH 663)

576 Bird in Hand, 1975, Bronze 16cm long, LH 664

577 Reclining Mother and Child: Shell Skirt, 1975, Bronze 20cm long, LH 665

578 Two Piece Reclining Figure: Holes, 1975, Bronze 22cm long, LH 666 *One other form exists: Two Piece Reclining Figure: Holes, 128cm long white marble 1975 (LH 667)*

579 Two Piece Reclining Figure: Bust, 1975, Bronze 19cm long, LH 668
One other form exists: Two Piece Reclining Figure: Bust, 108cm long white marble 1975 (LH 669)

580 Two Forms, 1975, Roman travertine marble 88cm long, LH 670

581 Girl: Bust, 1975, Roman travertine marble 69cm high, LH 671

582 Reclining Figure: Spider, 1975, Bronze 18cm long, LH 672

583 Maquette for Reclining Figure: Angles, 1975, Bronze 23.5cm long , LH 673
Two other forms exist: Largest is Reclining Figure: Angles, 218cm long bronze 1979 (LH 675)

584 Maquette for Reclining Figure: Prop, 1975, Bronze 28cm long, LH 676
Two other forms exist: Largest is Reclining Figure, 236cm long bronze 1982 (LH 677a)

585 Three Piece Reclining Figure: Maquette No.4, 1975, Bronze 18cm long, LH 678

586 Seated Mother and Child, 1975, Bronze 16cm long, LH 679

587 Girl and Dwarf, 1975, Bronze 15.5cm high, LH 680

588 Animal, 1975, Bronze 19cm long, LH 681

589 Mother and Child, 1975, Bronze 15cm high (with base) LH 682

590 Standing Mother and Child, 1975, Bronze 23cm high, LH 683

591 Mother and Child: Gothic, 1975 Bronze 19cm high, LH 684

592 Two Piece Reclining Figure: Armless, 1975, Bronze 61cm long, LH 685
One other form exists: Two Piece Reclining Figure: Armless, 222cm long black granite 1977 (LH 686)

566
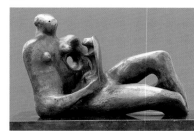

567
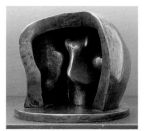

568
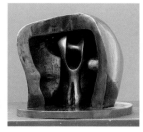

573

574

575

579

580
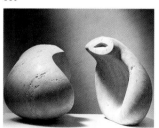

581
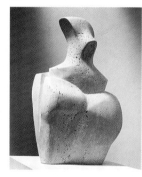

585
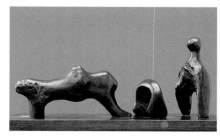

586
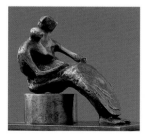

587

569

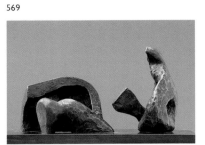

570

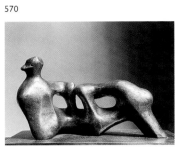

571

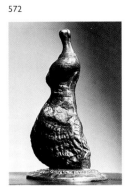

572

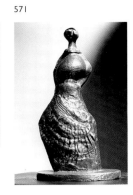

576

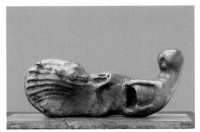

577

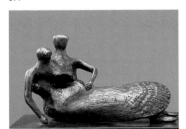

578

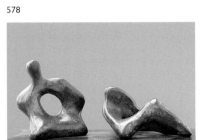

582

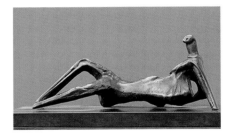

583

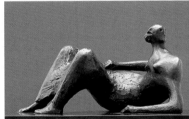

584

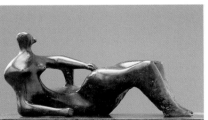

588

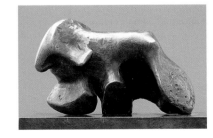

589

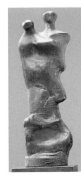

590

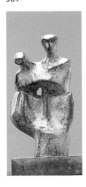

591

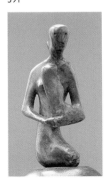

592

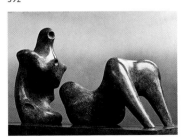

593 Reclining Figure Curved: Smooth, 1976, Bronze 21cm long, LH 688 *Two other forms exist: Largest is Reclining Figure: Curved, 144cm long black marble 1977 (LH 689)*

594 Reclining Figure: Single Leg, 1976, Bronze 23cm long, LH 690 *One other form exists: Reclining figure: Single Leg, 185cm long black granite 1976 (LH 691)*

595 Two Piece Reclining Figure: Thin, 1976, Bronze 25cm long, LH 692

596 Reclining Figure: Thin, 1976, Bronze 26cm long, LH 693

597 Two Piece Reclining Figure: Double Circle, 1976, Bronze 22cm long, LH 694 *One other form exists: Two Piece Reclining Figure: Double Circle, 119cm long black marble 1976 (LH 695)*

598 Mother and Child: Pisano, 1976, Bronze 14cm high, LH 696

599 Marquette for Mother and Child: Arms, 1976, Bronze 20cm long, LH 697 *One other form exists: Mother and Child: Arms, 80cm long bronze 1976-80 (LH 698)*

600 Mother and Child: Mould, 1976-7, Bronze 66cm long, LH 699

601 Twin Heads, 1976, Bronze 16cm long, LH 700 *One other form exists: Head, 38cm high black marble 1976 (LH 701)*

602 Butterfly, 1976, Bronze 7.7cm long, LH 702 *One other form exists: Butterfly, 47cm long marble 1977 (LH 703)*

603 Draped Reclining Figure, 1976, Bronze 20cm long, LH 704 *Two other forms exist: Largest is Draped Reclining figure, 182cm long travertine marble 1978 (LH 706)*

604 Maquette for Reclining Figure: Hand, 1976, Bronze 19cm long, LH 707 *Two other forms exist: Largest is Reclining Figure: Hand, 221cm long bronze 1979 (LH 709)*

605 Reclining Figure: Crossed Legs, 1976, Bronze 20cm long, LH 710

606 Reclining Figure: Matrix, 1976, Bronze 20cm long, LH 711

607 Reclining Figure: Umbilicus, 1976, Bronze 20cm long, LH 712

608 Three Upright Motives, 1977, Bronze 20cm high, LH 715 *Two other forms exist: Largest is Two Standing Figures, 246.5cm high travertine marble 1981 (LH 715a)*

609 Mother and Child: Egg form, 1977, Bronze 17cm high, LH 716 *One other form exists: Mother and Child: Egg Form, 194cm high white marble 1977 (LH 717)*

610 Egg form: Pebbles, 1977, Bronze 11cm long, LH 718 *One other form exists: Egg Form: Pebbles, 100cm long white crystalline marble 1977 (LH 719)*

611 Three Piece Reclining Figure: Maquette No.5, 1977, Bronze 25cm long, LH 720

612 Reclining Figure: Stiff Leg, 1977, Bronze 27cm long, LH 721

613 Working Model for Reclining Figure: Bone Skirt, 1977-9, Bronze 69cm long, LH 723 *Two other forms exist: Largest is Reclining Figure: Bone Skirt, 175cm long travertine marble 1978 (LH 724)*

614 Relief: Reclining Figure and Mother and Child, 1977, Bronze 48cm long, LH 725

615 Relief: Seated and Standing Mother and Child, 1977, Bronze 48cm long, LH 726

616 Relief: Seated Mother and Child, 1977, Bronze 32cm high, LH 727

617 Relief: Three-Quarters Mother and Child and Reclining Figure, 1977, Bronze 42cm long, LH 728

618 Mother and Child: Hair, 1977, Bronze 17cm high, LH 729

619 Maquette for Mother and Child: Upright, 1977, Bronze 22cm high, LH 730 *One other form exists: Mother and Child: Upright, 58cm high bronze 1978 (LH 731)*

593
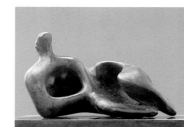

594
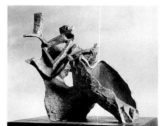

595
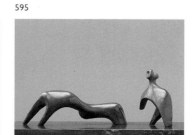

600
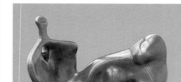

601
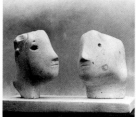

602
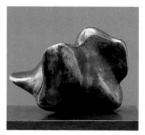

607
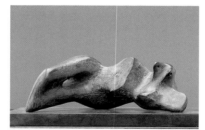

608
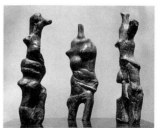

609
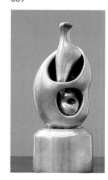

614

615

616
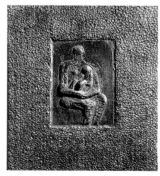

596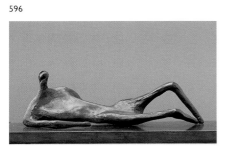

597

598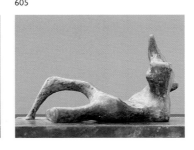

599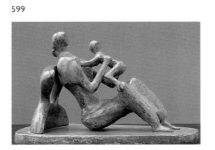

603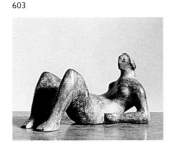

604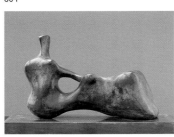

605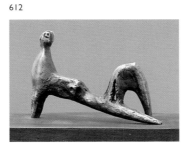

606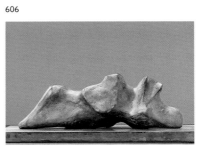

610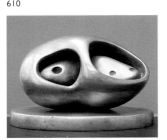

611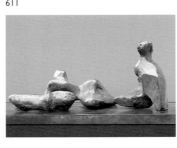

612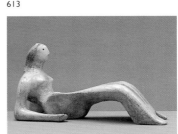

613

617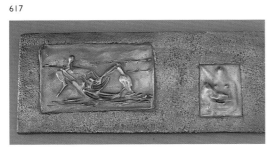

618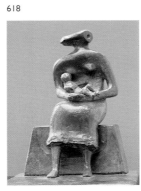

619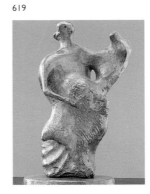

620 Reclining Figure: Wedge Base, 1977, Bronze 16.5cm long, LH 732
Two other forms exist: Largest is Thin Reclining Figure, 196cm long white marble 1979-80 (LH 734)

621 Twisted Torso, 1977, Bronze 11cm, LH 735

622 Torso, 1977, Marble 68cm high, LH 736

623 Picture Frame: Mother and Child, 1977, Bronze 12cm high, LH 737

624 Picture Frame: Roman Matron, 1977, Bronze 12cm high, LH 738

625 Reclining Figure: Flint, 1977, Bronze 21cm long, LH 739

626 Horse, 1978, Bronze 21cm long, LH 740
One other form exists: Horse, 68.5cm long bronze cast 1984 (LH 740a)

627 Three Bathers-After Cézanne, 1978, Bronze 30.5cm long, LH 741

628 Man and Woman I, 1978, Bronze 21cm high, LH 742

629 Man and Woman II, 1978, Bronze 22.5cm high, LH 743

630 Single Standing Figure, 1978, Bronze 16.5cm high, LH 744

631 Single Female Figure, 1978, Bronze 16cm high, LH 745

632 Two Sisters, 1978, Bronze 13cm high, LH 746

633 Egyptian Figures I, 1978, Bronze 13cm high, LH 747

634 Egyptian Figures II, 1978, Bronze 13cm high, LH 748

635 Seated Mother and Baby, 1978, Bronze 20cm high, LH 749

636 Marquette for Reclining Figure: Wing, 1978, Bronze 16cm long, LH 749a
One other form exists: Reclining Figure: Wing, 137cm long travertine marble 1978 (LH 750)

637 Maquette for Reclining Figure No.7, 1978, Bronze 20cm long, LH 751
One other form exists: Reclining Figure No.7, 90cm long bronze 1980 (LH 752)

638 Maquette for Mother and Child, 1978, Bronze 13cm high, LH 753
One other form exists: Mother and Child, 84cm high stalactite 1978 (LH 754)

639 Maquette for Two Piece Reclining Figure: Cut, 1978, Bronze 21cm long, LH 755
Three other forms exist: Largest is Two Piece Reclining Figure: Cut, 470cm long bronze 1979-81 (LH 758)

640 Caricature Head, 1978, Bronze 11cm high, LH 759

641 Smooth Head, 1978, Bronze 12cm high, LH 760

642 Woman and Dog, 1978, Bronze 11cm high, LH 761

643 Family, 1978, Bronze 23.5cm long, LH 762

644 Mother and Child: Towel, 1979, Bronze 27cm high, LH 763

645 Mother and Child: Rubenesque, 1979, Bronze 16cm long, LH 764
One other form exists: Mother and Child: Armless, 16cm long bronze 1979 (LH 765)

646 Head on Bone Base, 1979, Bronze 11cm high, LH 766

620
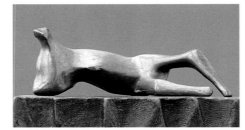

621
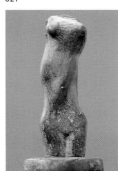

626
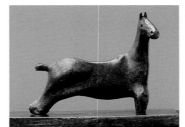

627
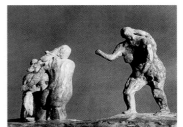

628
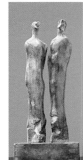

635
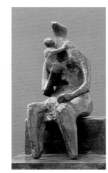

636
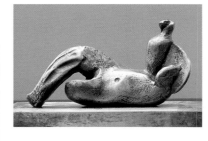

641
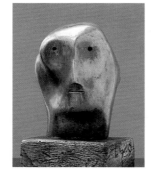

642
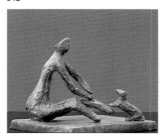

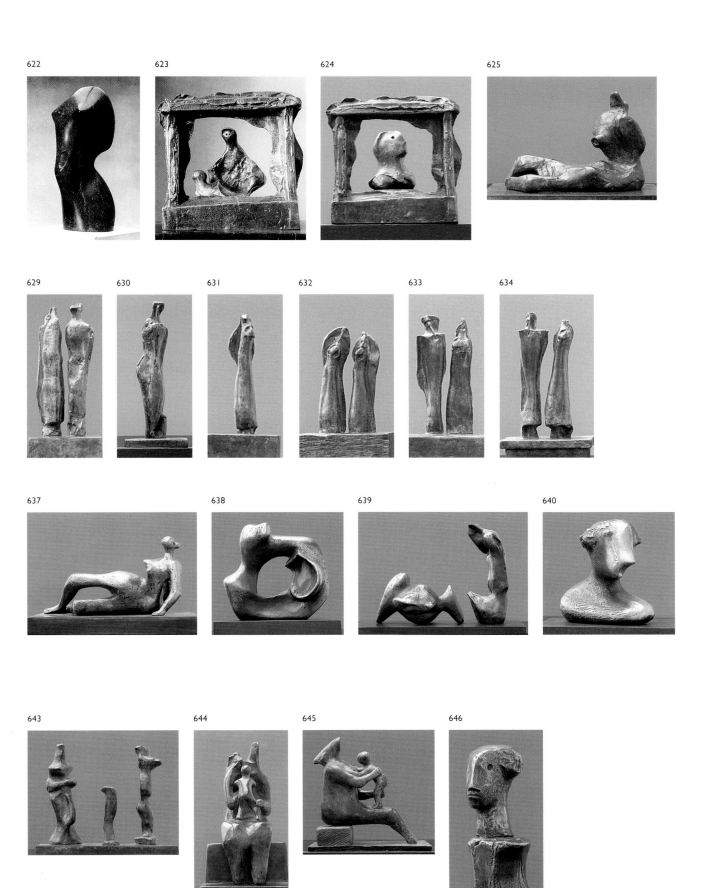

622

623

624

625

629

630

631

632

633

634

637

638

639

640

643

644

645

646

647 Mother and Child: Ovals, 1979, Bronze 15cm high, LH 767

648 Mother and Child: Arm, 1979, Bronze 14cm high, LH 768

649 Mother and Child: Paleo, 1979, Bronze 13cm high, LH 769

650 Mother and Child with Tree Trunk, 1979, Bronze 26cm long, LH 770

651 Tree Figure, 1979, Bronze 18cm high, LH 771

652 Two Standing Figures: Twisting, 1979, Bronze 18cm high, LH 772

653 Relief: Reclining Figure, 1979, Bronze 38.1cm long, LH 773

654 Relief: Two Seated Mother and Child, 1979, Bronze 31cm long, LH 774

655 Maquette for Girl with Crossed Arms, 1979, Bronze 15cm high, LH 775
One other form exists: Girl with Crossed Arms, 72cm high Roman travertine marble 1980 (LH 776)

656 Reclining Figure: Pointed Legs, 1979, Bronze 23cm long, LH 777

657 Reclining Mother and Child I, 1979, Bronze 20cm long, LH 778

658 Reclining Mother and Child II, 1979, Bronze 21cm long, LH 779

659 Reclining Mother and Child III, 1979, Bronze 23cm long, LH 780

660 Reclining Mother and Child IV, 1979, Bronze 20cm long, LH 781

661 Draped Seated Mother and Child on Ground, 1980, Bronze 20.5cm long, LH 783

662 Draped Mother and Child on Curved Bench, 1980, Bronze 19cm high, LH 784

663 Mother and Child: Hands, 1980, Bronze 19.5cm high, LH 785

664 Thin Nude Mother and Child, 1980, Bronze 17cm long, LH 786

665 Draped Woman on Block Seat, 1980, Bronze 15.5cm long, LH 787

666 Reclining Nude: Crossed Feet, 1980, Bronze 16cm long, LH 788

667 Mother and Child: Round Form, 1980, Bronze 19cm high, LH 789

668 Mother and Child: Circular Base, 1980, Bronze 13.5cm high, LH 790

669 Maquette for Curved Mother and Child, 1980, Bronze 18.5cm high, LH 791
One other form exists: Mother and Child: Curved, 58.5cm high bronze 1983 (LH 792)

670 Two Piece Point and Hole, 1980, Bronze 23.5cm long, LH 793

671 Reclining Figure: Small Head, 1980, Bronze 13.5cm long, LH 794

672 Male Torso, 1980, Bronze 16cm high, LH 795

673 Maquette for Three Quarter Figure: Lines, 1980, Bronze 21.5cm high, LH 796
One other form exists: Three Quarter Figure: Lines, 84cm high bronze 1980 (LH 797)

242

647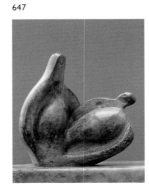
648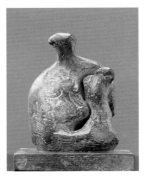
649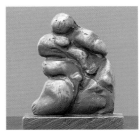

654
655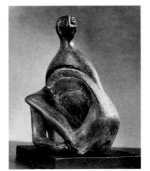
656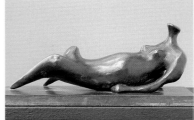

660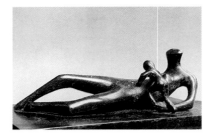
661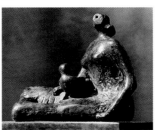
662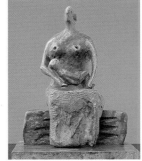

667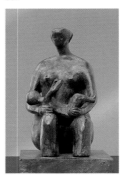
668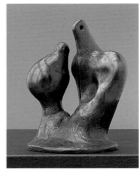
669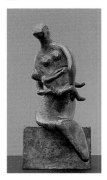

650

651

652

653

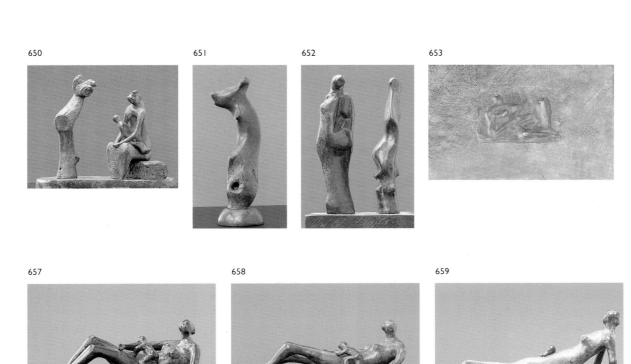

657

658

659

663

664

665

666

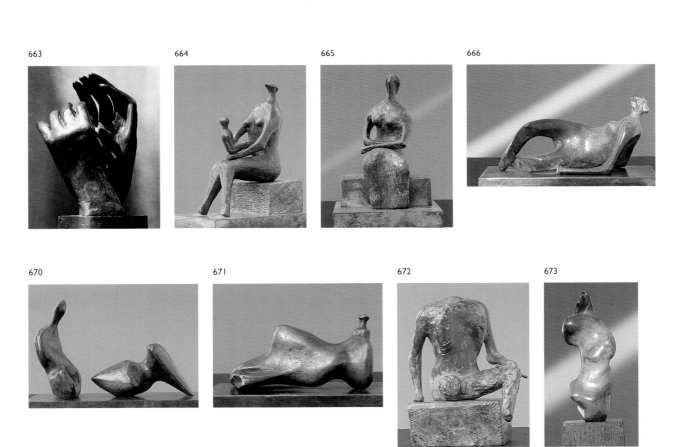

670

671

672

673

674 Resting Animal, 1980,
Bronze 21.5cm long, LH 798

675 Small Animal, 1980,
Bronze 8cm long, LH 799

676 Dog's Head, 1980,
Bronze 12cm long, LH 800

677 Horse's Head, 1980,
Bronze 19.5cm high, LH 801

678 Small Shell Mother
and Child, 1980, Bronze
10.5cm high, LH 802

679 Reclining Girl: Shell Skirt,
1980, Bronze 18.5cm long,
LH 803

680 Seated Mother and
Child: Thin, 1980, Bronze
24cm high, LH 804

681 Reclining Figure: Skirt,
1980, Bronze 15cm high,
LH 805

682 Three Quarter Figure:
Wedge, 1980, Bronze
17cm high, LH 806

683 Torso Relief, 1980,
Bronze 13.5cm high, LH 807

684 Reclining Woman No.1,
1980, Bronze 25cm long,
LH 808
*Two other forms exist: Largest
is Reclining Woman: Elbow,
221cm long bronze 1981
(LH 810)*

685 Reclining Woman No.2,
1980, Bronze 29cm long,
LH 811

686 Half-Figure on
Bone Base, 1981, Bronze
16cm high, LH 812

687 Standing Figure on
Round Base, 1981, Bronze
16.5cm high, LH 813

688 Two Torsos, 1981,
Bronze 20.5cm high, LH 814

689 Draped Reclining Figure:
Knee, 1981, Bronze
19cm long, LH 815

690 Reclining Torso, 1981,
Bronze 21.5cm long, LH 816

691 Family Group: Two Piece,
1981, Bronze 15cm long,
LH 817

692 Curved Head, 1981,
Bronze 7cm high, LH 818

693 Point and Oval, 1981,
Bronze 13.5cm long, LH 819

694 Maquette for Draped
Reclining Mother and Baby,
1981, Bronze 21cm long,
LH 820
*Two other forms exist: Largest
is Draped Reclining Mother
and Baby, 265.5cm long
bronze 1983 (LH 822)*

695 Two Piece Reclining
Figure: Arch, 1981, Bronze
20.5cm high, LH 823

696 Reclining Figure:
Flat Face, 1981, Bronze
18.5cm long, LH 824

697 Reclining Man and
Woman, 1981, Bronze
24cm long, LH 825

698 Maquette for Reclining
Figure: Pointed Head, 1981,
Bronze 18.5cm long, LH 826
*One other form exists:
Reclining Figure: Pointed Head,
86.5cm long bronze 1982
(LH 827)*

699 Three Piece Maquette,
1981, Bronze 32cm long,
LH 828

700 Fat Torso, 1981, Bronze
14.5cm high, LH 829

674
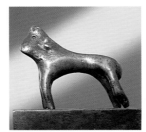

675
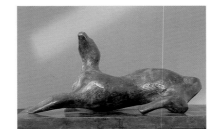

676
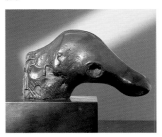

681
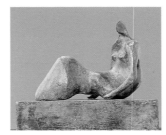

682
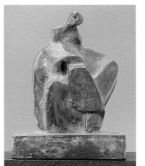

683

688
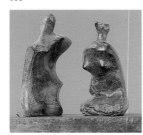

689
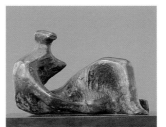

690
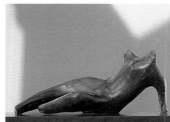

695

696
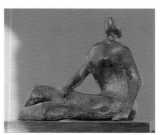

697
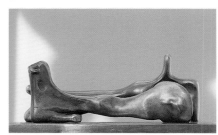

677

678

679

680

684

685

686

687

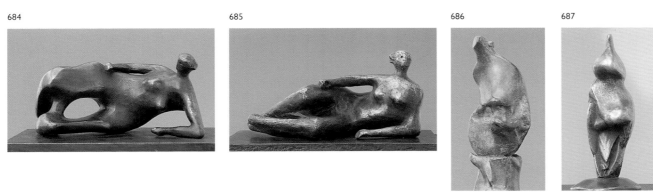

691

692

693

694

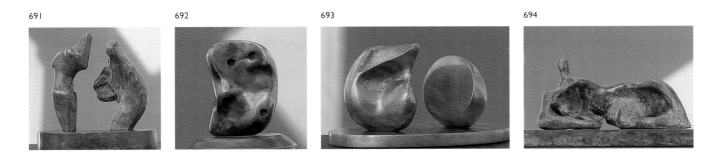

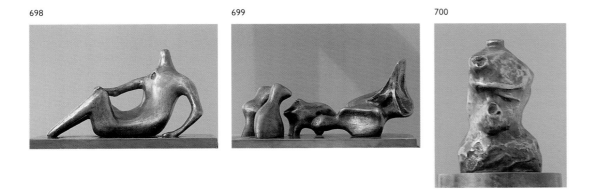

698

699

700

701 Reclining Figure:
Right Angles, 1981, Bronze
20cm long, LH 830

702 Maquette for Reclining
Figure: Open Pose, 1981,
Bronze 24cm high, LH 831
One other form exists:
Reclining Figure: Open Pose,
91.5cm long bronze1982
(LH 832)

703 Standing Man and
Woman, 1981, Bronze
18.5cm high, LH 833

704 Head, 1981, Bronze
10cm high, LH 834

705 Semi-Seated Mother
and Child, 1981, Bronze
19.5cm long, LH 835

706 Maquette for Mother
and Child: Block Seat, 1981,
Bronze 18cm high, LH 836
Two other forms exist: Largest
is Mother and Child: Block
Seat, 244cm high bronze
1983-4 (LH 838)

707 Mother Holding Child,
1981, Bronze 14cm high,
LH 839

708 Mother and Child: Chair,
1981, Bronze 30.5cm high,
LH 840

709 Reclining Woman: Hair,
1981, Bronze 25cm long,
LH 841

710 Reclining Woman: Skirt,
1981, Bronze 17.5cm long,
LH 842

711 Standing Woman, 1981,
Bronze 23.5cm high, LH 843

712 Standing Man, 1981,
Bronze 21cm high, LH 844

713 Standing Girl, 1981,
Bronze 21cm high, LH 845

714 Three-Quarter Figure:
Chest, 1981, Bronze
11.5cm high, LH 846

715 Small Three-Quarter
Figure: Simple Skirt, 1981,
Bronze 9.5cm high, LH 847

716 Reclining Man: Headless,
1982, Bronze 25.5cm long,
LH 848

717 Maquette for Mother
and Child: Hood, 1982,
Bronze 15cm high, LH 849
Two other forms exist: Largest
is Mother and Child: Hood,
183cm high travertine marble
1983 (LH 851)

718 Maquette for Three
Figures, 1982, Bronze
9cm long, LH 852
One other form exists: Three
Figures, 36cm long bronze
1982 (LH 853)

719 Reclining Figure: Peapod,
1982, Bronze 21.5cm long,
LH 854

720 Reclining Figure: Twisting,
1982, Bronze 23cm long,
LH 855

721 Reclining Figure:
Fragment, 1982, Bronze
10.5cm long, LH 856

722 Reclining Figure: Holes,
1982, Bronze 12.5cm long,
LH 857

723 Draped Torso, 1982,
Bronze 19cm high, LH 858

724 Torso Column, 1982,
Bronze 20.5cm high, LH 859

725 Male Torso, 1982, Bronze
13.5cm long, LH 860

726 Rock Form, 1982, Bronze
15cm high, LH 861

727 Half-Figure: Round Head,
1982, Bronze 16cm high,
LH 862

701
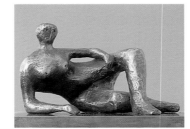

702

703
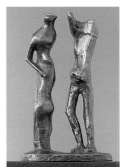

708
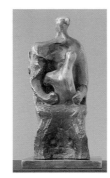

709
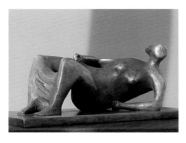

710
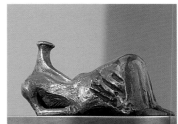

715
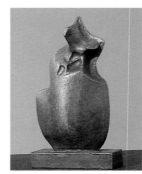

716
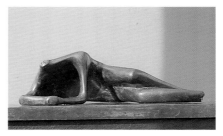

717
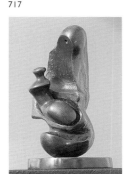

721
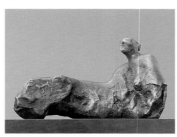

722
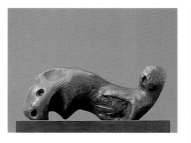

723

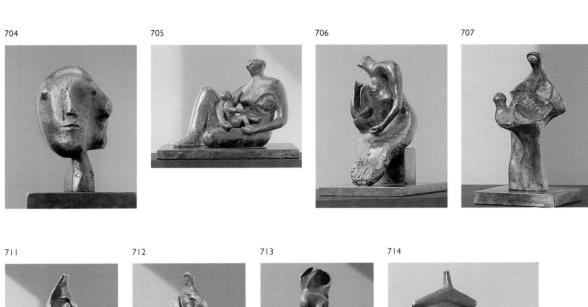

704 705 706 707

711 712 713 714

718 719 720

724 725 726 727

728 Torso: Shoulders, 1982, Bronze 18cm high, LH 863

729 Bonnet Figure, 1982, Bronze 16cm high, LH 864

730 Two Small Forms, 1982, Bronze 11cm long, LH 865

731 Standing Figure, 1982, Bronze 23cm high, LH 866

732 Head of Horse, 1982, Bronze 14cm high, LH 867

733 Animal Head: Open Mouth, 1982, Bronze 13cm long, LH 868

734 Maquette for Mother with Child on Lap, 1982, Bronze 15cm high, LH 869 *One other form exists: Mother with Child on Lap, 78.5cm high bronze cast 1985 (LH 870)*

735 Small Mother and Child, 1982, Bronze 12cm long, LH 871

736 Oblong Mother and Child, 1982, Bronze 13.5cm high, LH 872

737 Mother with Twins, 1982, Bronze 15cm high, LH 873

738 Mother with Child on Knee, 1982, Bronze 16cm high, LH 874

739 Three-Quarter Mother and Child on Round Base, 1982, Bronze 18cm high, LH 875

740 Seated Woman Holding Child, 1982, Bronze 17.5cm high, LH 876

741 Mother and Child: Rock, 1982, Bronze 16.5cm high, LH 877

742 Mother and Child on Rectangular Base, 1982, Bronze 16cm high, LH 878

743 Seated Figure on Log, 1982, Bronze 16.5cm high, LH 879

744 Girl, 1982, Bronze 18.5cm high, LH 880

745 Girl: One Arm, 1983, Bronze 11cm high, LH 881

746 Three-Quarter Woman, 1983, Bronze 9.5cm high, LH 882

747 Three-Quarter Figure on Tubular Base, 1983, Bronze 19cm high, LH 883

748 Figurine, 1983, Bronze 10cm high, LH 884

749 Tube Form, 1983, Bronze 12.5cm high, LH 885

750 Boat Form, 1983, Bronze 10cm long, LH 886

751 Two Bulb Forms, 1983, Bronze 10.5cm high, LH 887

752 Three-Quarter Figure: Cyclops, 1983, Bronze 19cm high, LH 888

753 Half-Figure, 1983, Bronze 15cm high, LH 889

754 Maquette for Carving, 1983, Bronze 12cm high, LH 890

728

729

730

735

736

737

742

743

744

749

750

751
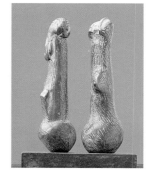

731

732

733

734

738

739

740

741

745

746

747

748

752

753

754

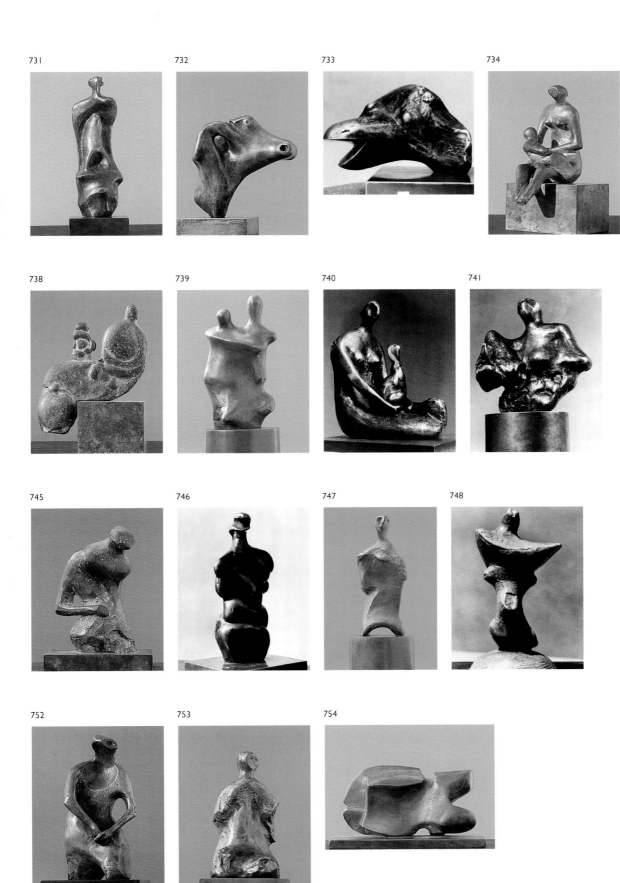

755 Bone Head, 1983, Bronze 14cm high, LH 891

756 Animal Turned Head, 1983, Bronze 13cm long, LH 892

757 Two Tall Forms, 1983, Bronze 15.5cm high, LH 893

758 Two Standing Women, 1983, Bronze 14.5cm high, LH 894

759 Seated and Standing Figures, 1983, Bronze 18cm long, LH 895

760 Standing Figure: Pointed Head, 1983, Bronze 22cm high, LH 896

761 Twins, 1983, Bronze 11.5cm high, LH 897

762 Half-Figure: Mother and Child, 1983, Bronze 11.5cm high, LH 898

763 Small Mother and Child on Round Base, 1983, Bronze 6.5cm high, LH 899

764 Mother and Child: Skirt, 1983, Bronze 10cm high, LH 900

765 Reclining Girl, 1983, Bronze 12.5cm high, LH 901

766 Maquette for Reclining Figure: circle, 1983, Bronze 15cm long, LH 902
One other form exists:
Reclining Figure: Circle, 89cm long bronze 1983 (LH 903)

767 Reclining Figure: Turned Head, 1983, Bronze 20.5cm long, LH 904

768 Reclining Figure, 1983, Bronze 18cm long, LH 905

769 Maquette for Reclining Figure: Umbilicus, 1983, Bronze 22cm long, LH 906
One other form exists:
Reclining Figure: Umbilicus, 94cm long bronze 1984 (LH 907)

770 Reclining Figure: Hollows, 1983, Bronze 20.5cm long, LH 908

771 Two Standing Figures: Concretions, 1983, Bronze 21cm high , LH 909

772 Three-Quarter Girl, 1983, Bronze 10cm high, LH 910

773 Seated Woman: Shell Skirt, cast 1984, Bronze 18cm high, LH 911

774 Skeleton Figure, cast 1984, Bronze 12.5cm high, LH 912

775 Female Torso, cast 1964, Bronze 17cm high, LH 913

776 Small Head, cast 1984, Bronze 7.5cm high, LH 914

777 Three-Quarter Figure: Hollow, cast 1984, Bronze 17cm high, LH 915

778 Seated Figure: Thin Head, cast 1984, Bronze 14.5cm high, LH 917

779 Head, 1984, Bronze 62cm high, LH 918

780 Three-Quarter Figure: Points, cast 1985, Bronze 12cm high, LH 919

755
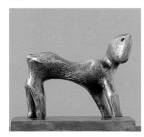

756

757
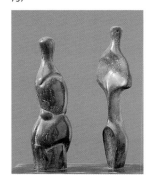

762
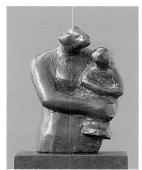

763
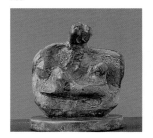

764
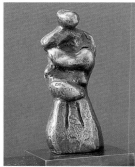

768
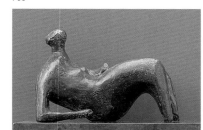

769
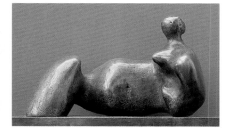

774
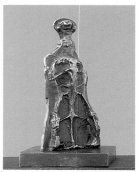

775
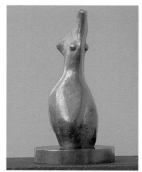

776
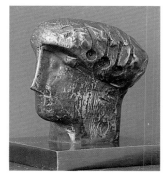

758

759

760

761

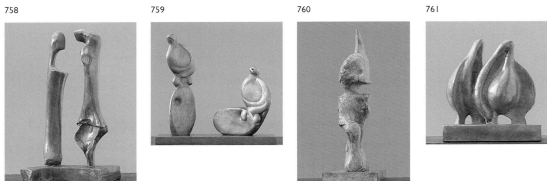

765

766

767

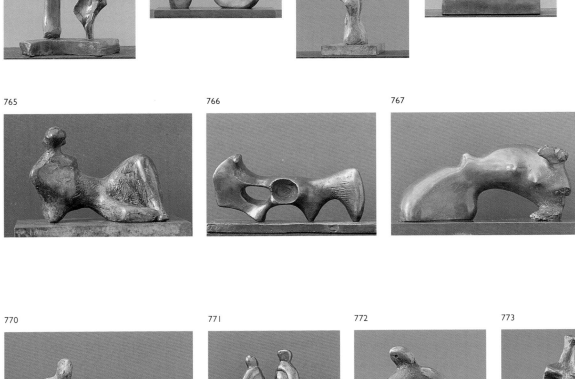

770

771

772

773

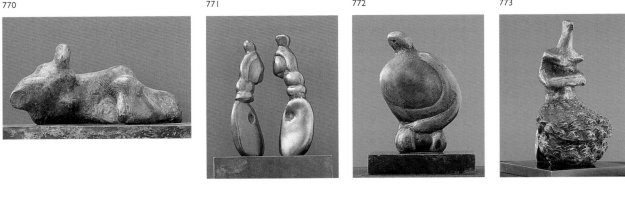

777

778

779

780

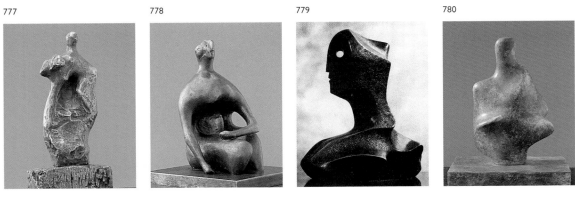

Select bibliography

There is a five volume *Henry Moore Bibliography*, edited by
Alexander Davis and published by the Henry Moore Foundation,
Much Hadham, 1992 - 94. Here I have presented a simple list of
those books employed in the creation of this one.

Henry Moore, Complete Sculpture, Lund Humphries, London.
Vol 1, 1921 - 48, ed. Herbert Read, 5th edn., ed.
David Sylvester, 1988.
Vol 2, 1949 - 54, ed. Herbert Read, 3rd edn., ed.
Alan Bowness, 1986.
Vol 3, 1955 - 64, ed. Alan Bowness, 2nd edn., 1986.
Vol 4, 1964 - 73, ed. Alan Bowness, 1977.
Vol 5, 1974 - 80, ed. Alan Bowness, 2nd edn., 1994.
Vol 6, 1980 - 86, ed. Alan Bowness, 1988.
The LH numbers used in the present volume are drawn from
this *catalogue raisonnée*.

Berthoud, Roger, *The Life of Henry Moore*, Faber and Faber,
London; E. P. Dutton, New York, 1987.

James, Philip (ed.), *Henry Moore on Sculpture*, Macdonald, London,
1966; Viking, New York, 1967; Da Capo, New York, 1992.

Garrould, Ann, *Henry Moore Drawings*, Thames and Hudson,
London; Rizzoli, New York, 1988.

Hedgecoe, John, *Henry Spencer Moore*, Thomas Nelson, London;
Simon and Schuster, New York, 1968.

Hall, Donald, Henry Moore, The Life and Work of a Great
Sculptor, Gollancz, London, 1966

Moore, Henry and Hedgecoe, John, *Henry Moore, My Ideas,
Inspiration and Life as Artist*, Ebury Press, London 1986.

Read, Herbert, *Henry Moore, A Study of his Life and Work*, Thames
and Hudson, London, 1965; Praeger, New York, 1966.

Notes to text

(All quotations in the captions to photographs are from
Hedgecoe, *Henry Spencer Moore*, 1968)

1 Moore, Henry, *Heads, Figures and Ideas*, Rainbird, London, 1958
2 Forma, Warren, *Five British Sculptors: Work and Talk*, Grossman,
 New York, 1964.
3 Moore, Henry, 'The Sculptor Speaks', *The Listener*, vol 18,
 no 449, London, 1937.
4 Forma, Warren, *op. cit.*
5 Russell, John and Vera, 'Conversations with Henry Moore',
 The Sunday Times, London, Dec 17 and 24, 1961.
6 Russell, John and Vera, *op. cit.*
7 Moore, Henry, 'Primitive Art', *The Listener*, vol 25, no 641,
 London, 1941.
8 Hall, Donald, 'An interview with Henry Moore', *Horizon*, vol
 3, no 2, New York, 1960.
9 Sweeney, James Johnson, 'Henry Moore', *The Partisan Review*,
 vol 14, no 2, New York, 1947.
10 'Contemporary English Sculptors: Henry Moore',
 Architectural Association Journal, vol 45, no 519, London 1930.
11 Forma, Warren, *op. cit.*
12 Hedgecoe, John, *Henry Spencer Moore*, 1968.
13 Arts Council of Great Britain, *Sculptures and Drawings by
 Henry Moore*, The Tate Gallery, London, 1951.
14 Galerie Bayeler, *Henry Moore: Drawings, Gouaches,
 Watercolours*, Basle, 1970.

Major Collections

The following is a list of some of the museums and public institutions that own sculptures by Henry Moore. The list is not exhaustive; it is intended as a guide only, the museums chosen generally having several of his full-scale sculptures.

Albright-Knox Art Gallery, Buffalo, USA

Arts Council of Great Britain, London, UK

Art Institute of Chicago, Chicago, USA

Art Gallery of Ontario, Toronto, Canada

The Baltimore Museum of Art, Baltimore, USA

Bayerische Staats gemäldesammlungen, Munich, Germany

The British Council, London, UK

City Art Gallery, Wakefield, UK

City Art Gallery, Manchester, UK

Dallas Museum of Art, Dallas, USA

Detroit Institute of Arts, Detroit, USA

Didrichsen Art Museum, Helsinki, Finland

Fogg Art Museum, Cambridge, USA

Peggy Guggenheim Collection

(Museum of Modern Art), Venice, Italy

Hakone Open Air Museum, Hakone, Japan

Hamburger Kunsthalle, Hamburg, Germany

Hiroshima Museum of Art, Hiroshima, Japan

Hirshhorn Museum and Sculpture Garden, Washington, USA

Israel Museum, Jerusalem, Israel

Leeds City Art Gallery, Leeds, UK

Louisiana Museum of Modern Art, Humlebaek, Denmark

Miller Art Center, Sturgeon Bay, USA

Metropolitan Museum of Art, New York, USA

Musée des Beaux-Arts, Montreal, Canada

Museum Ludwig, Cologne, Germany

Museum of Fine Arts, Boston, USA

Museum of Modern Art, New York, USA

National Gallery of Art, Washington, USA

Nationalgalerie Staatliche Museen, Berlin, Germany

Nelson - Atkins Museum of Art, Kansas City, USA

Palm Springs Desert Museum, Palm Springs, USA

John B. Putnam Jr Memorial Collection

The Art Museum, Princeton, USA

Rijksmuseum Kroller-Muller, Otterlo, Netherlands

Sir Robert and Lady Sainsbury Collection, Norwich, UK

Saint Louis Art Museum, Saint Louis, USA

San Diego Museum Of Art, San Diego, USA

San Francisco Museum of Modern Art, San Francisco, USA

Scottish National Gallery of Modern Art, Edinburgh, UK

The Norton Simon Museum of Art, Pasadena, USA

David and Alfred Smart Museum of Art, Chicago, USA

Sprengel Museum Hannover, Hannover, Germany

Staatsgalerie Stuttgart, Stuttgart, Germany

Tate Gallery, London, UK

Teheran Museum of Contemporary Art, Teheran, Iran

Walker Art Center, Minneapolis, USA

Whitworth Art Gallery, Manchester, UK

Yale Center for British Art, New Haven USA

Index

256